BARACK BEFORE OBAMA

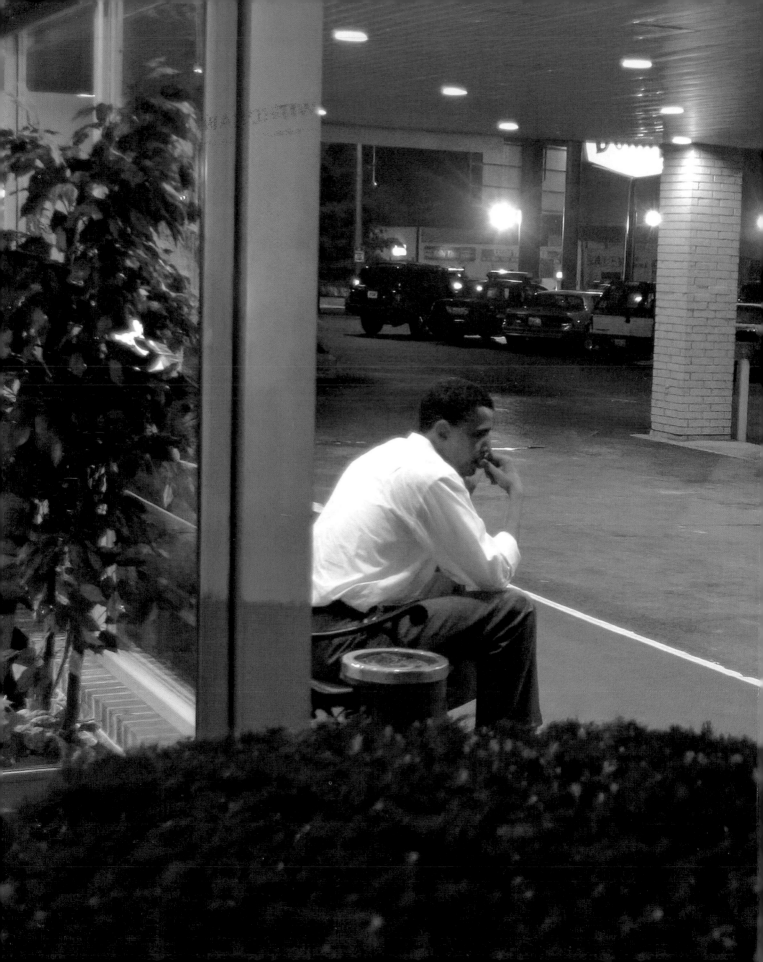

BARACK BEFORE OBAMA

LIFE BEFORE THE PRESIDENCY

DAVID KATZ

Foreword by BARACK OBAMA

ccc
An Imprint of HarperCollins*Publishers*

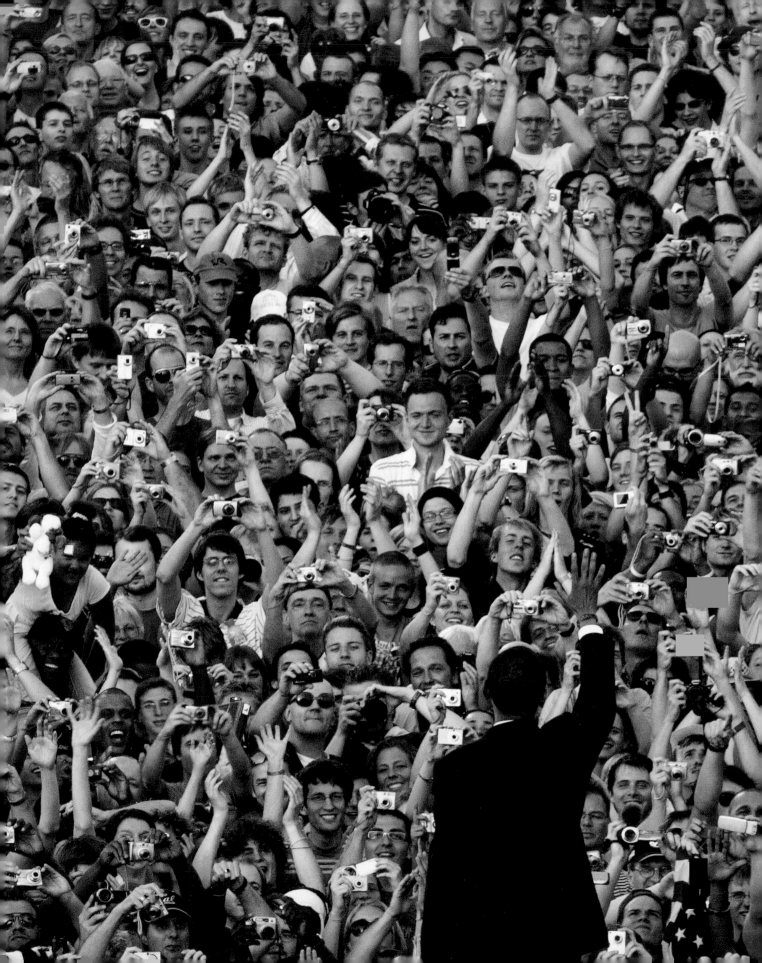

To my family—Betsy, Arlo, and Zoe—you make life so special;
and to my mother, father, and sister—Lucinda, Norman, and Shira—
for always believing in me and pushing me.

FOREWORD

When I first met David Katz, he was fresh out of college with dreams of becoming a campaign photographer, and I was a largely unknown state senator with a much longer-shot dream of becoming the United States junior senator from Illinois.

At the time, I didn't know that our bare-bones campaign had even hired a photographer until David, clutching his camera, followed me into my car after one of our events on the South Side of Chicago. Before long, the two of us were spending long days together, getting to know one another as we crisscrossed the state, from the rolling hills of farmland to downtown skyscrapers. David was there for my keynote speech at the 2004 Democratic National Convention. He was there for my first big electoral win that November—and he was with us on another big November night four years later.

But even more than the moments folks may already be familiar with, David was there for a period of great transition for our family. Our daily lives were suddenly being documented and scrutinized. I couldn't walk down the street without being recognized. We were suddenly welcoming Oprah into our living room. It wasn't always a smooth transition, but, as these photos show, Michelle and I still found plenty of ways to laugh and play with our girls, make lifelong memories, and just be a family during an extraordinary time.

Our lives have changed a great deal since these photos were taken. The whole world has. Those little girls have grown up and have gone off to college. My hair is quite a lot grayer. Michelle, of course, still takes my breath away. But when I look back to the days when it was all just beginning, what

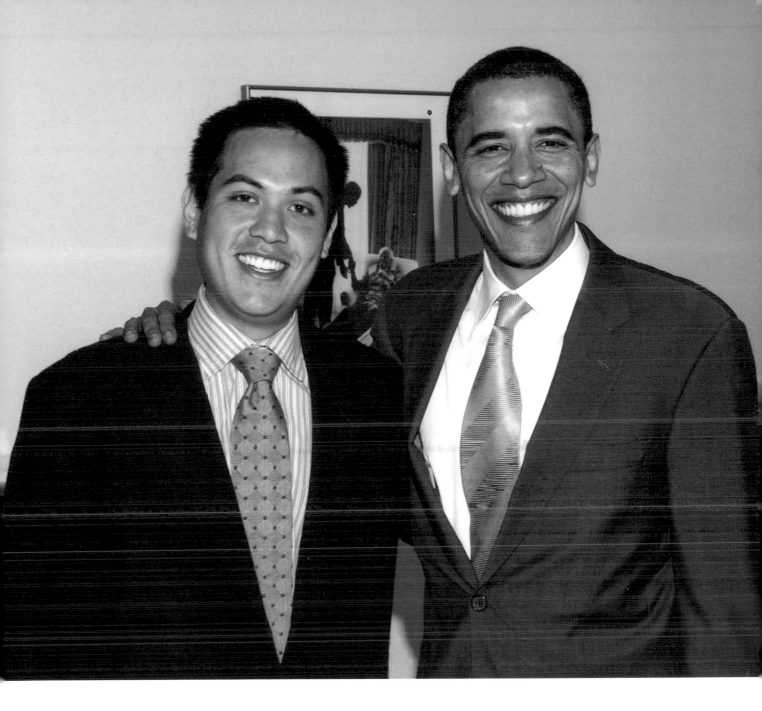

I'm struck by is how many things haven't changed at all: The comfort of the embrace of family and friends. The hope that carries us through long days. And the belief in a country that still has brighter days ahead.

I'm grateful that David was there to document it all. And I think you will be, too.

—*Barack Obama*

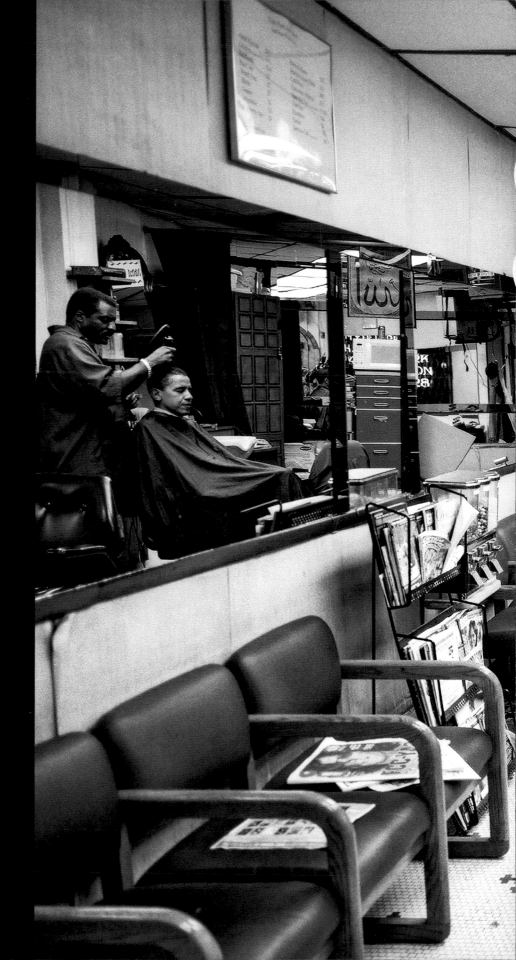

After a long day of campaigning during the 2004 US Senate race, Barack Obama gets his hair trimmed by his longtime barber, James Zariff Smith, at the Hyde Park Hair Salon in Chicago.

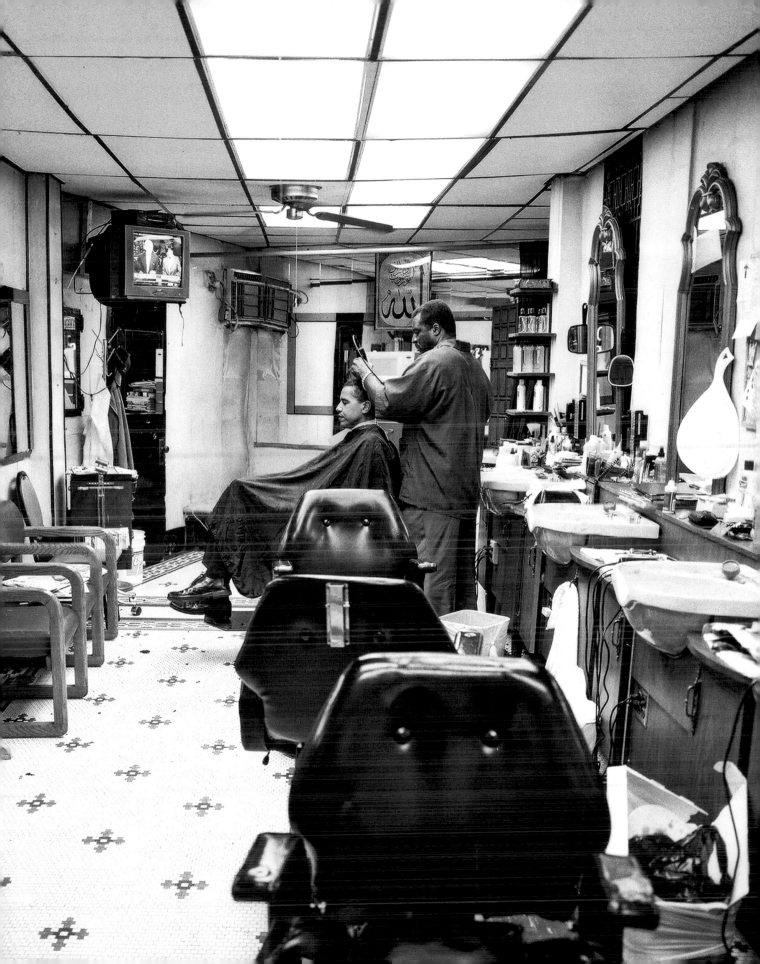

INTRODUCTION

Before Barack Obama became the forty-fourth president of the United States, he was Barack Obama the law professor, civil rights lawyer, and US Senate candidate, one unsuccessful race away from retiring from politics. People often forget that he was a long shot to win the 2004 Senate Democratic primary, let alone the general election. Just two years after that historic win, he would announce his candidacy for the presidency of the United States, and two years later he was sworn into office as our first African American president.

Barack Before Obama is my collection of rarely and never-before-seen photographs from his 2004 Senate campaign, his time working in the US Senate, and his historic 2008 presidential campaign. I had the privilege to take more than 90,000 pictures during these three periods, photographing and interacting with Barack and his family. While there is an abundance of photographs publicly available from the presidential era, the time between 2004 and 2008 is a chapter in Obama's life that has not been told in much detail; this collection depicts some of the many small moments when his political career was just gaining traction. Some of my favorite photographs include the Obamas' first encounter with Oprah and her friend and colleague Gayle King; Obama at the barber after a long day campaigning; the only time he met Nelson Mandela; and the night he was elected president, surrounded by his family and advisers.

When I first met Barack Obama in January 2004, he had just launched a campaign for the US Senate, and he was polling at a distant third place. I had

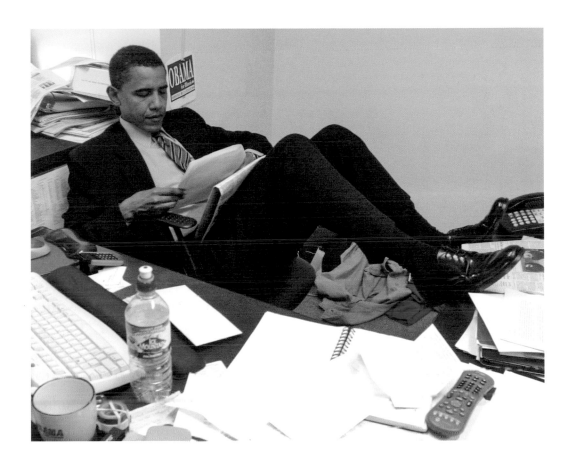

recently graduated from college and was living with my parents in Chicago, trying to figure out a career path.

At the recommendation of friends, I went to see Obama speak at a black church on the South Side of Chicago. It was my first time seeing him in person, and I was struck by the powerful connection he was able to forge with multiple generations in the church. Inspired and moved by that experience, I began to think of how I could meaningfully contribute to his Senate campaign. At the University of Michigan, I had worked as a staff photographer and the photo editor of the *Michigan Daily*, one of the largest college newspapers in the country. I reviewed Obama's campaign website and political ads, and concluded they needed more compelling photos of the candidate, so I lugged my leather-bound photo portfolio into the Chicago office of Obama's campaign manager, Jim Cauley. By the end of our meeting, Cauley offered me

the role of official photographer. I doubt it was a particularly competitive hiring process, given that the entire campaign team was no more than ten people.

About a month into my job, Cauley asked staff members for a volunteer to drive Obama around Illinois to his various campaign stops. I was surprised when nobody else in the room raised a hand. I jumped at the chance, knowing that developing a closer relationship to the candidate would allow me to capture more intimate images. For the next ten months, I spent six days a week crisscrossing Illinois in the driver's seat of a Chevy Suburban with Barack and his closest advisers as we worked to familiarize this "Chicago" candidate with the rest of the state. Born and raised in Chicago myself, I had never been to a fish fry or county fair, so our experience traveling to other cities like Effingham, Mount Vernon, and Marion made me see my home state in a new way.

The day before the Senate election in 2004, Obama turned to me and asked, "If we win tomorrow, are you going to come to Washington with me to be my personal aide?" After a year of spending sixteen-hour days together, we had developed a very trusting relationship, and I gladly signed on for this next phase of his political journey. As a personal aide, I spent every working minute anticipating Obama's needs—reminding him to make calls, meeting with constituents, drafting notes to his friends and colleagues, and driving him to and from the office. When he first arrived in DC, the Senate staff had found him an apartment in a high-rise building. He was concerned that it was too sterile an environment in which to finish writing his book *The Audacity of Hope*, so I found him a cozy one-bedroom apartment with a small backyard garden and a few architecturally charming details. Barack was a night owl, frequently staying up late to work on the book; on more than one occasion, I had to bang on his door to wake him up and to get him to the Senate on time.

Political photographers attempt to master the art of blending into the background while still positioning themselves in the right place at the right time to get the perfect shot. Pictures come alive when your subjects are so comfortable with you that they do not even notice you. When this happens, their body language, facial expressions, and movements become most authentic,

revealing their true feelings in the moment. I hope in these images you will see the Obamas in a different way than you have ever seen them before. While Barack always seemed at ease in front of the camera, it was in moments with his children—showing Malia how a voting machine works, or playing in front of their apartment with Sasha—when he seemed most relaxed. Once he became president those moments were harder and harder to come by. I'm sure he often longed for the days when he could feel like Barack Before Obama.

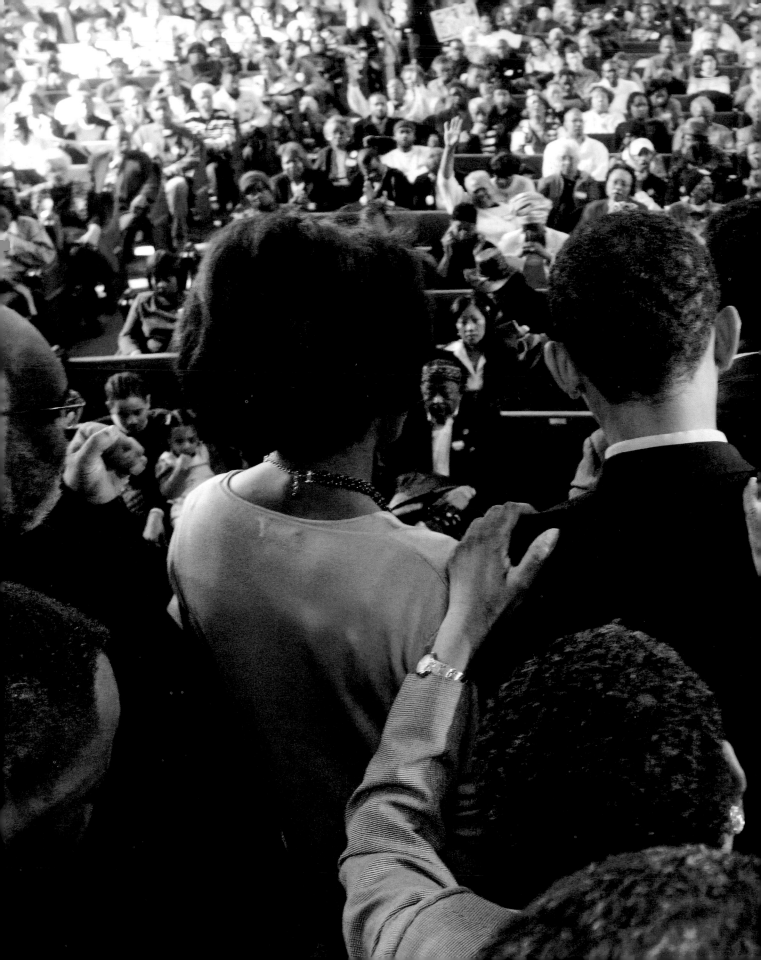

2004
2005

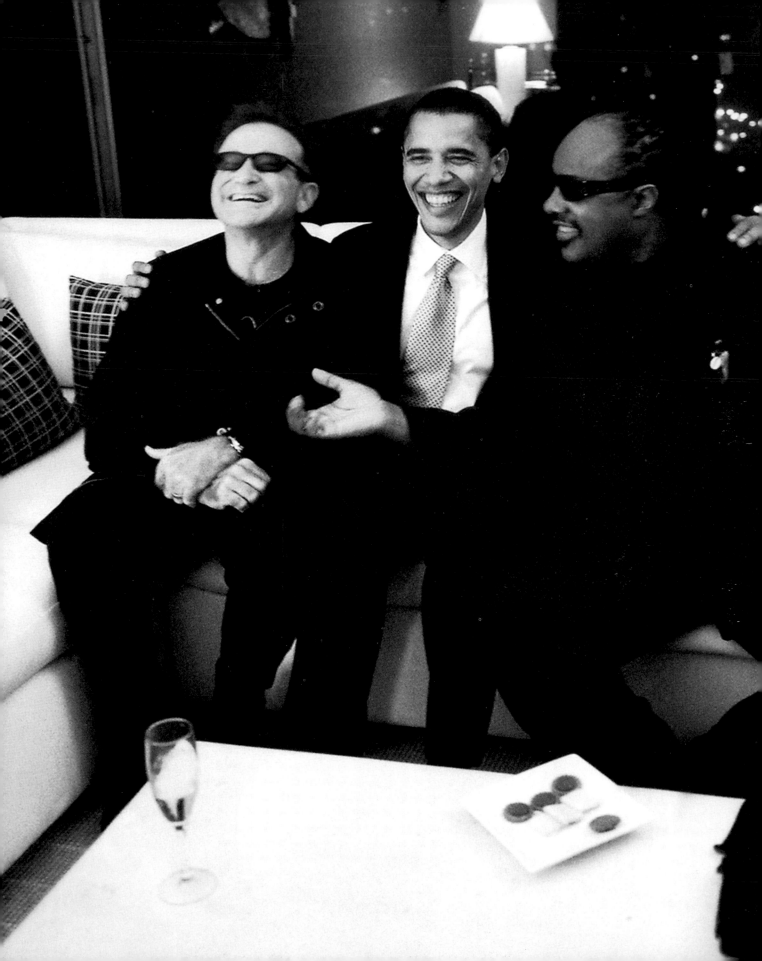

ROBIN & STEVIE

Stevie Wonder and Robin Williams headlined a 2004 fundraiser for Obama's Senate campaign that started with Obama meeting Williams backstage at the Park West theater. When we opened the door to his dressing room, Obama and I both saw him with his head bowed, deep in thought. It was a version of Robin Williams I had never seen before—serious, completely calm, almost Zen-like. He and Stevie Wonder performed that night to a crowd of about three hundred supporters; Michelle and Barack laughed and danced like they were two parents having the best date night of all time. At the after-party, Obama toasted Wonder and Williams and then later sat and laughed with them on a sofa as Williams performed a perfect impersonation of Wonder. Campaign manager Jim Cauley later said Obama told him how he and Michelle got to dance that night to the same Stevie Wonder song they had heard on their first date. The next morning Obama said to me wistfully, "Do you know that ten minutes after we left last night, Stevie Wonder played a concert for twenty people? Can't believe we missed that." Robin Williams's son Zak Williams also attended the fundraiser. He recalled, "It was a special evening. The energy in the room was something else, and it felt like there was momentum building because people were absolutely taken with Obama, his charisma and their sense that he was what we needed at that time. Three people at the top of their profession just being normal, joking around. Dad loved Obama mostly because of how transformative he was, but also because of how smooth he was. He would say, 'He is one cool guy. You just want to be around him.'"

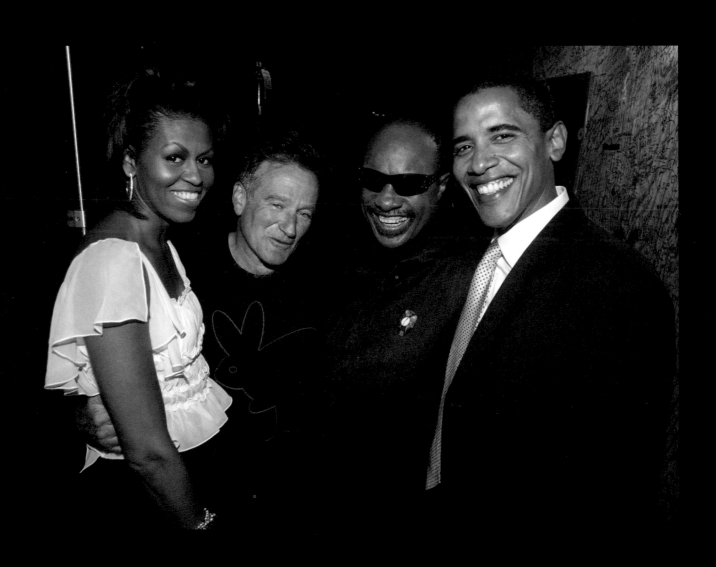

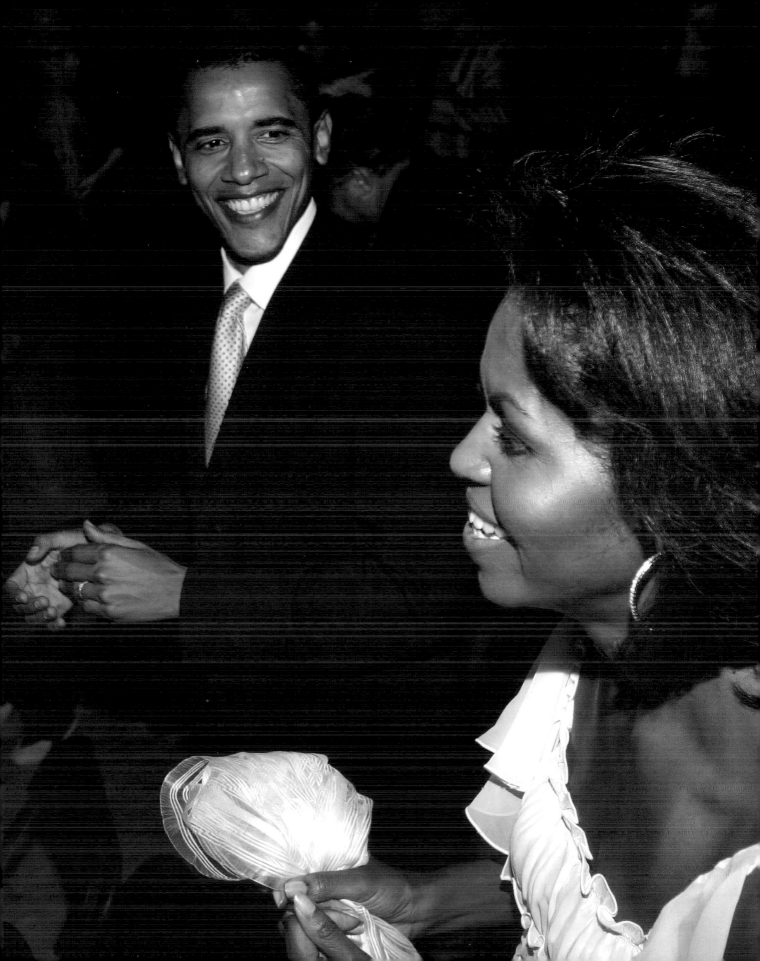

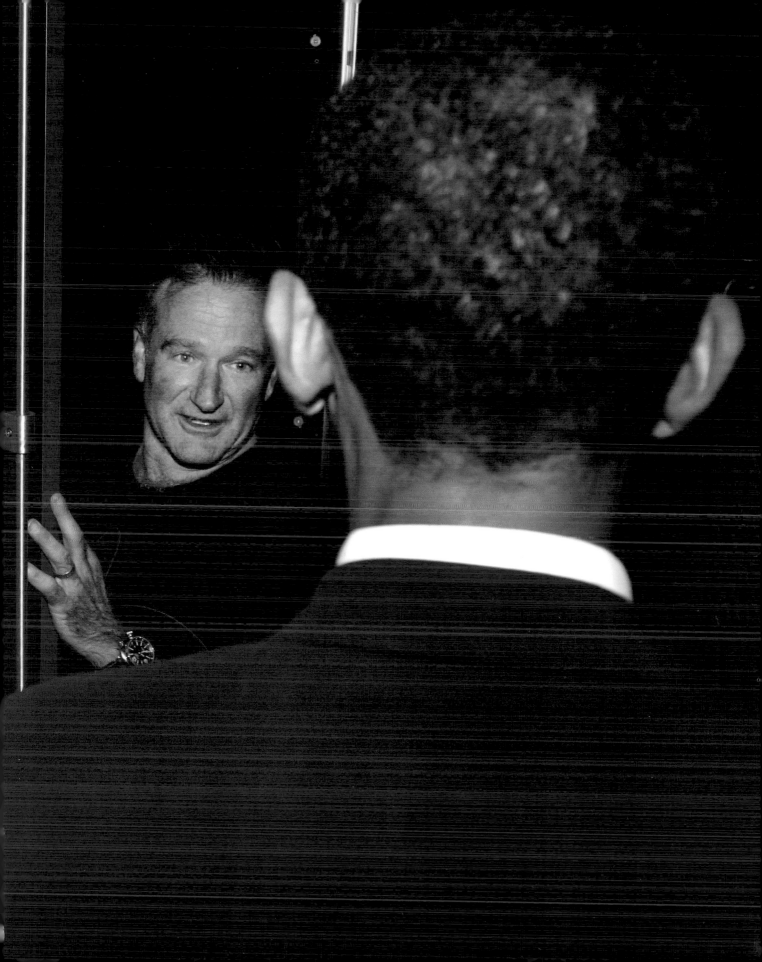

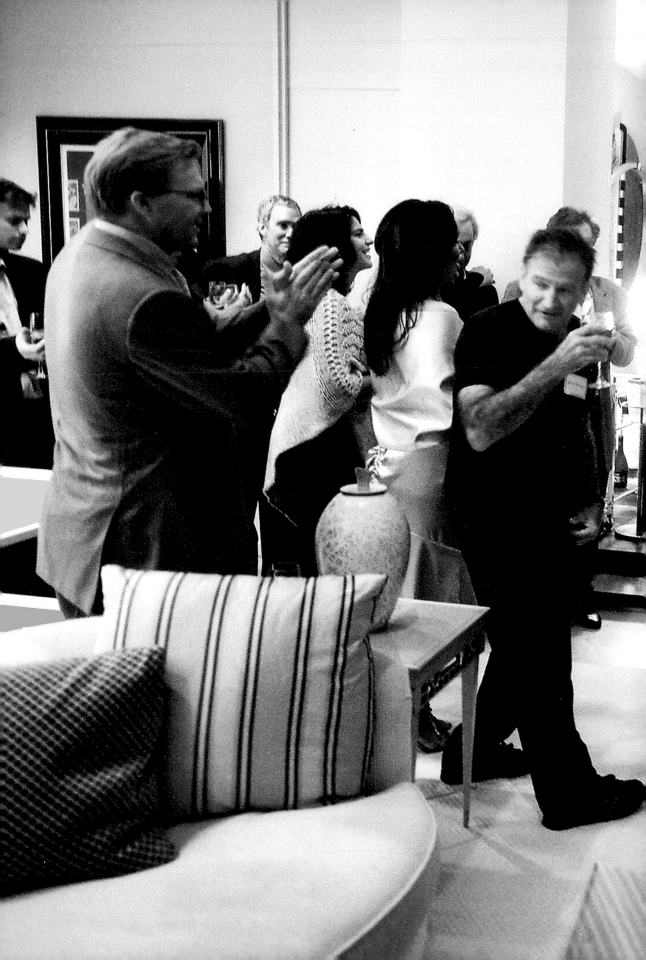

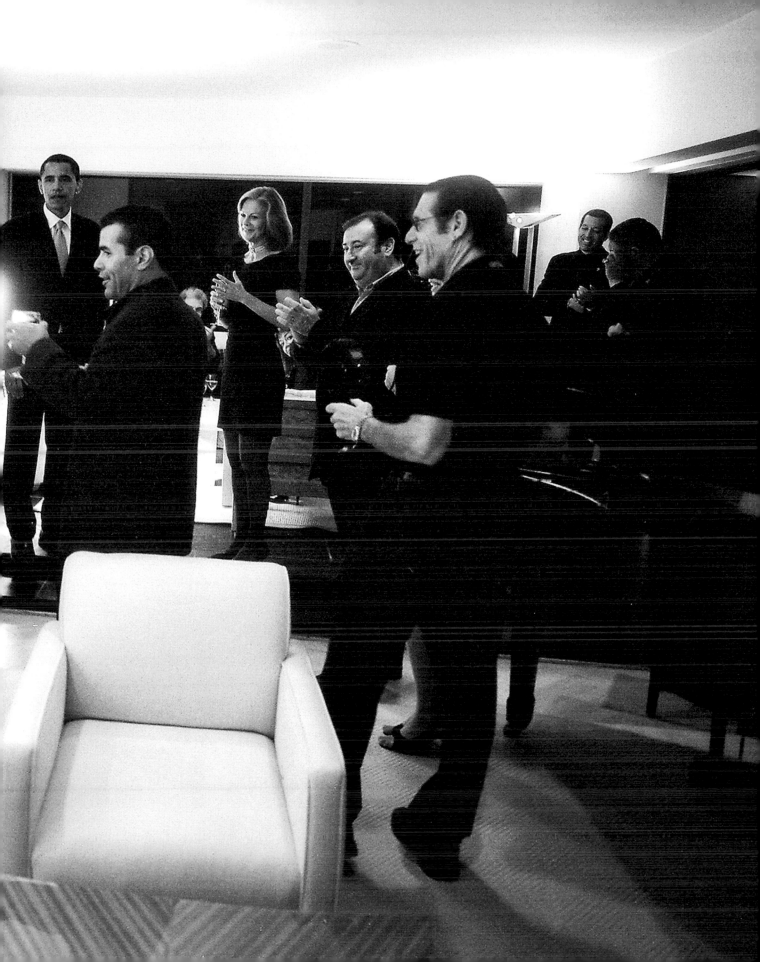

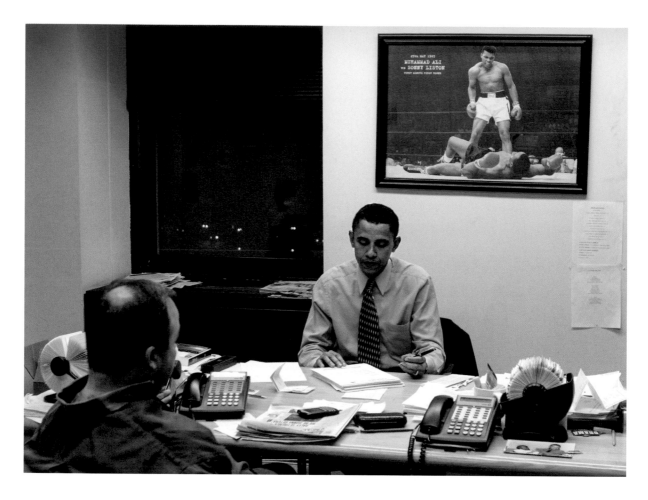

It was in this downtown Chicago office, Obama's Senate campaign headquarters, where I was interviewed and hired to photograph Obama, in January 2004. When I met with the campaign manager, Jim Cauley (pictured opposite Obama), I showed him my portfolio with the hope of becoming the campaign photographer. He liked the photos, but the campaign was conserving cash. He said, "If you volunteer and help us out for a few months, I'll hire you if we win the primary. Why don't you jump in the car with Barack tomorrow to take pictures, and just go everywhere he goes."

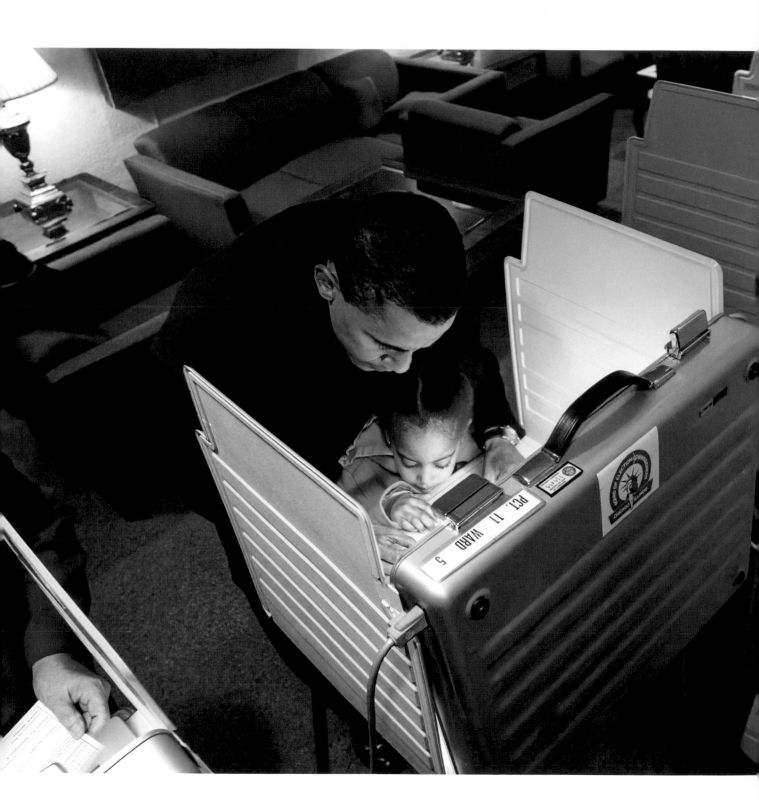

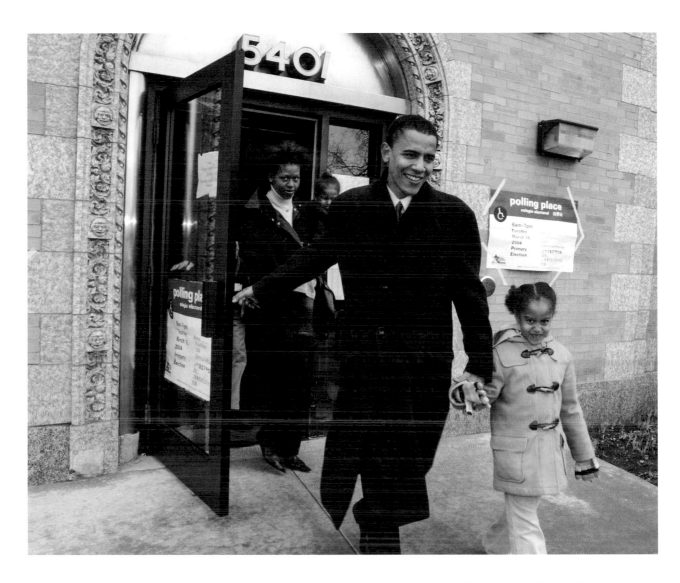

On primary election day in 2004, Obama decided to bring the entire family to vote. I was lucky enough to follow him into the voting area. He spent a few minutes showing Malia how the voting machine worked.

Barack hugs Sasha on the set of a political advertising shoot. These ads were being filmed to prepare for an advertising surge late in the 2004 campaign.

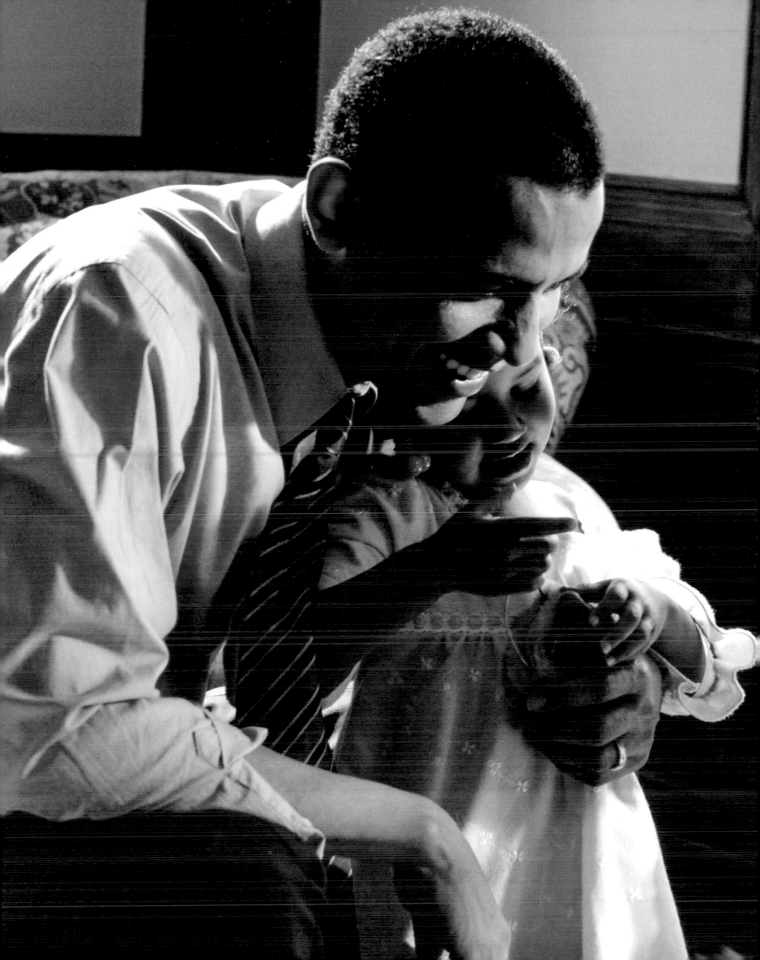

OPRAH & GAYLE

O prah had taken notice of the Obamas in 2004 after his famous Democratic National Convention (DNC) speech and wanted to interview them for *O, The Oprah Magazine*. The Obamas lived on the second floor of a typical three-floor walk-up in the Hyde Park neighborhood of Chicago. The apartment layout was standard for the neighborhood, with the solarium and living room in the front and the bedrooms and kitchen in the back. The living room was decorated with art they had collected during their travels. It was a home perfectly suited for a professor, a hospital executive, and their growing family, but noticeably less glamorous than the usual backdrops in the magazine. Oprah brought Gayle King along and they interviewed the Obamas in the solarium. But as my campaign colleague Tommy Vietor (now of Crooked Media) remembers, when it came time for the photographs, "Even though the crew had totally rearranged the Obamas' living room for the inter-view and photo shoot, Oprah was *not* having it, so they did it outside instead. It was the Obamas and Oprah walking around on that grassy park area in front of their house."

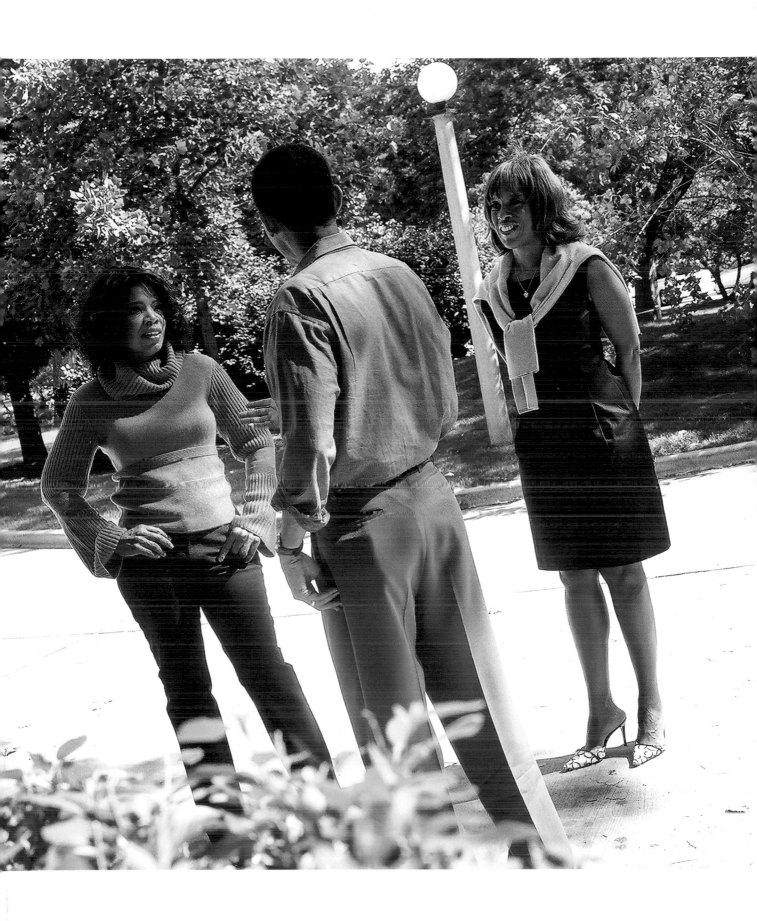

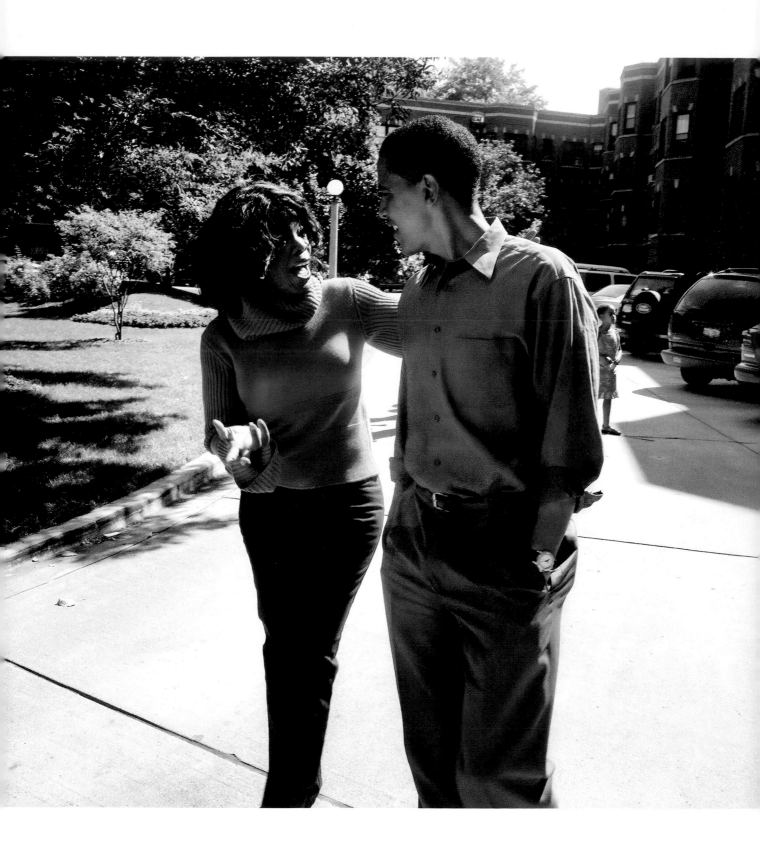

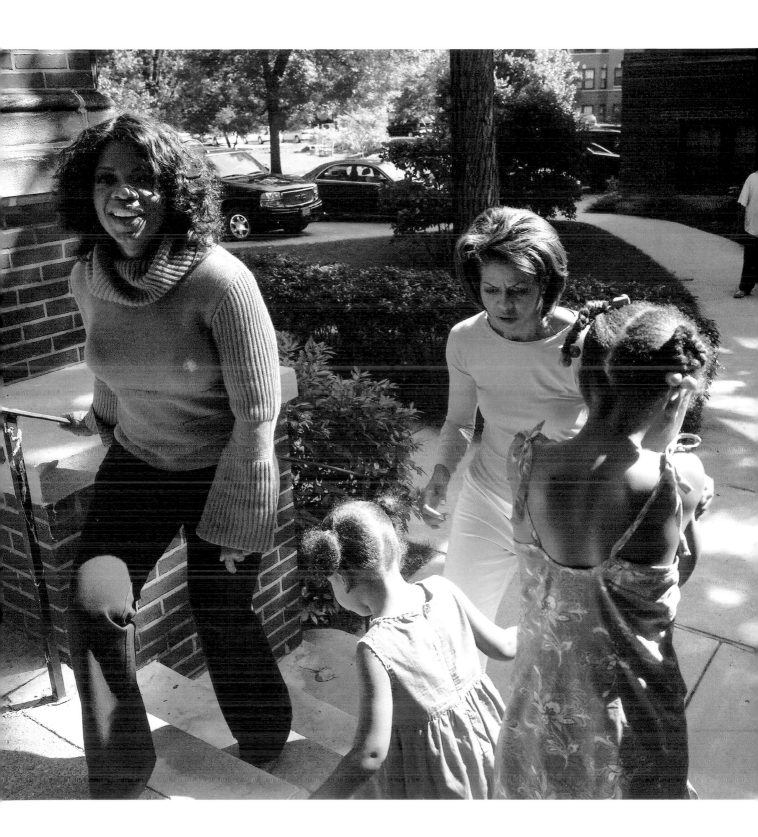

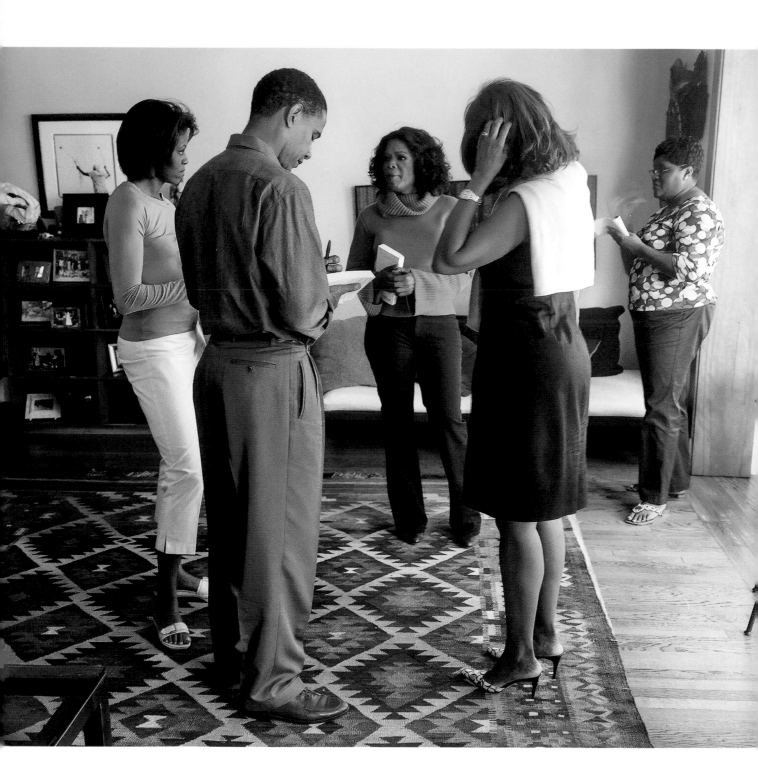

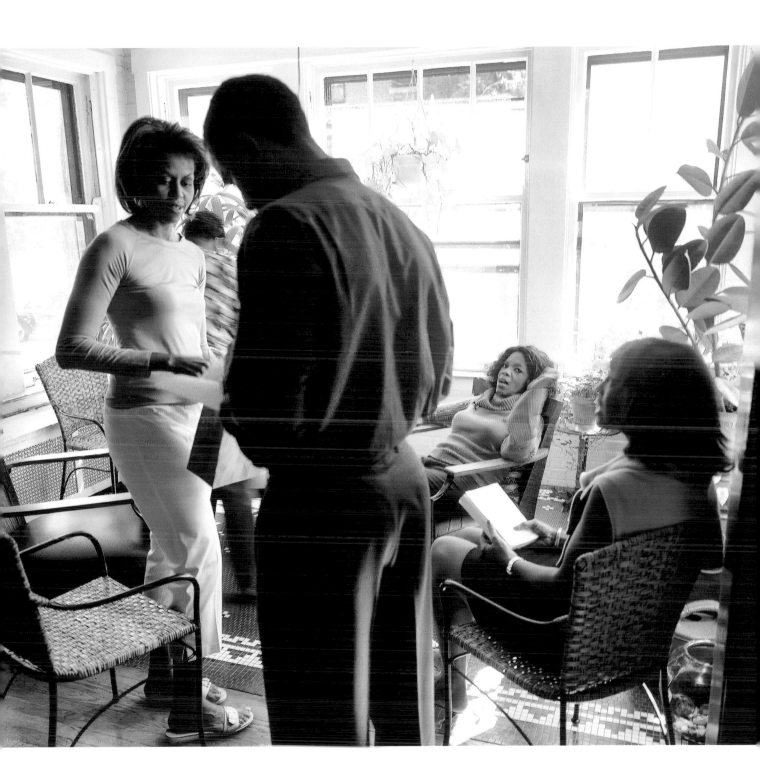

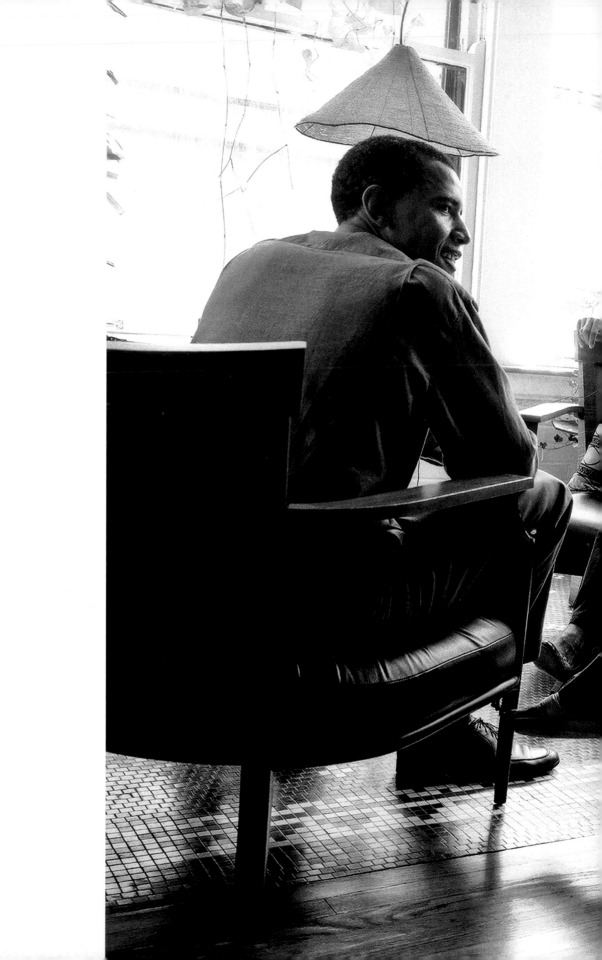

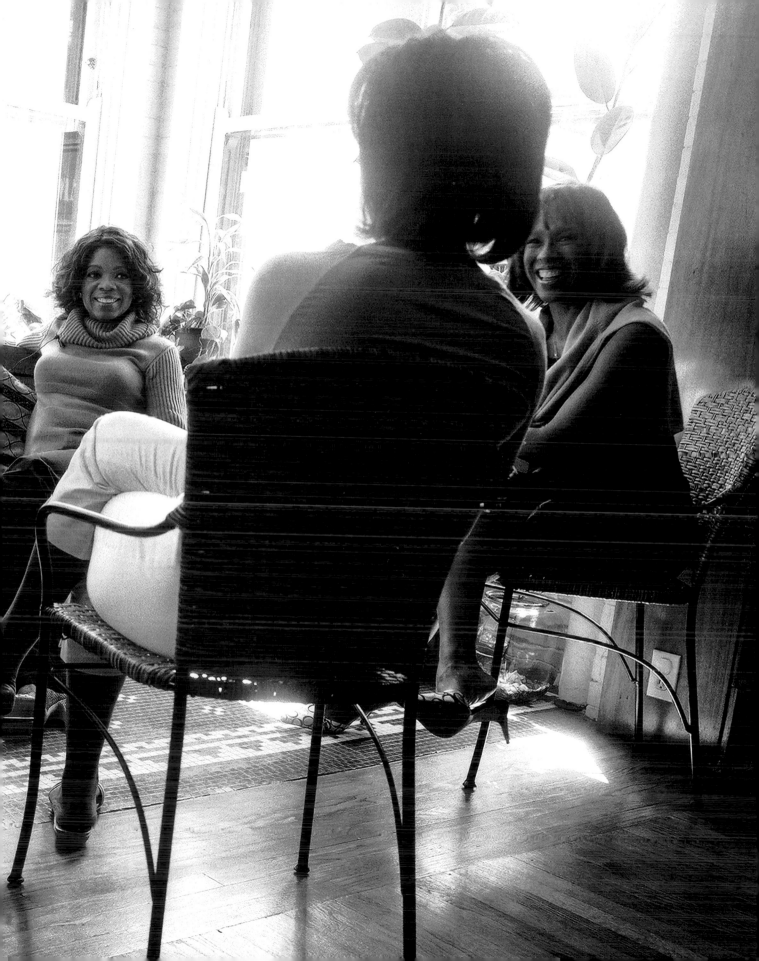

CALL TIME

Politicians spend an incredible amount of time on the phone calling donors to raise money, consultants to discuss advertising campaigns, and staff to edit a speech or rearrange their schedule. During the 2004 campaign, much of the time we spent in the car together was used for phone calls. I was present when John Kerry offered Obama the keynote speaking slot at the DNC. After an event we attended at a VFW hall in deep downstate Illinois, the campaign's strategist, David Axelrod, called me to ask how the crowd had received Obama. "When you told me he was a big hit, I was absolutely stunned," Axelrod recalled. It was unusual for Chicago candidates to be received so well in Southern Illinois. During his time in the Senate, Obama would sometimes call reporters to correct the record if he felt they had written something that lacked context or needed an alternative perspective. He seemed to enjoy the banter with reporters, often getting into deep policy discussions. He treated them with respect and as thought partners.

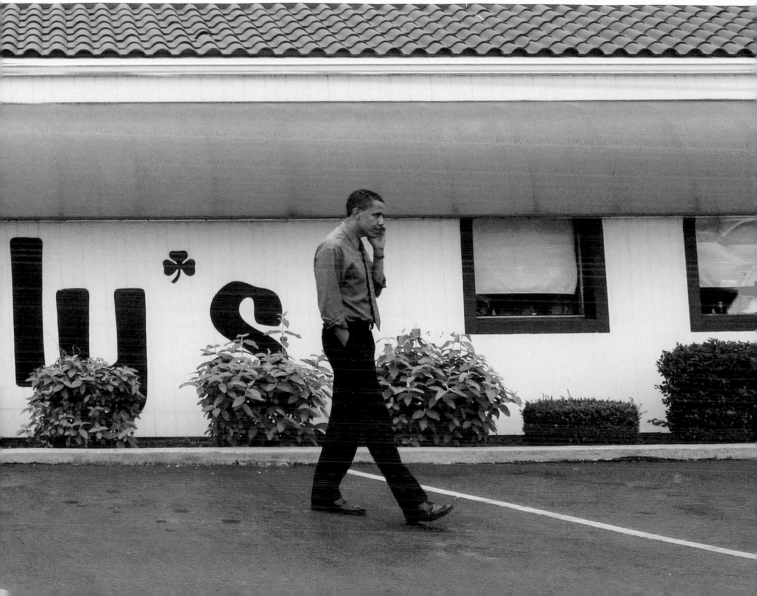

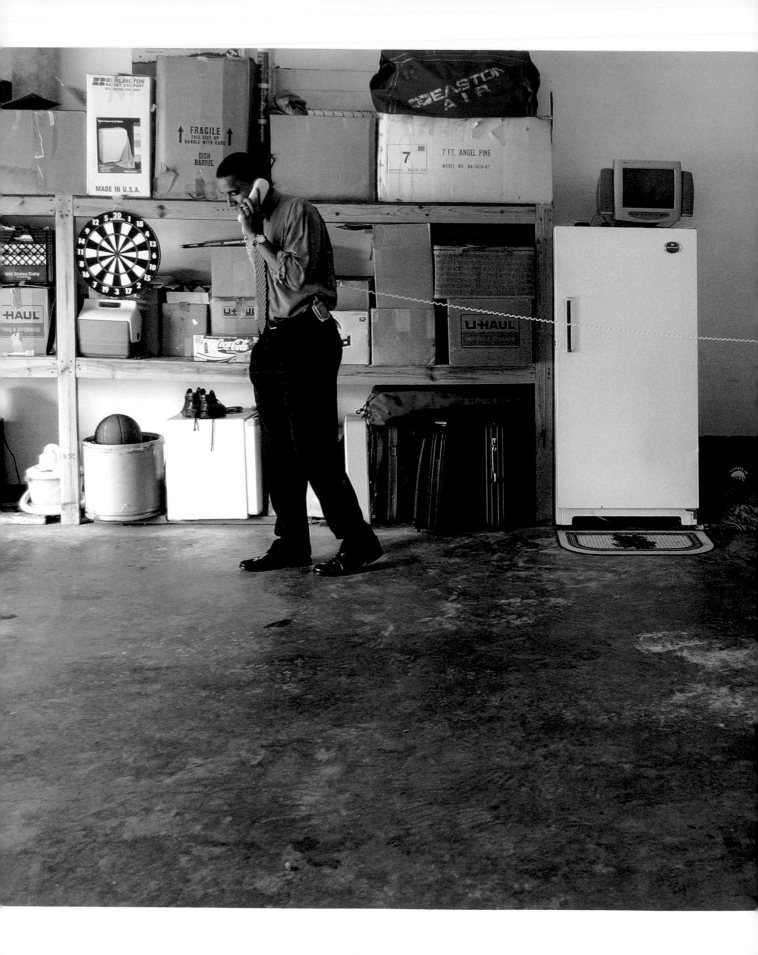

During a get-to-know-the-candidate event at the home of Michael Richards's parents, Obama had to take a call but cell phone service was spotty, so he stepped into the Richardses' garage for the conversation. Richards first met Obama when he was a member of the College Democrats at the University of Illinois and had supported him in 2002 when he was considering a run for attorney general of Illinois, later working on Obama's 2004 Senate campaign.

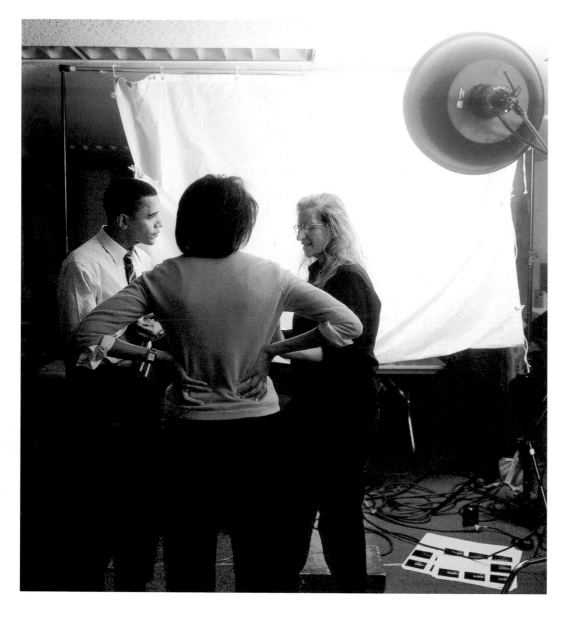

▲ I had always admired Annie Leibovitz. Luckily, I got to meet her when she photographed Obama in our campaign headquarters in Chicago. She focused much more on connecting with her subject than really anything else (like lighting), which surprised me. Her goal was to put her subject at ease. She was great at small talk and asked Obama what music he liked and pulled up jazz on her iPod. During one of these shoots, I asked her for advice about my own photos, and she told me to wait at least fifteen years before releasing them.

▶ Obama watches intently as results come in on election night 2004 of the Democratic primary for US Senate in Illinois.

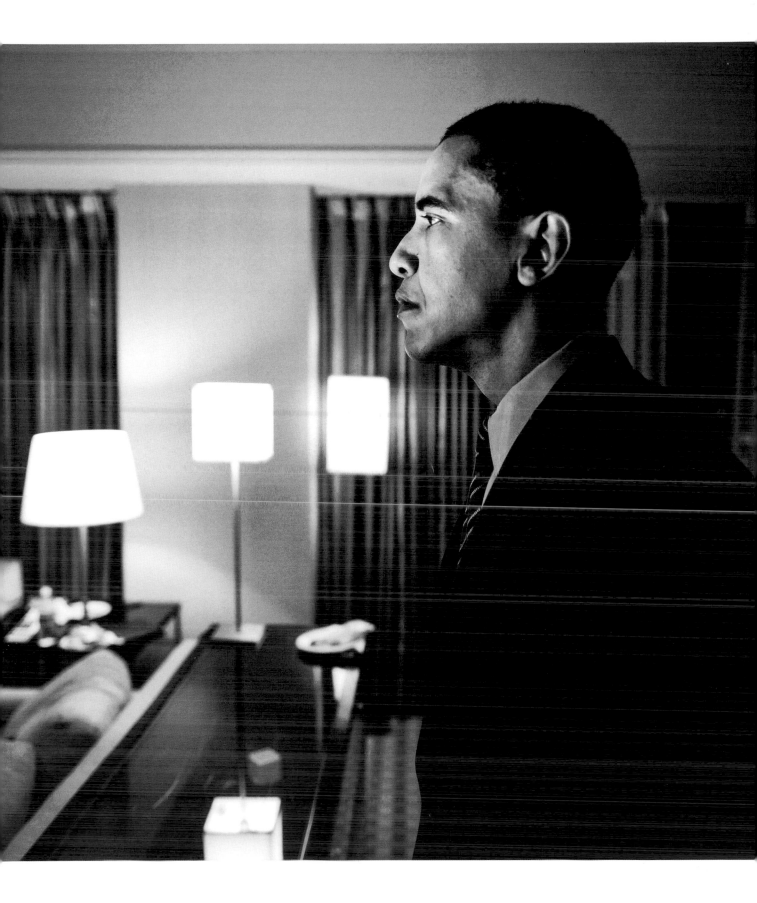

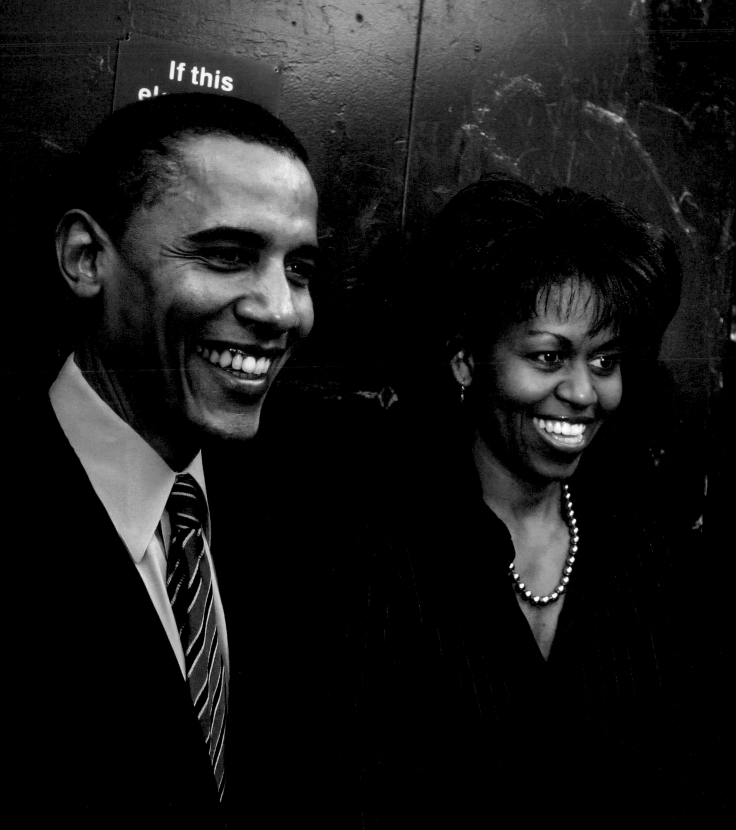

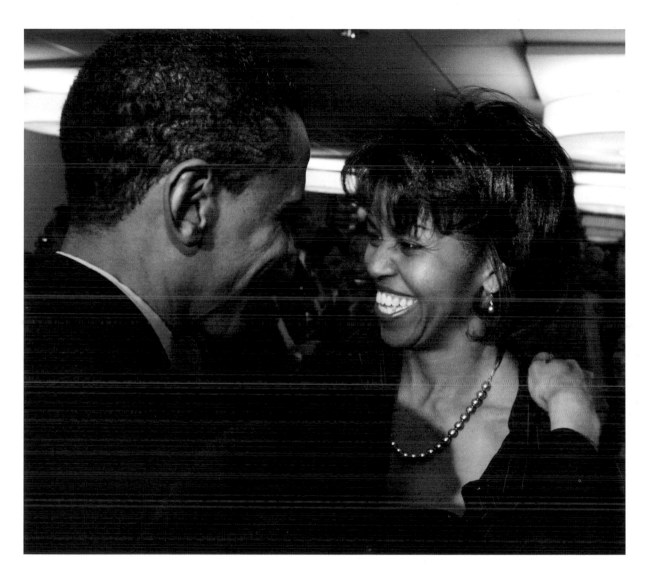

The Obamas ride the freight elevator en route to their Democratic primary election night party. Obama had just defeated Dan Hynes, the establishment candidate, by a 29 percent margin.

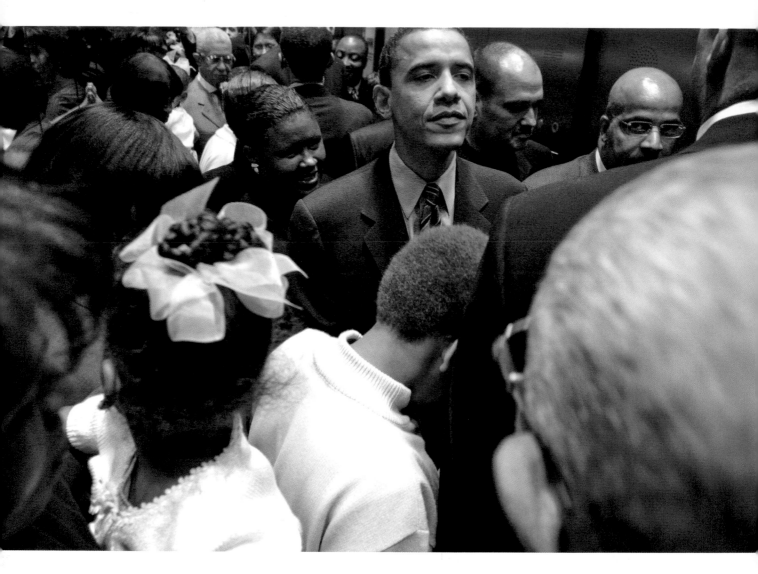

▲ Obama rides the elevator to his primary
election night viewing party. He was minutes
away from being elected the Democratic
nominee in the US Senate race in Illinois.

▶▼ The morning after the primary election,
we flew to downstate Illinois to thank
supporters on a multistop visit. En route,
Obama reads the *Chicago Sun-Times*'s
election coverage. We made a number of
stops at small airports, including a visit to
the Marion airport's manager's office for
Obama to make a phone call.

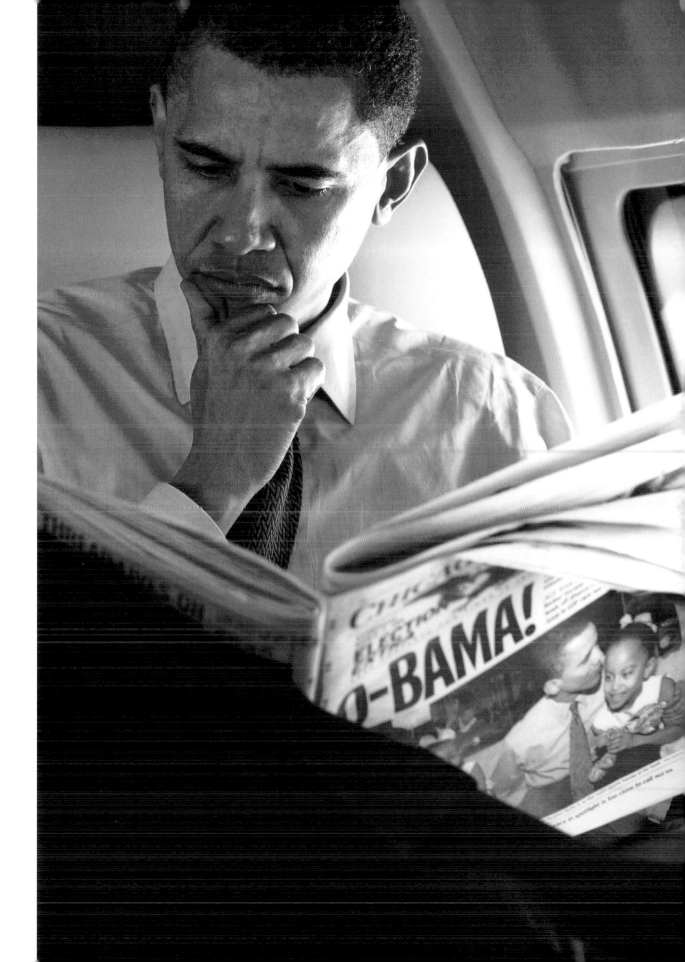

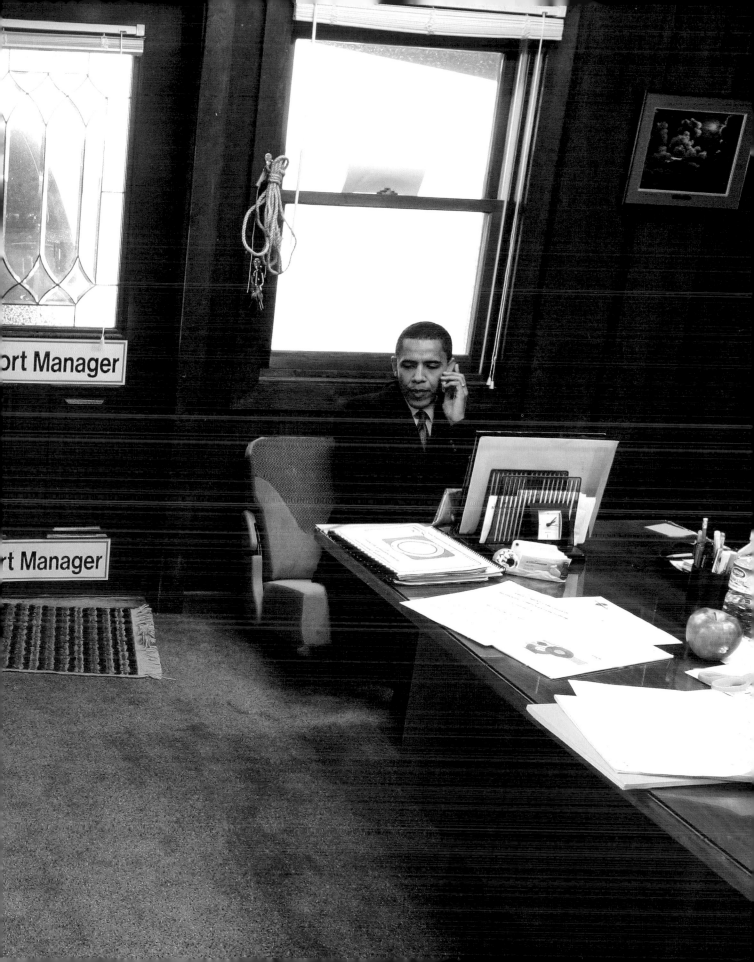

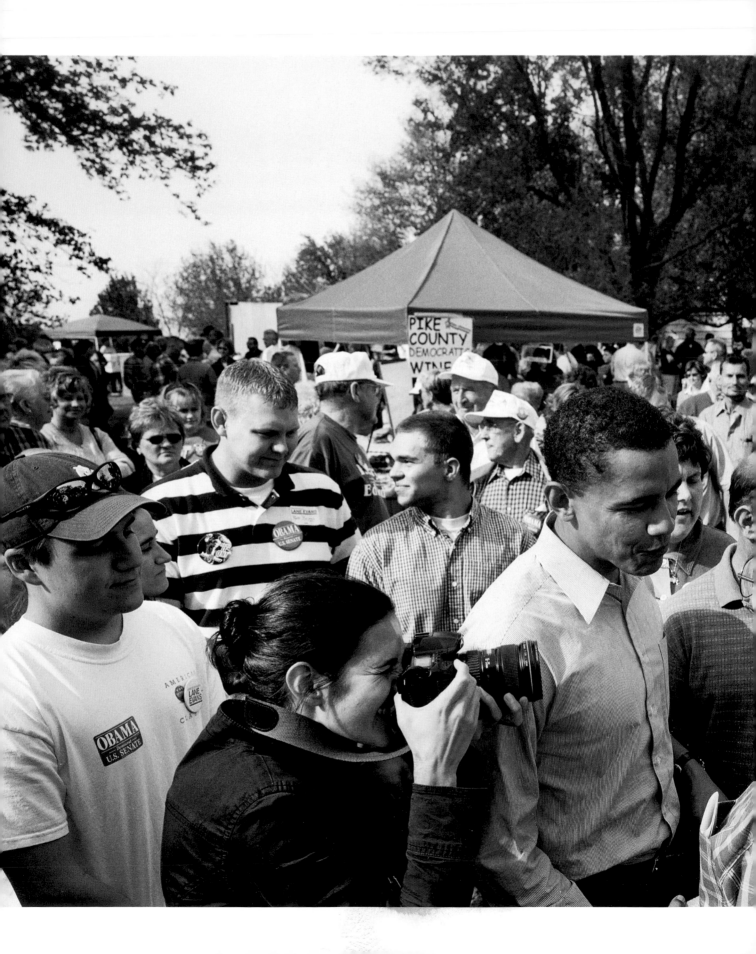

Obama was very close to his mother's parents. During World War II, his grandfather Stanley Dunham served in the Army's 1830th Ordnance Supply and Maintenance Company, Aviation, and his grandmother Madelyn Dunham worked on the Boeing B-29 assembly line in Wichita, Kansas. Partly because of his grandparents' history, Obama always felt a strong connection to veterans and eventually served on the Senate's Veterans' Affairs Committee.

DOWNSTATE

Southern Illinois is very different from the urban district Obama lived in and represented in the state legislature. People in Southern Illinois often have slight Southern accents, and towns like Metropolis (home to a famous Superman statue) sit on the Ohio River bordering Kentucky. In 2004, the campaign faced this divide head-on. "Strategically, you can't just be a northern candidate," said David Plouffe, 2008 presidential campaign manager and campaign strategist during the 2004 Senate campaign. "The rural Illinois communities were very familiar to Obama. They were similar to Kansas, where he spent time with his grandparents. He was quite comfortable there. He's an introvert and not Clintonian in his political appetite. His retail political skills were always underappreciated. Talking to a farmer, diner owner, or retiree was something he liked. He listens to people. Most politicians are just waiting until they can speak again."

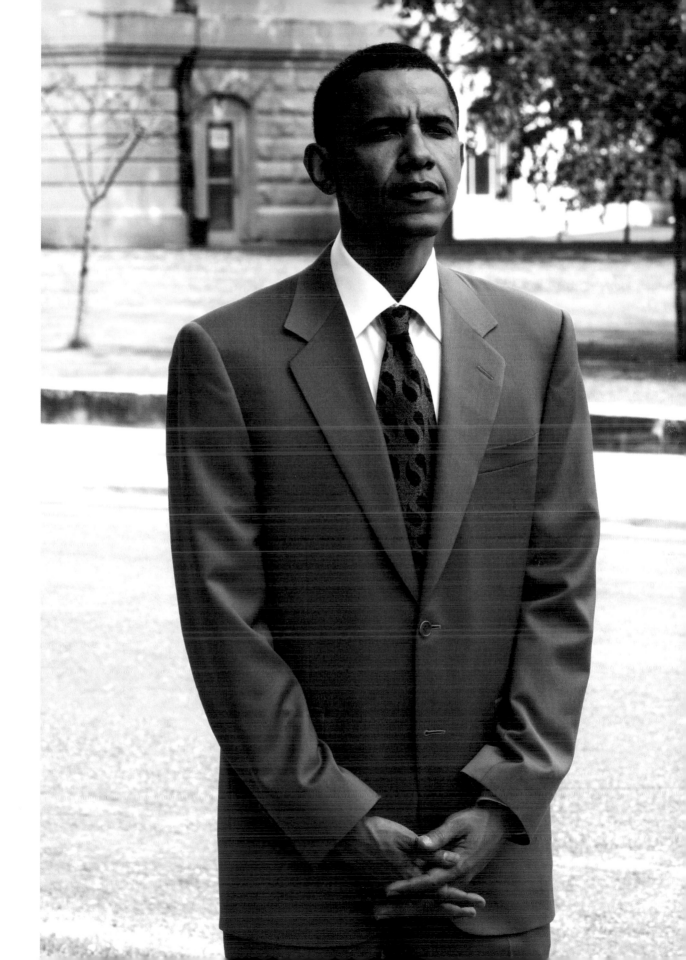

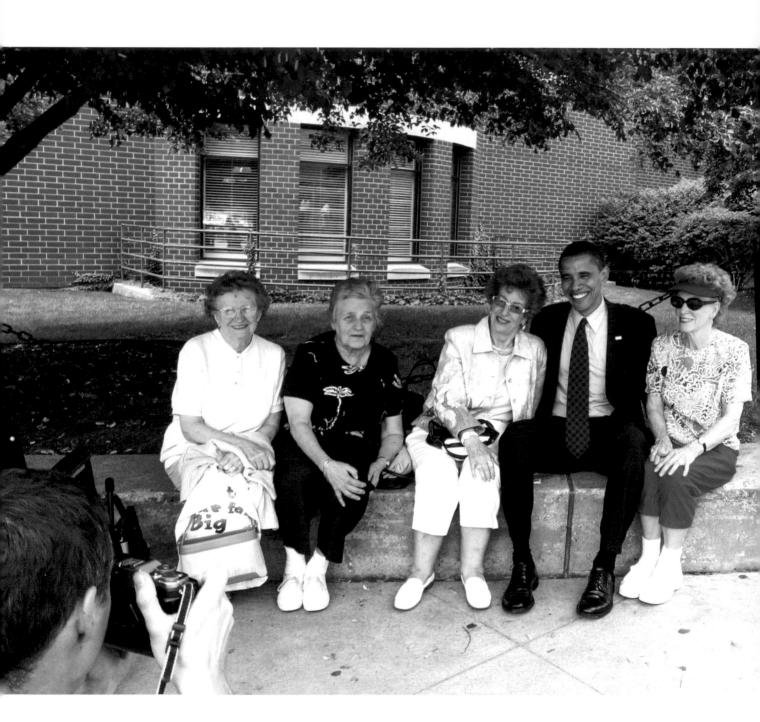

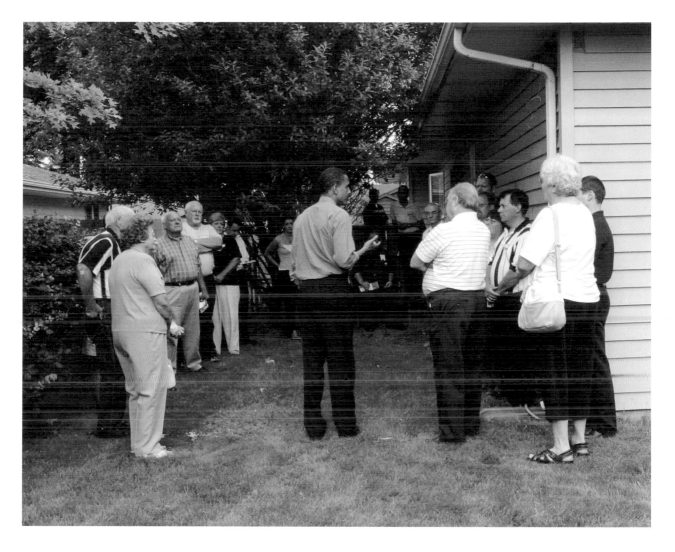

◀ During our stops in Springfield for Obama to take votes in the legislature, we would often walk from our campaign office to the capitol. As Obama's popularity increased after the DNC speech, supporters would often stop us and ask to have their photo taken with the candidate.

▲ Small gatherings and house parties were particularly effective in introducing Obama to a more rural, downstate audience.

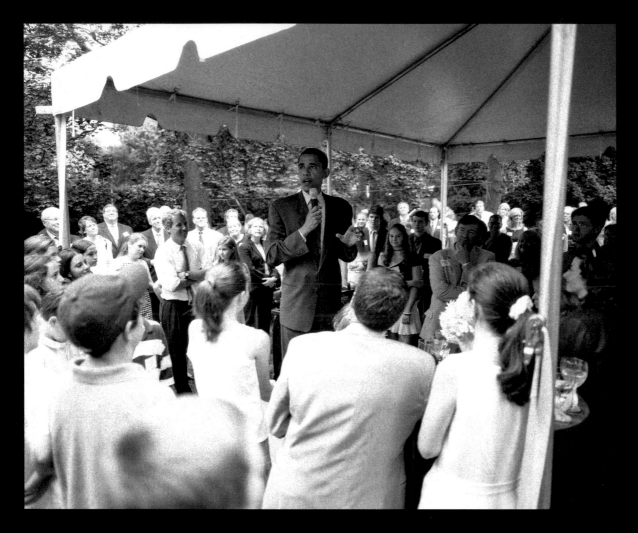

▲ I was always amazed at how the words rolled off Obama's tongue. He once told me, "I may not be great at everything, but I know how to talk." It was always a mystery to me when he prepared his thoughts for a speech or a fundraiser because I never saw him practicing or particularly nervous. Maybe he knew he always had at least five minutes to gather his thoughts as a fundraising host or pastor was introducing him. In the photo on pages 58 and 59, Obama waits to speak at a school auditorium three days before the general election.

▲ ▶ Chris Kennedy, one of Robert F. Kennedy's sons (above, standing to the right of Obama) hosted a fundraiser for us at his house in suburban Chicago in 2004. I'll never forget observing a master political host at work. From the minute we arrived, Kennedy spent the next forty-five minutes taking Obama around his home to introduce him to each of his guests, making one connection after another.

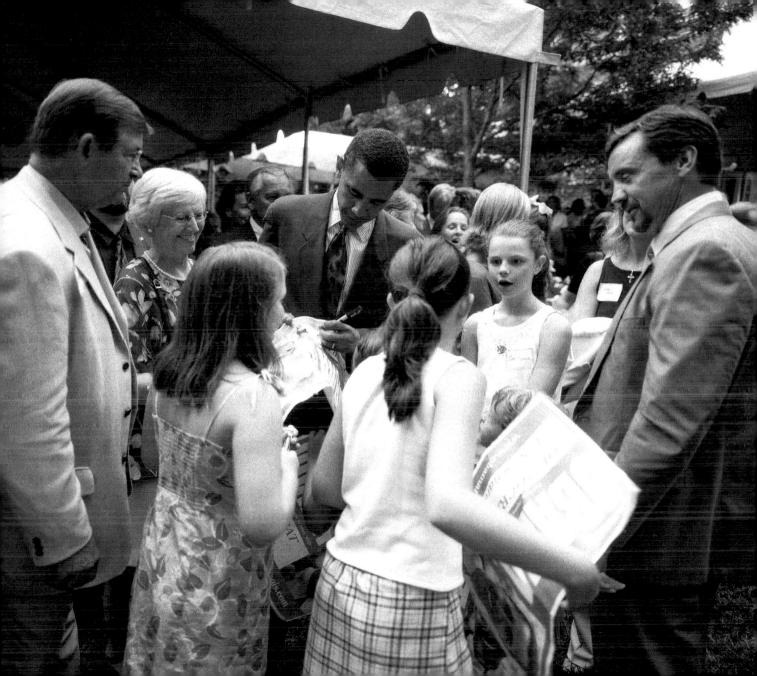

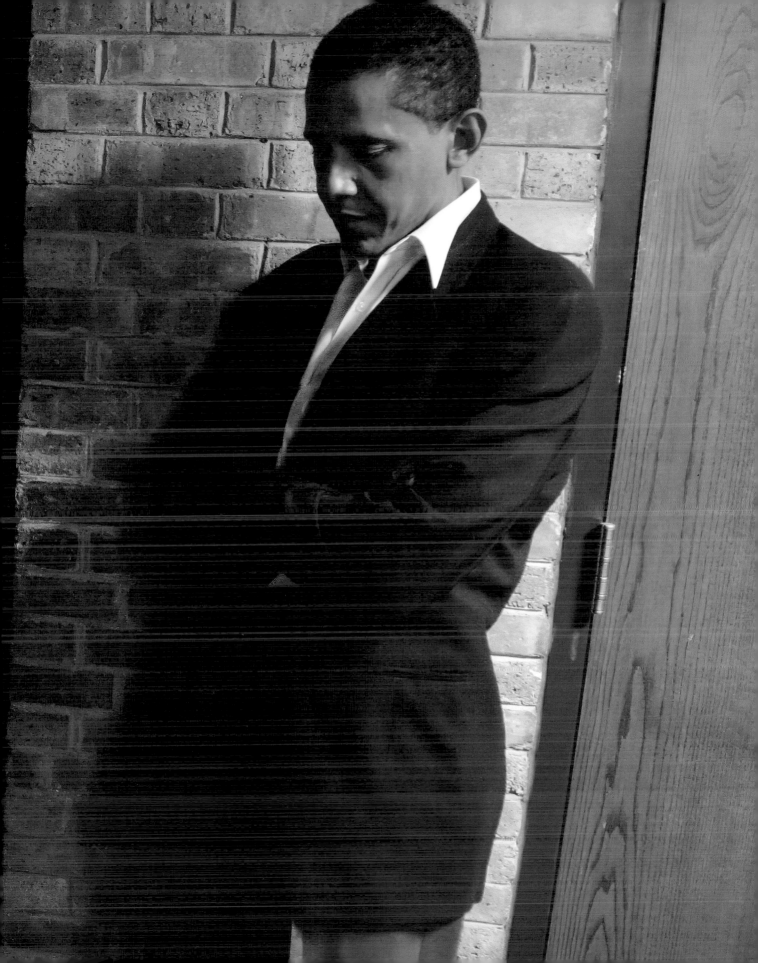

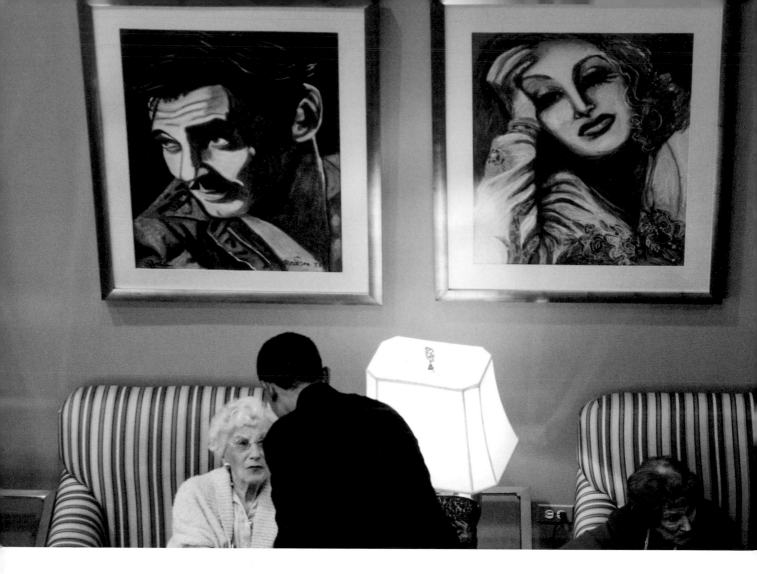

▲ ▶ Obama, only forty-three when he was elected to the Senate in 2004, had a great connection with young voters. He was cool and in tune with the younger generation's feelings. But he had a great touch with older voters as well, including with these two ladies and this gentleman at the Hallmark retirement community in Chicago.

▼ Obama's greatest strength as a politician was connecting with a wide range of people. During his Illinois Senate race, that often meant white, working-, and middle-class people in rural parts of the state. There were still lots of barriers to overcome. Even in 2004, there were clubs in Southern Illinois that did not admit African Americans. Robert Stephan, the campaign's young downstate staffer, recalls a poignant conversation about race with Obama. "We talked about views on race among our generations, and how much things had improved across our fifteen-year age difference. We also discussed an invitation I received as a member of his staff, to a lunch meeting with union leaders. When I learned the club did not allow African Americans, I politely excused myself. He saw hope in those kinds of actions."

One of the only times
Obama reprimanded me
was just after I took this
photo. It was seconds
before he was to deliver
his victory speech during
the 2004 Senate election.
He needed to focus, and
I was distracting him. It
was so out of character
for him to ask me not to
photograph. I was caught
completely off guard.

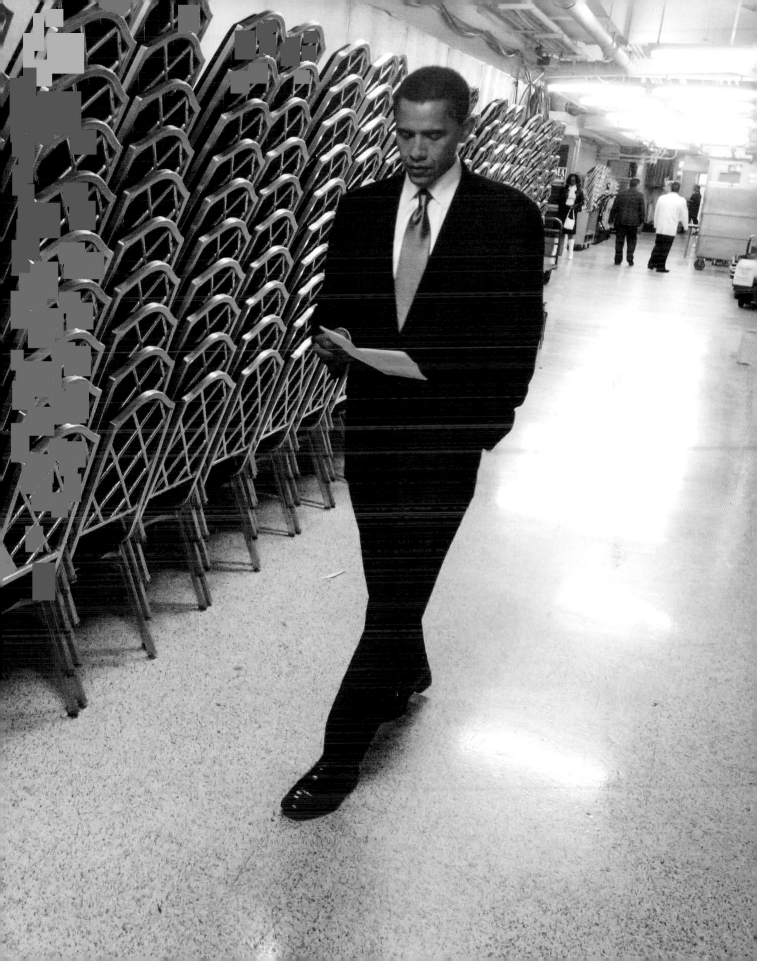

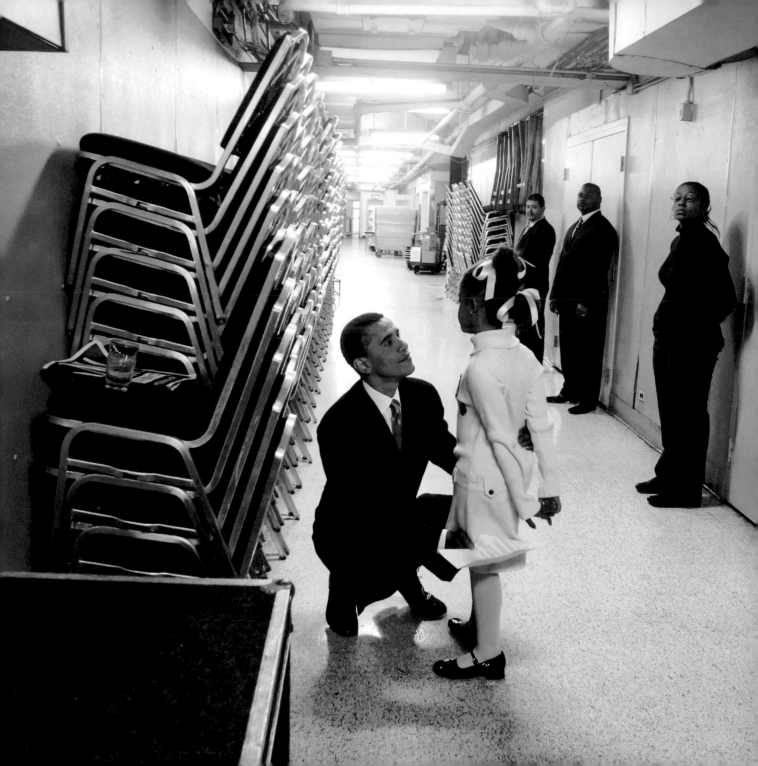

WORKING DAD

During the 2004 Senate campaign, Obama was still a state senator, so we had to make frequent trips to Springfield, Illinois, for him to cast votes. We also campaigned away from Chicago for most of the week, so he cherished the few moments he had with his children when he was back in town. When Obama began considering a run for president, his advisers knew that his having small children would be one of his foremost considerations and, in all honesty, a significant barrier. The Obamas were trying to maintain as normal a life as possible for their kids. David Plouffe remembers wanting to be straightforward with Michelle so that she would not have any illusions about the impact a presidential run would have on their family. The campaign needed her out on the road as well because she had such a powerful, compelling voice, and that made balancing family life even more challenging. Plouffe told Michelle, "There are no shortcuts. He will be on the road all the time, he won't come home most nights, and when he does it will be very late. The kids can come to Iowa in '07 and spend parts of their summer campaigning, but there will be a two-year period where he will be more absent than not." David Axelrod remembers Obama coming into his office after a family trip to Hawaii in December 2006. He had pretty much made up his mind to run for president, but he wanted to have one more heart-to-heart to discuss the decision. He parked himself in Axelrod's big leather chair and they spoke about what the decision would mean for his family. Axelrod cautioned him: "My concern is not that you'll lose but that you'll win."

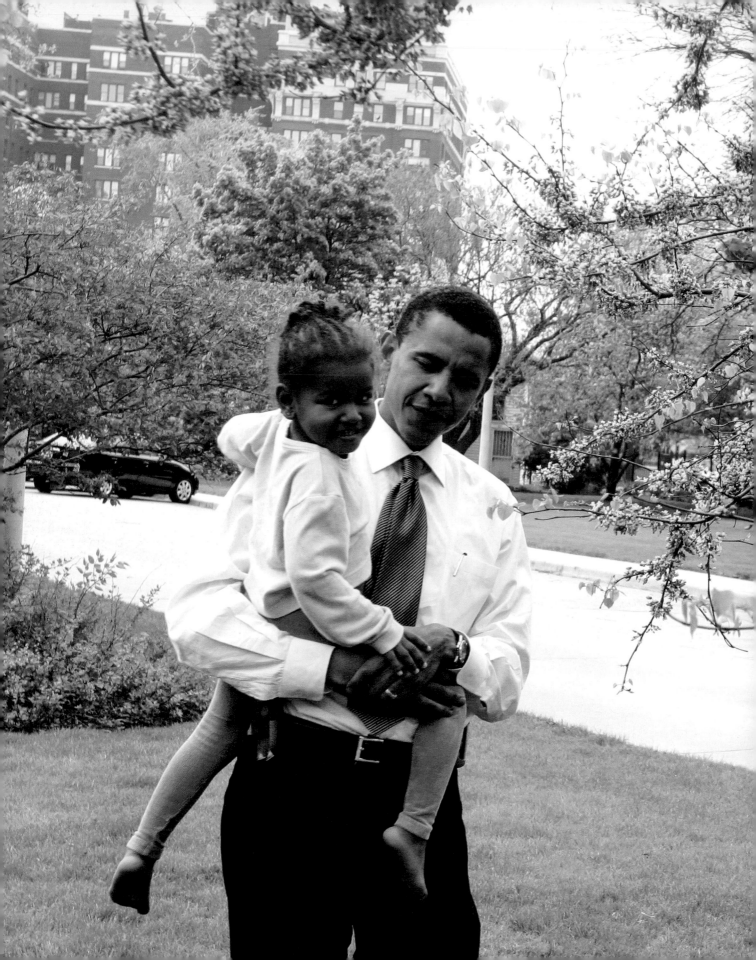

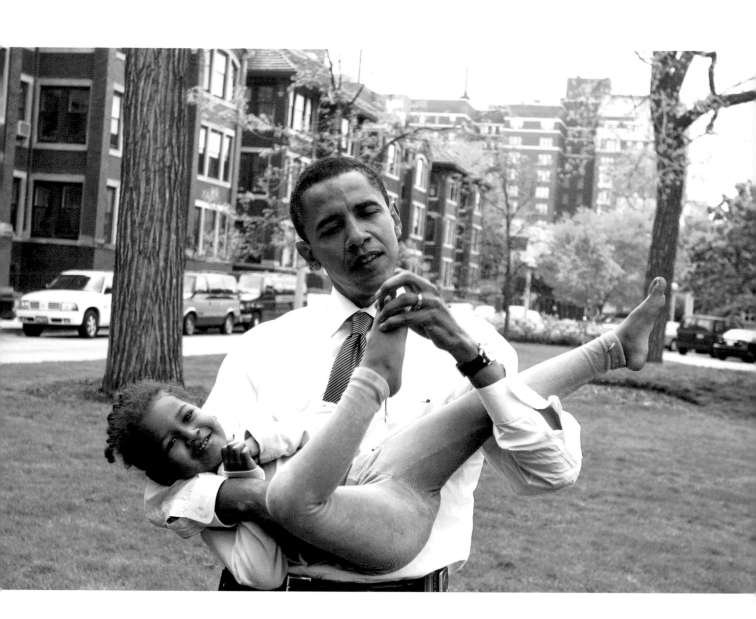

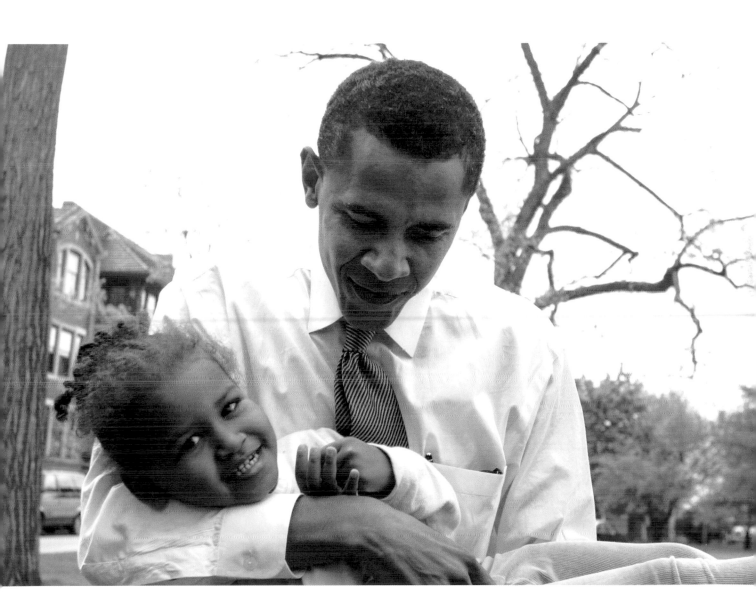

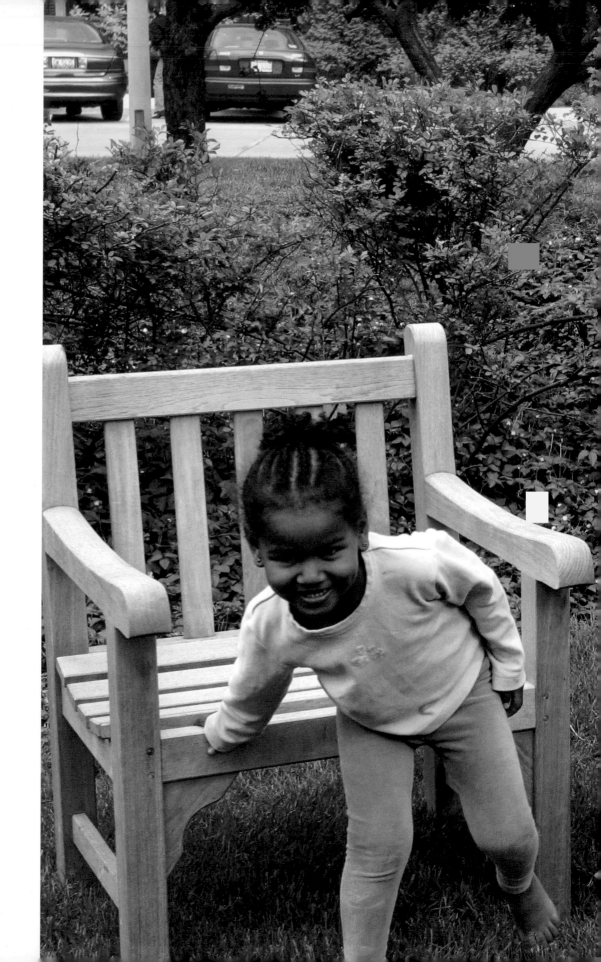

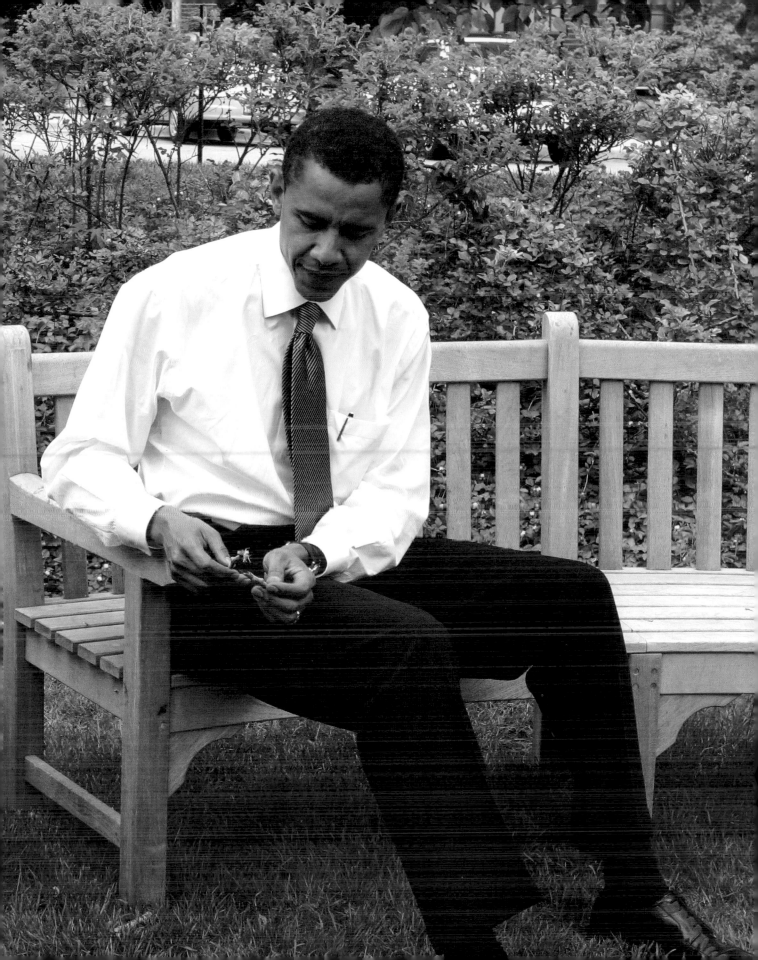

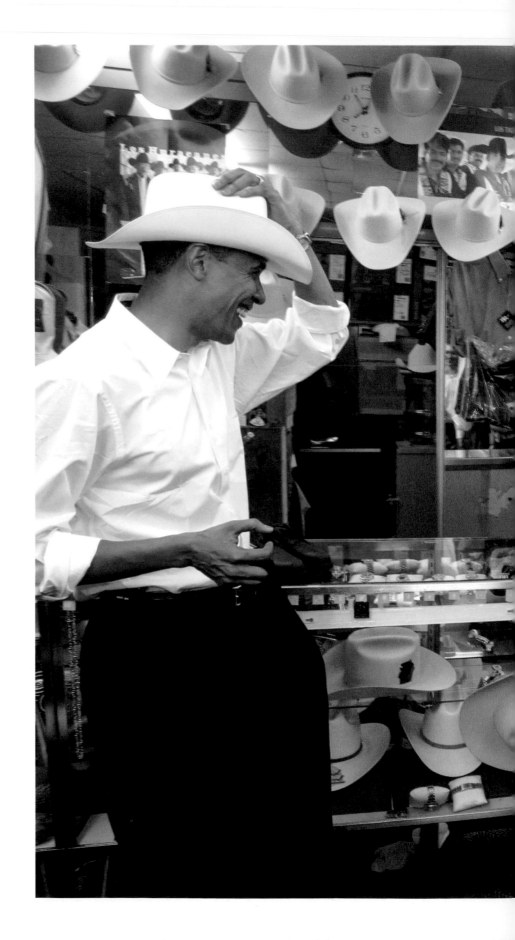

Obama tries on a cowboy
hat in the Little Village
neighborhood of Chicago
during a 2004 campaign stop.

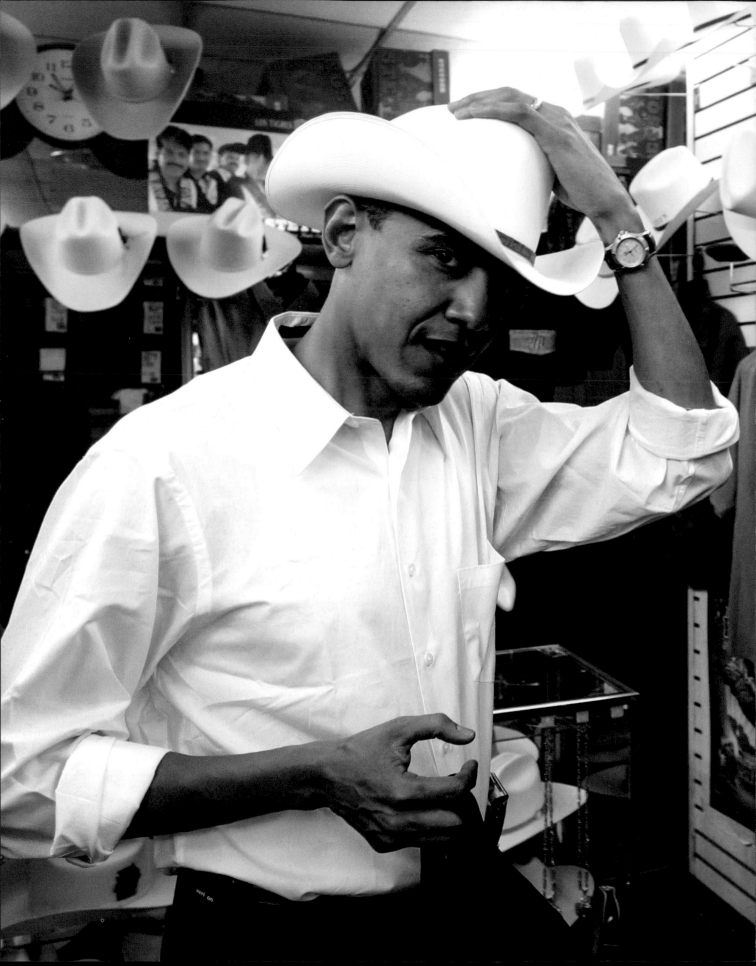

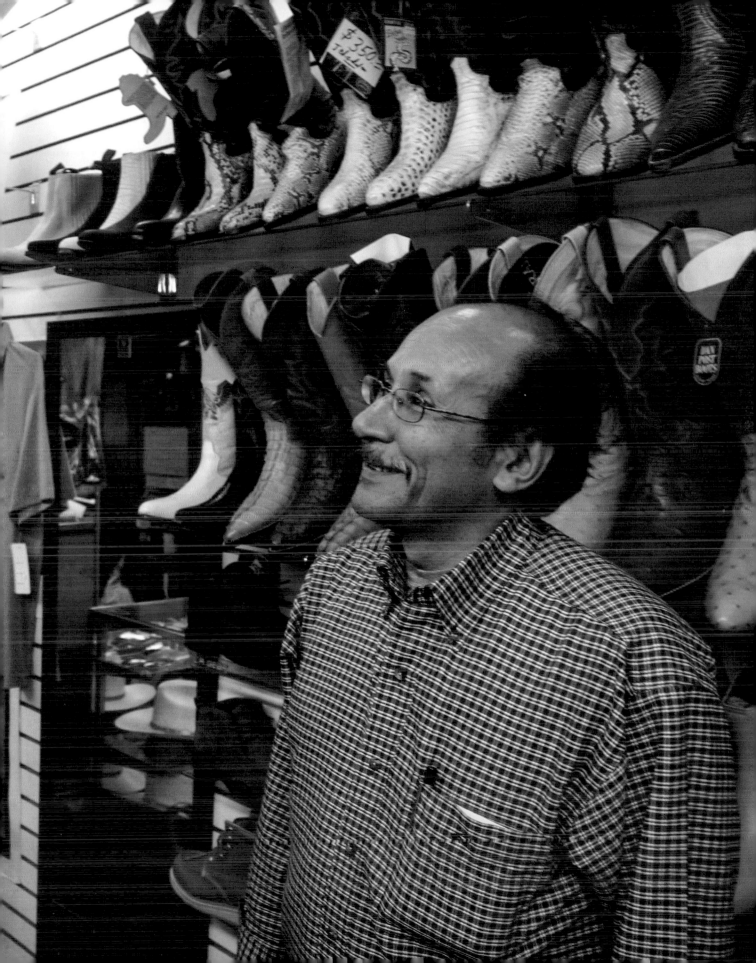

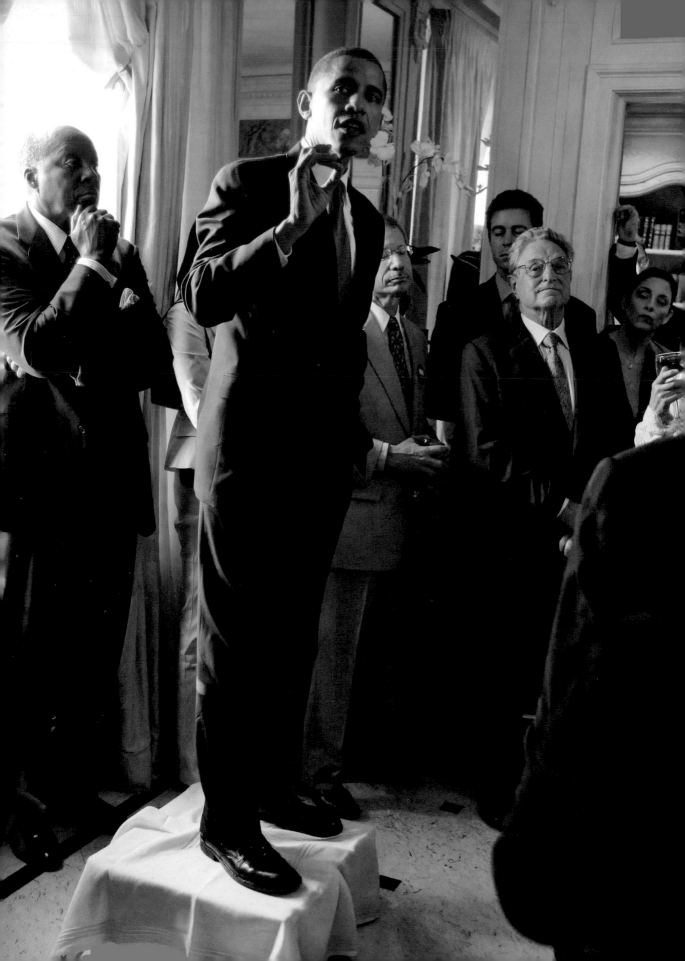

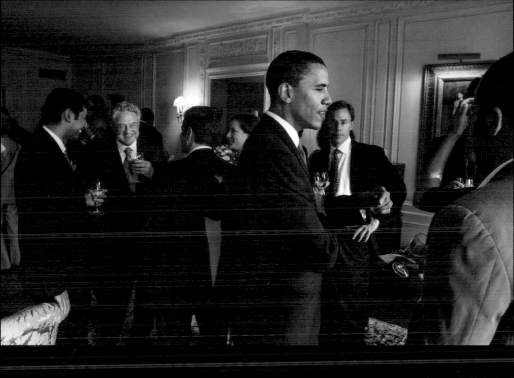

SOROS

n 2004, George Soros (pictured to the left of Obama on the opposite page and to the left of Obama above) hosted a fundraiser for our campaign at his apartment on New York City's Fifth Avenue. During that campaign, we spent six out of seven days a week stumping in rural Illinois, eating Subway sandwiches and attending fish fries and backyard barbecues. So when we pulled up to Soros's building on the Upper East Side of Manhattan, we all felt a bit out of place. Our suits suddenly looked a little ragged, and our shoes hadn't been shined. We rode the elevator with NBA all-star Dikembe Mutombo, and Obama was set to be introduced by Vernon Jordan. Even Obama seemed a little intimidated by the grand marble foyer and the double-floor library in Soros's residence. It wasn't until he saw some of his law school classmates, his book publisher, and a few other familiar faces that he settled in. I was always amazed at how well Barack could connect with people in such an array of environments. He seemed to live for the days when he could spend his time with the widest variety of people.

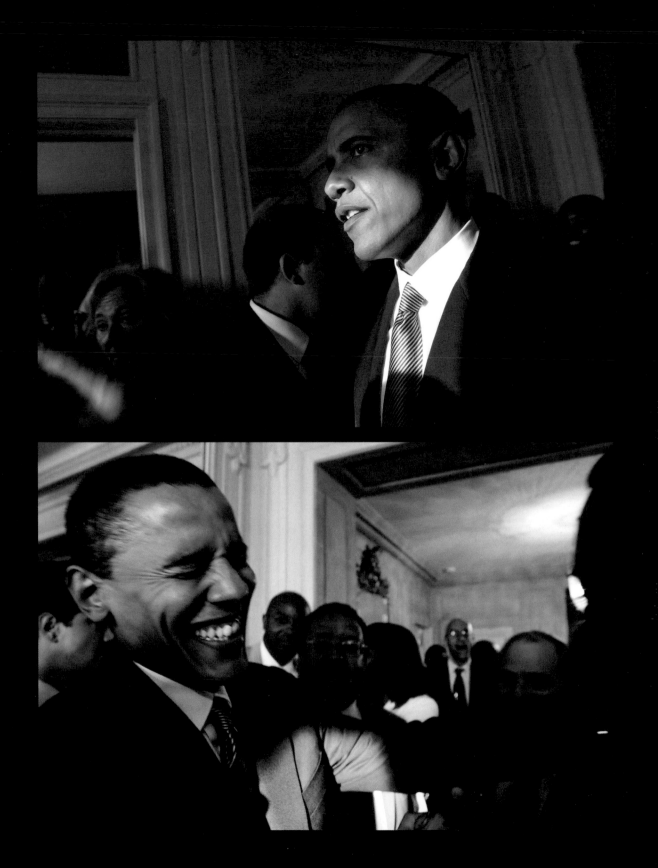

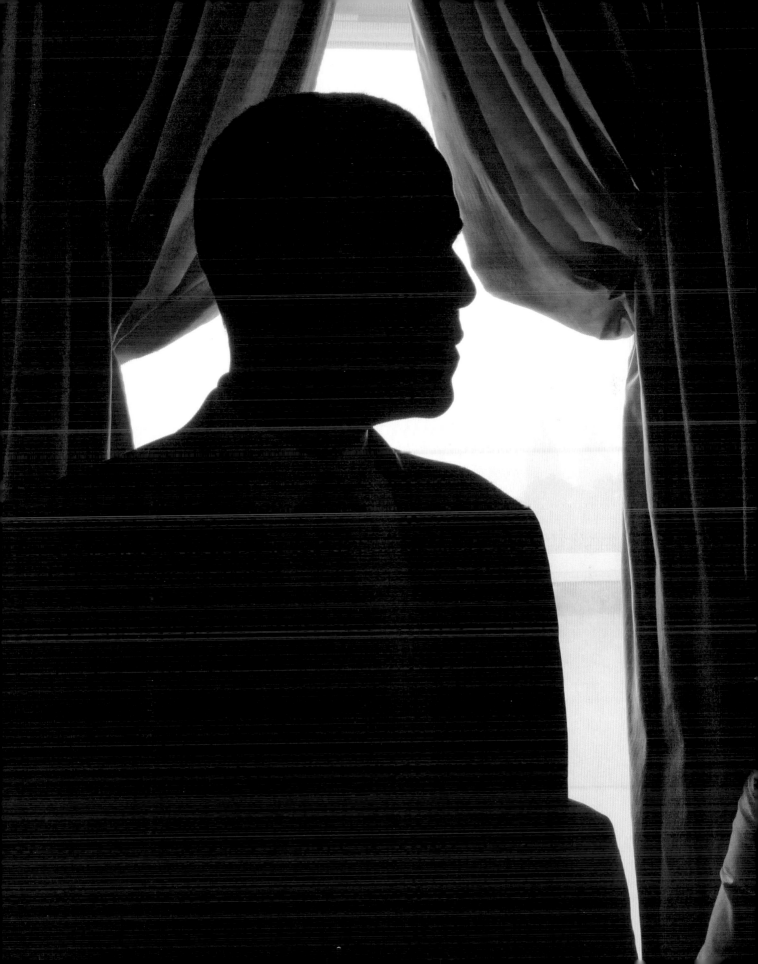

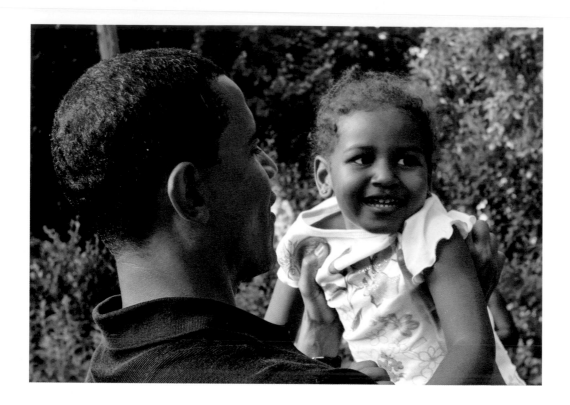

BARBARA'S BACKYARD

Barbara Bowman is a pioneer in early childhood education. She got to know Barack Obama in the 1990s when she was lobbying the Illinois legislature for childhood education funding. Her daughter, Valerie Jarrett, whom Michelle had worked for in Mayor Richard Daley's office and who later became Barack's senior adviser in the White House, asked Barbara if she would host a book party for Barack after he had finished his first book, *Dreams from My Father*. Barbara had a grand backyard that was perfect for hosting parties. She recalls, "For his first book party in 1996, we had to twist arms to get forty people to show up. For his second book party in 2007, I invited a hundred people and three hundred people showed up. The third time we hosted a party, it was a fundraiser in 2012 and we didn't have to invite anyone (the campaign did that) and five hundred people showed up." She also graciously opened up her backyard for an Obama for Illinois staff barbecue in 2004 as a thank-you to those working so hard through the campaign. These photographs are from that party.

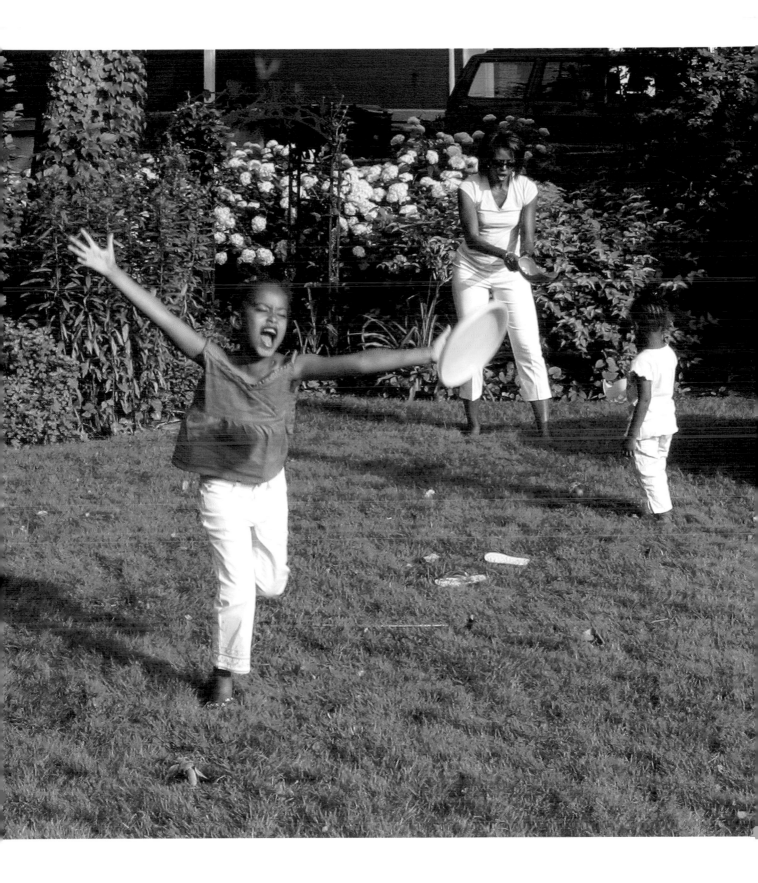

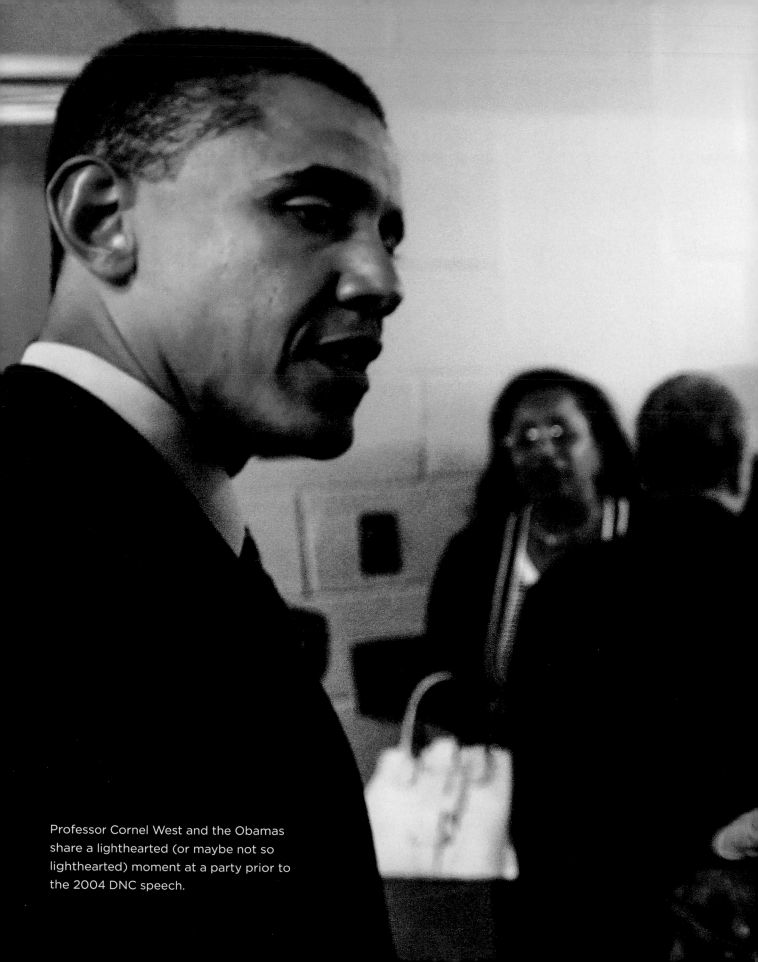

Professor Cornel West and the Obamas share a lighthearted (or maybe not so lighthearted) moment at a party prior to the 2004 DNC speech.

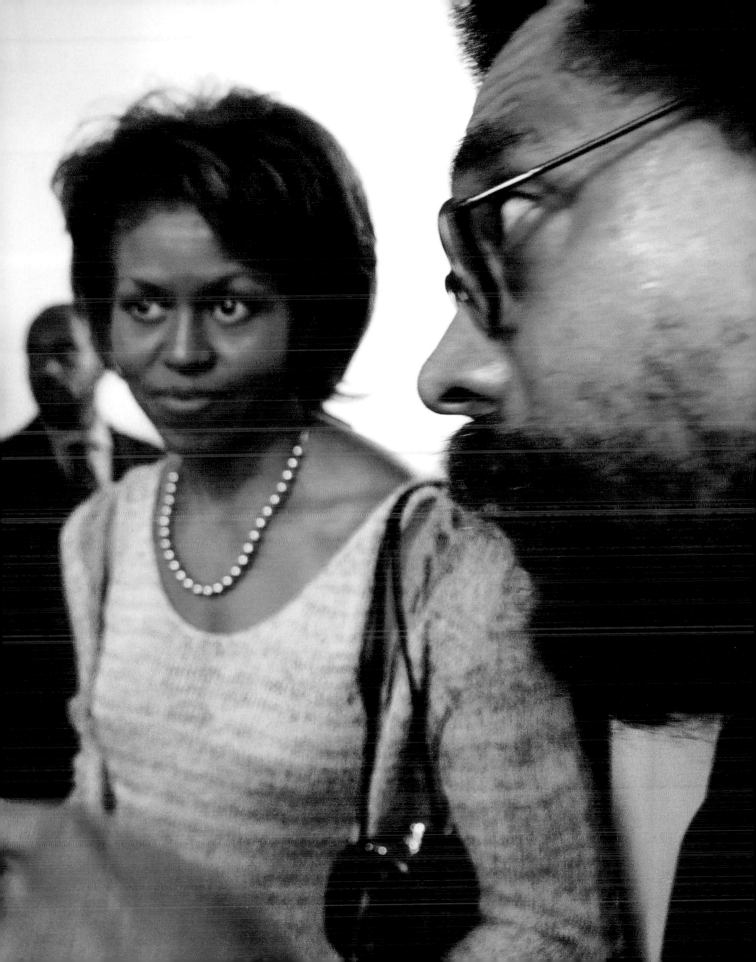

ADVISERS

David Plouffe met Barack Obama for the first time in late 2002 at a breakfast at the Westin hotel in Chicago. Obama was in the early days of running for the US Senate. Plouffe was then a partner in the firm Axelrod & Associates (David Axelrod's political consultancy), and there was a healthy debate within the firm about whether they should take on an untested candidate named Barack Hussein Obama: "David [Axelrod] really wanted to work with him, so we took a flier. I met him to get to know him, but to also work on some remedial issues. He was still driving himself to events and fundraisers, and he wasn't using that time to be productive, like making calls to donors and political leaders. He was still maintaining his own schedule and fighting back about releasing control to the campaign. It's hard to imagine that six years later he would be the Democratic nominee for president of the United States. We held a lot of strategy sessions in Springfield, and one of the main topics was when to run advertising. We were getting outspent by millions in the early months. We made the fraught decision to hold our media spend until very late in the campaign. There were many conference calls about this. In the end, we made the bet that he would be so captivating on TV that it would pay off."

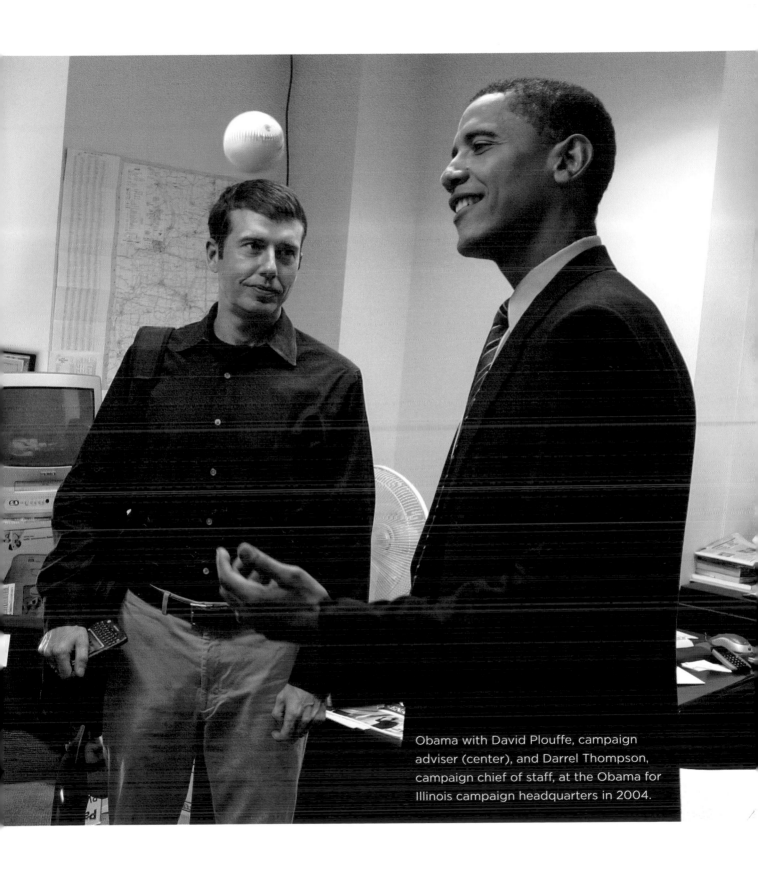

Obama with David Plouffe, campaign adviser (center), and Darrel Thompson, campaign chief of staff, at the Obama for Illinois campaign headquarters in 2004.

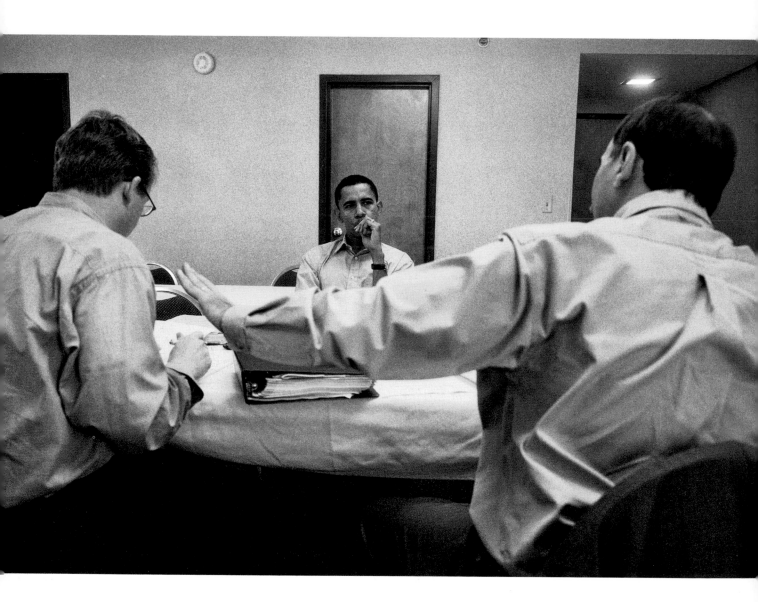

▲▼ Obama with Robert Gibbs (in glasses), communications director, and David Axelrod, campaign adviser, during a strategy session in Springfield, Illinois, in 2004.

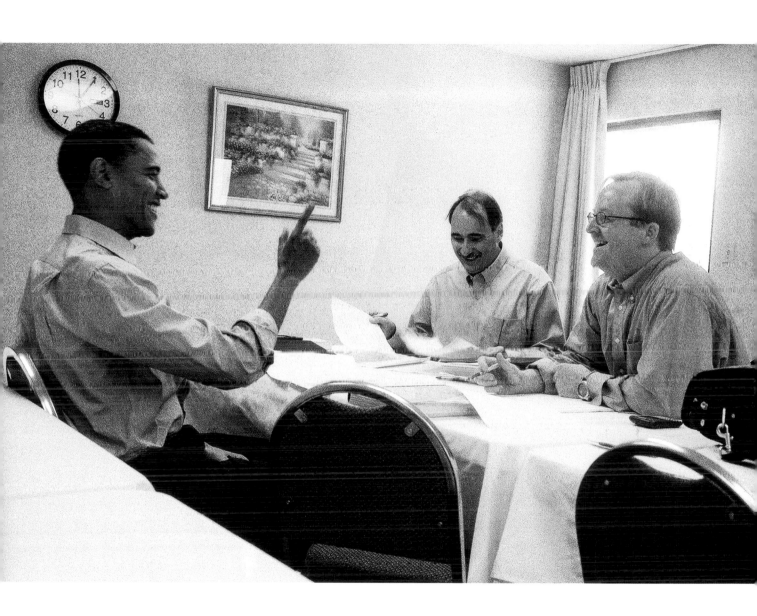

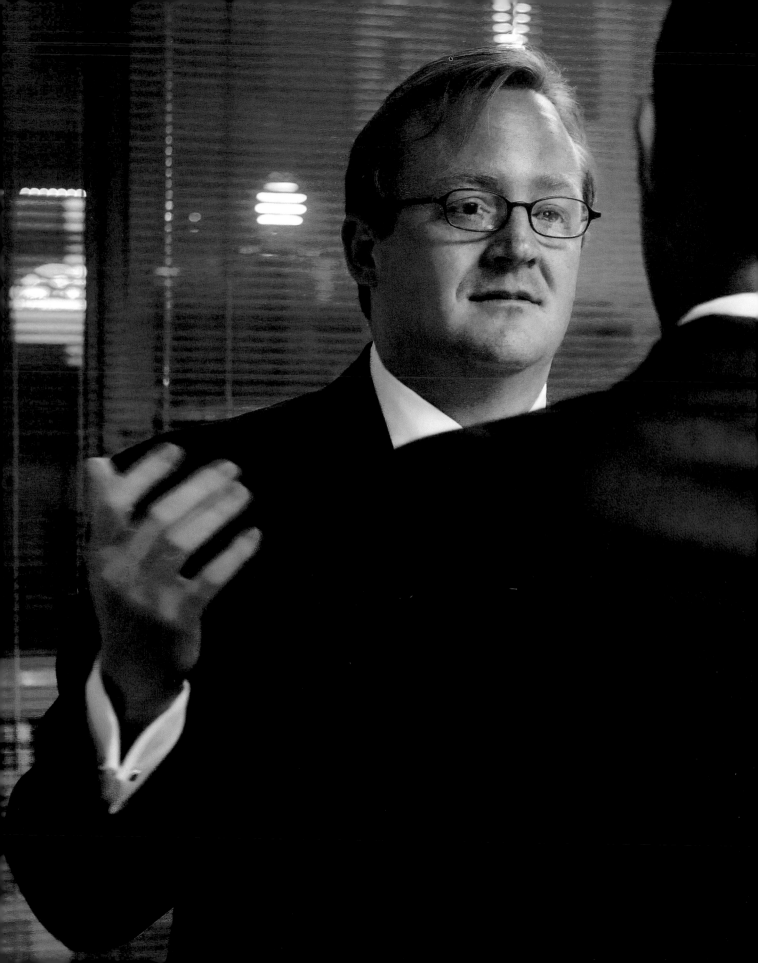

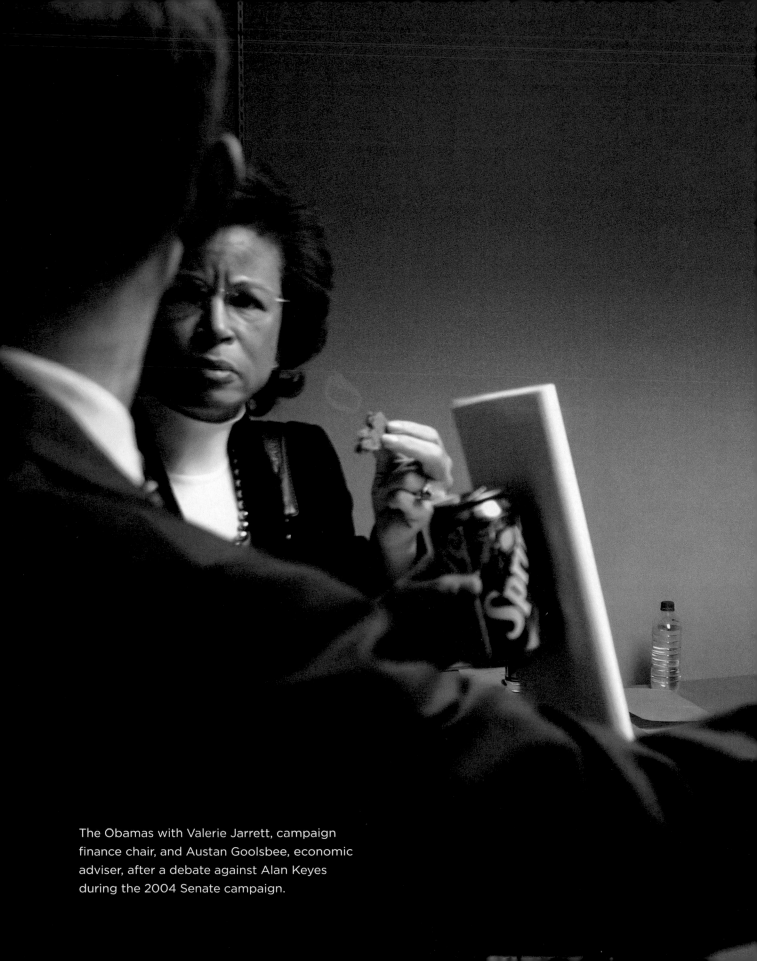

The Obamas with Valerie Jarrett, campaign
finance chair, and Austan Goolsbee, economic
adviser, after a debate against Alan Keyes
during the 2004 Senate campaign.

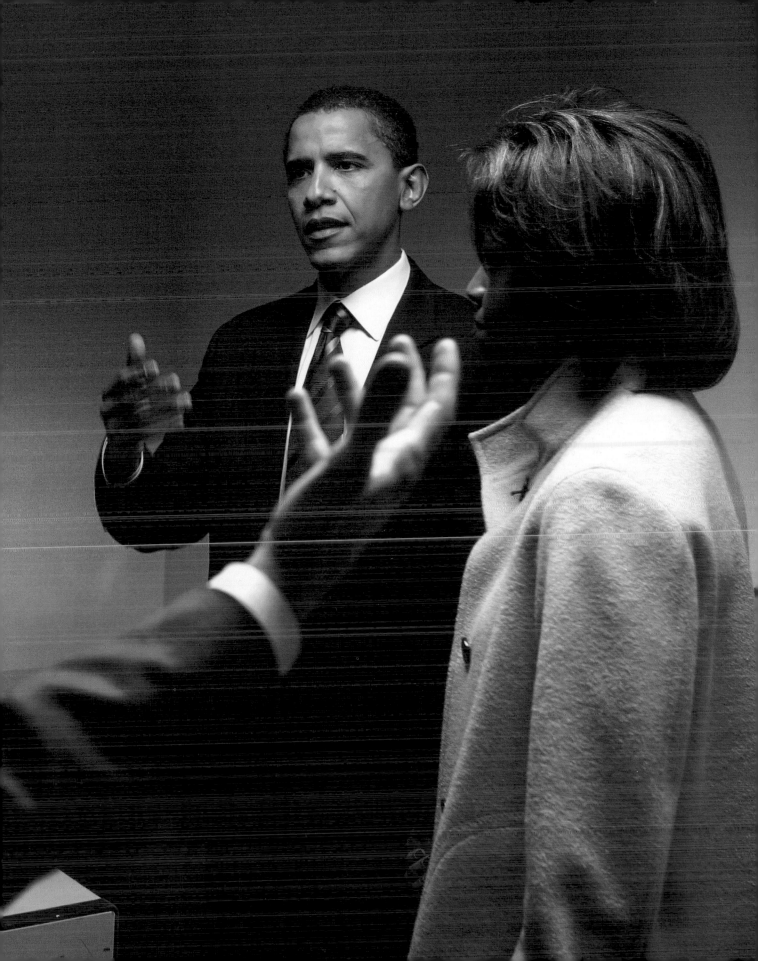

RV TOUR

After the famous "Red State, Blue State" speech at the 2004 DNC, we traveled to downstate Illinois and stopped in thirty-five cities in five days. Our goal for the trip was to introduce Obama and his family to areas outside of Chicago where people were less familiar with him. The staff sold him on such a lengthy trip because his family would be with him. The staff made sure to carve out time from campaigning for trips to ice cream parlors with his daughters. Jeremiah Posedel, our downstate director at the time, described the trip this way: "We were planning on fifty people showing up to these events and then he gave the DNC speech. We had crowds of four hundred to five hundred people in small Illinois towns like Metropolis and Chillicothe, and we were running behind after each stop. We were so late we had to jump out of the RV and into the staff SUV. I was driving 100 mph just to get to the next stop within an hour of the starting time. By the third day Obama had hardly seen his family, and by the last day Obama was pretty drained. Our last stop, in Taylorville, we were walking down an alley and he told me I did a great job, but don't ever do that again. Then he fake-punched me in the stomach and took off back to Chicago for another rally to celebrate his forty-third birthday."

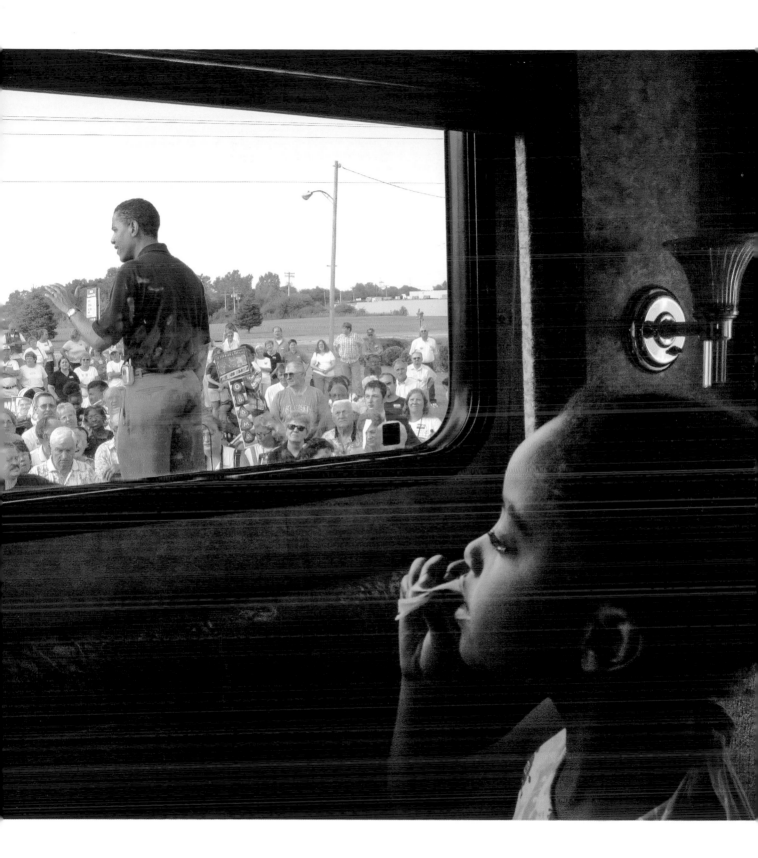

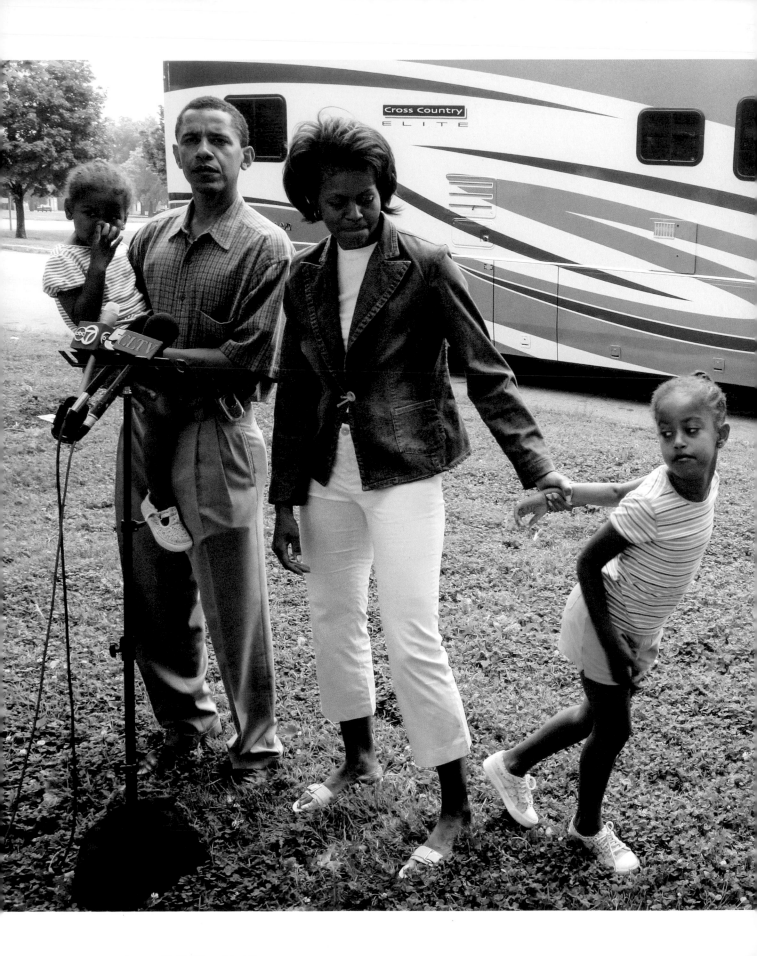

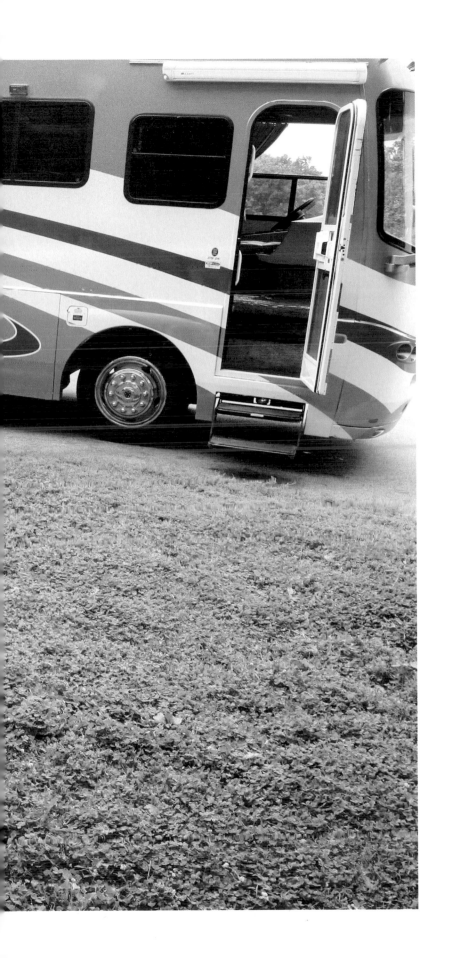

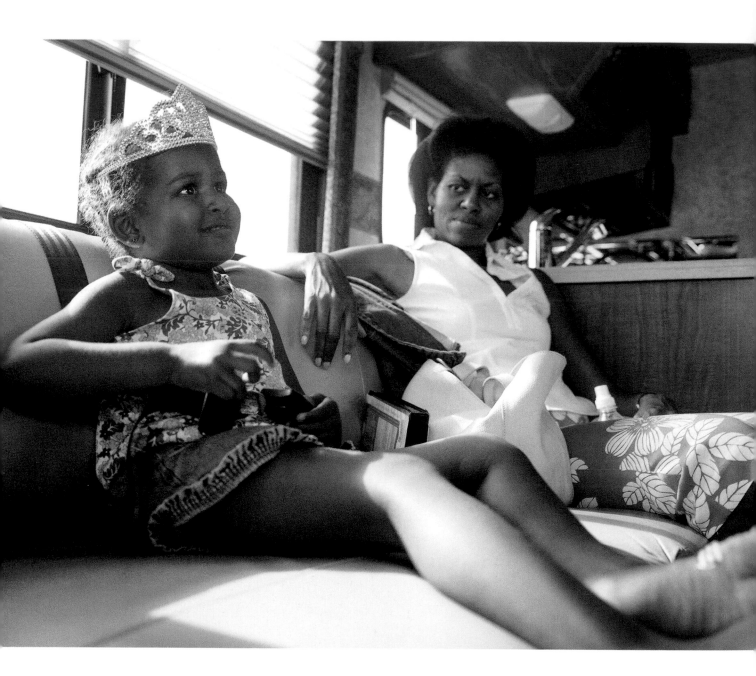

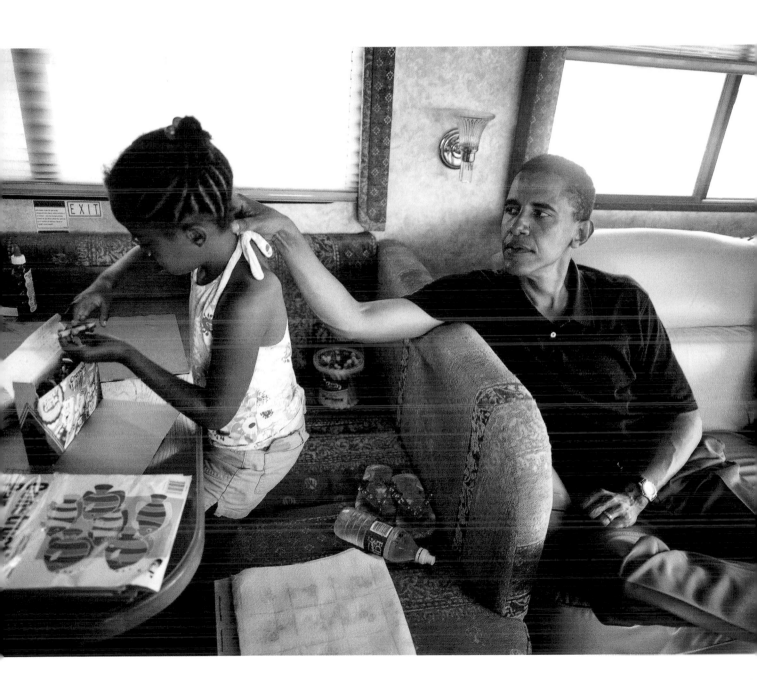

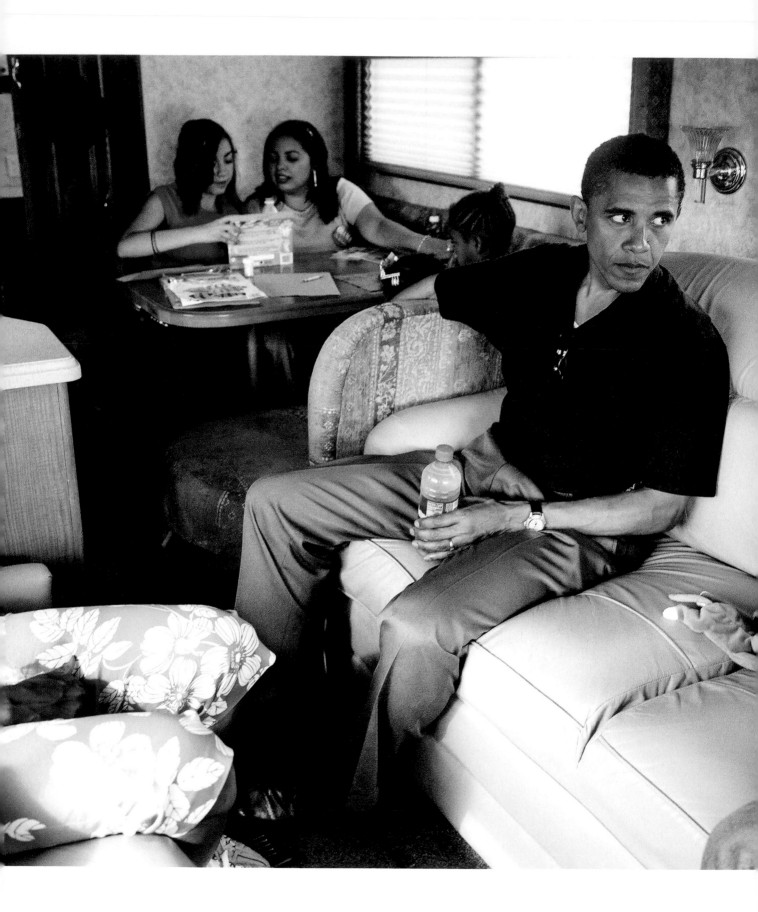

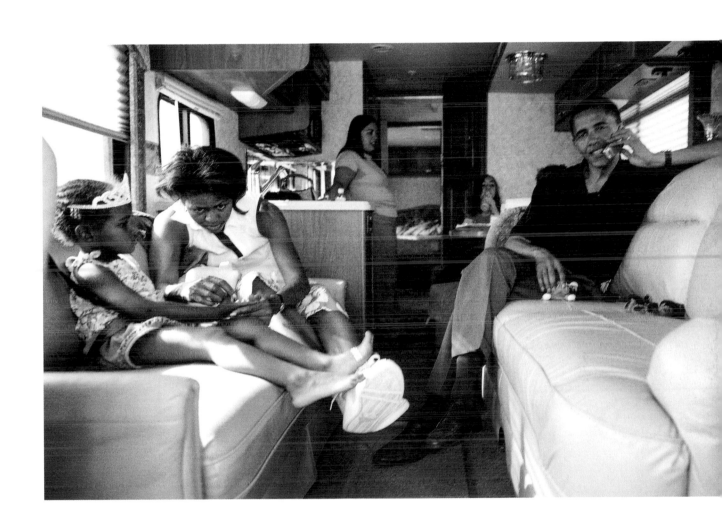

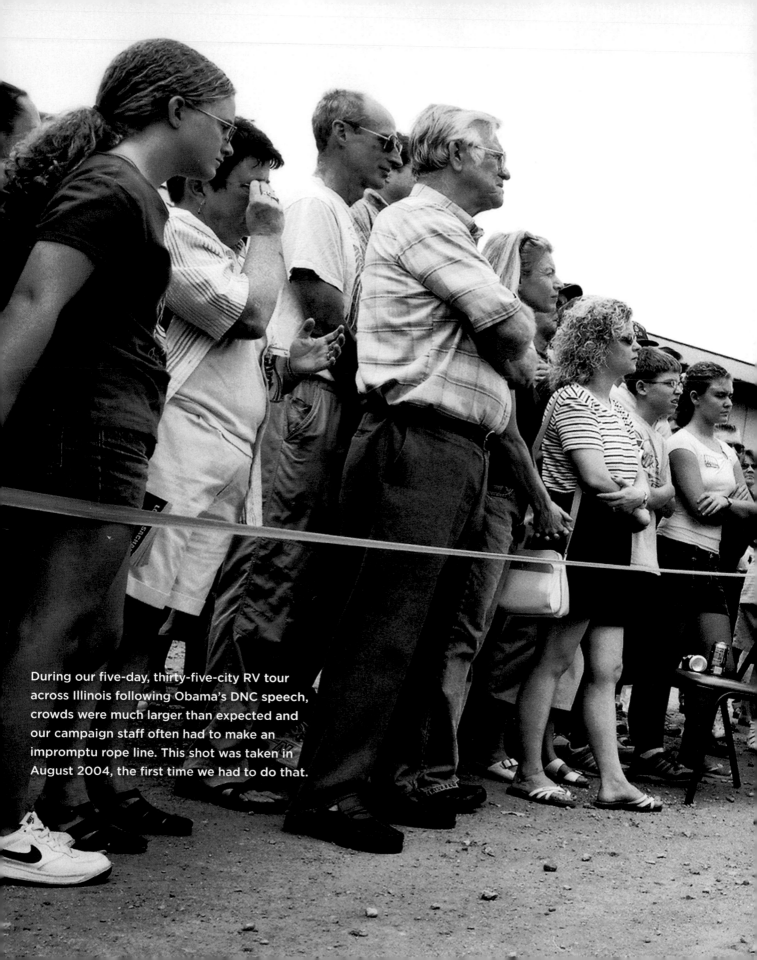

During our five-day, thirty-five-city RV tour across Illinois following Obama's DNC speech, crowds were much larger than expected and our campaign staff often had to make an impromptu rope line. This shot was taken in August 2004, the first time we had to do that.

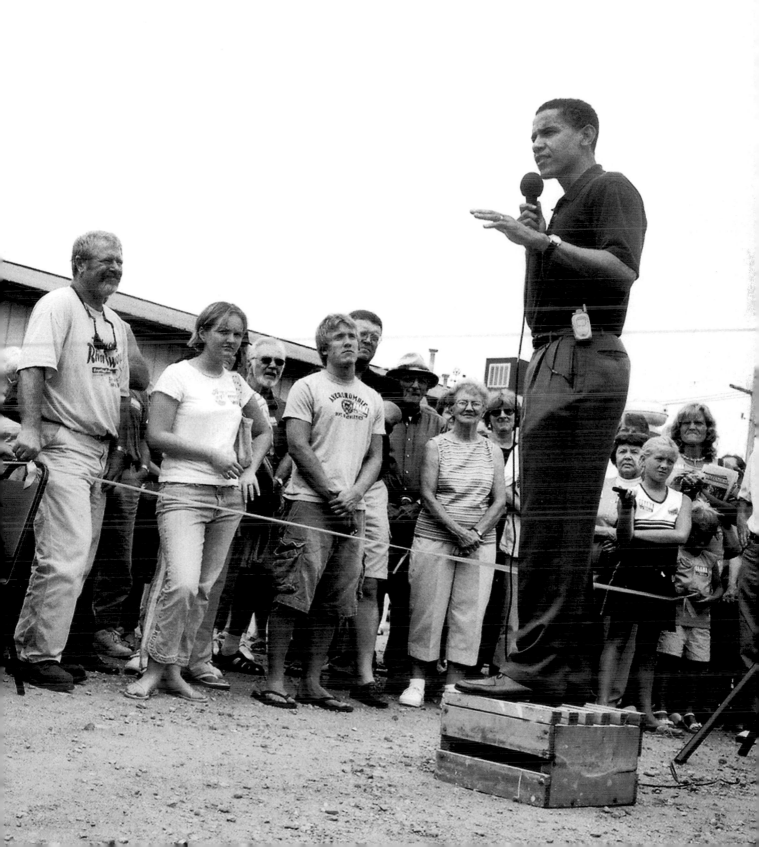

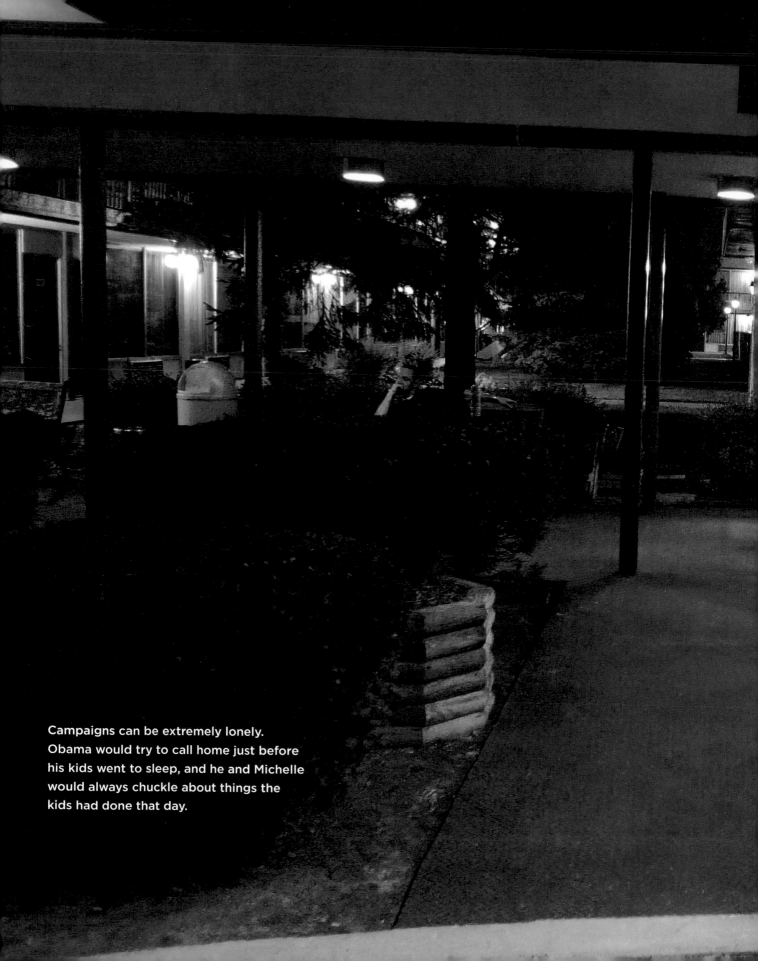

Campaigns can be extremely lonely.
Obama would try to call home just before
his kids went to sleep, and he and Michelle
would always chuckle about things the
kids had done that day.

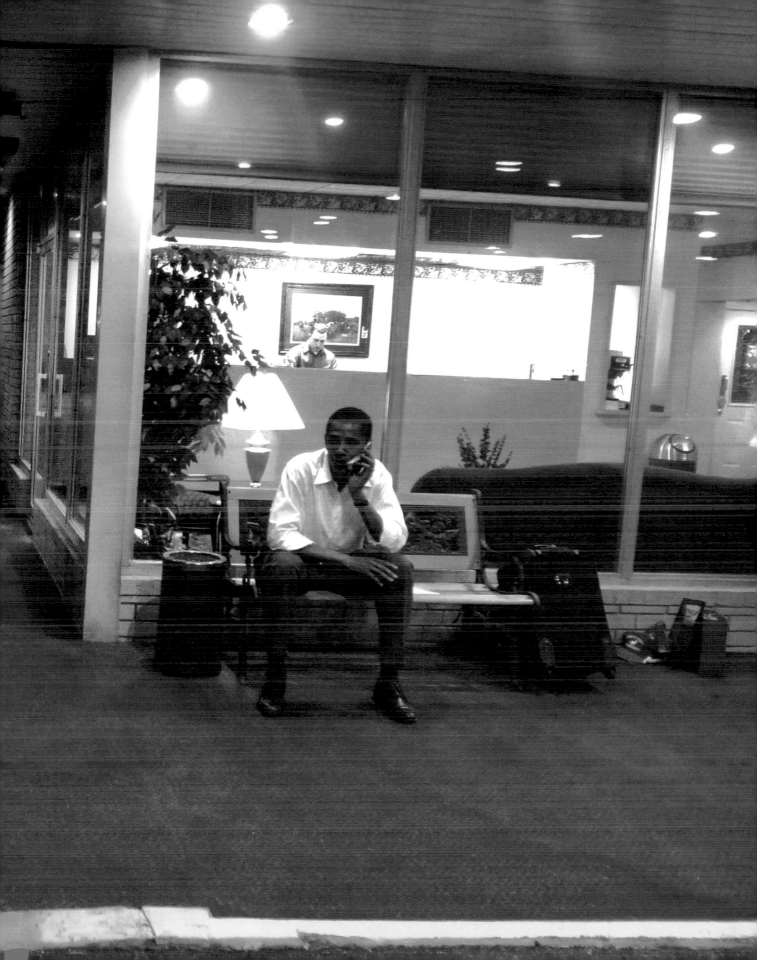

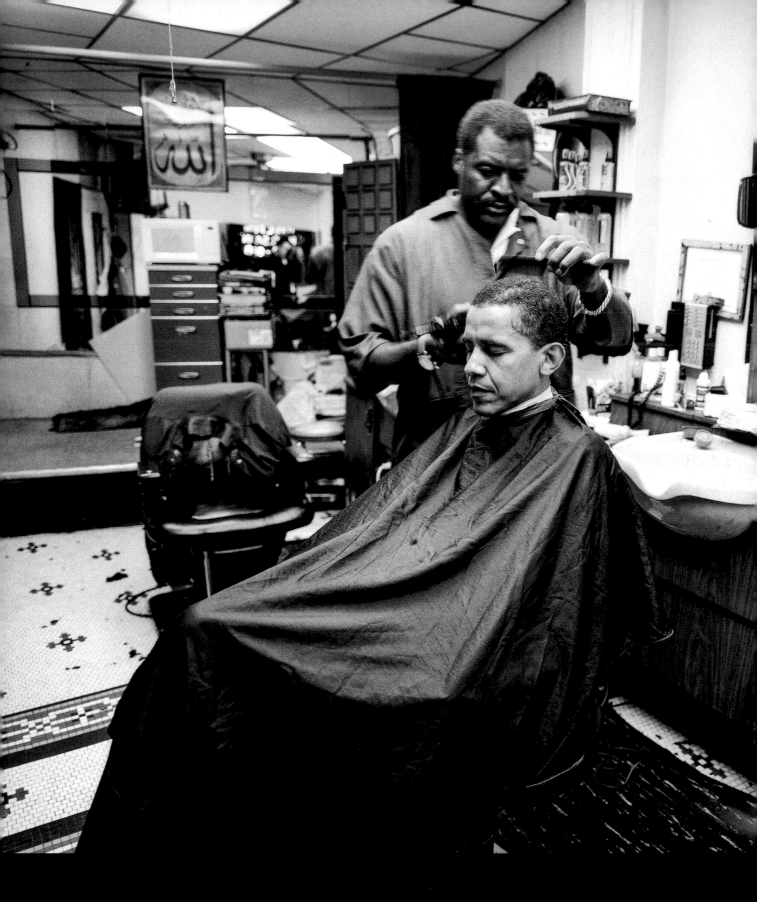

BARBERSHOP

Obama had been getting his hair cut at the same barbershop on the South Side of Chicago since the late 1990s. It was called Hyde Park Hair Salon and served a predominantly African American clientele. When his original barber left to open his own place down the street, Obama asked James Zariff Smith (pictured here) if he wanted to cut his hair, and he and Zariff hit it off, chattering about Chicago sports and life in the barbershop. During the 2004 Senate campaign, Zariff would open the shop late at night to cut Obama's hair after we returned to the city from a week of campaigning downstate. Just before his famous DNC appearance, Obama mentioned to Zariff that he would be on TV giving an important speech and that he needed a very clean haircut. Zariff decided to change the cut he had given Obama for years. "When his hair was longer, I used to pick his hair and cut it with scissors. For this speech, I wanted to cut it down short and neat. I took the clippers down from 2 to 1 and used the clipper-over-comb technique near the ears. People don't realize it, but we really changed his look for the DNC speech."

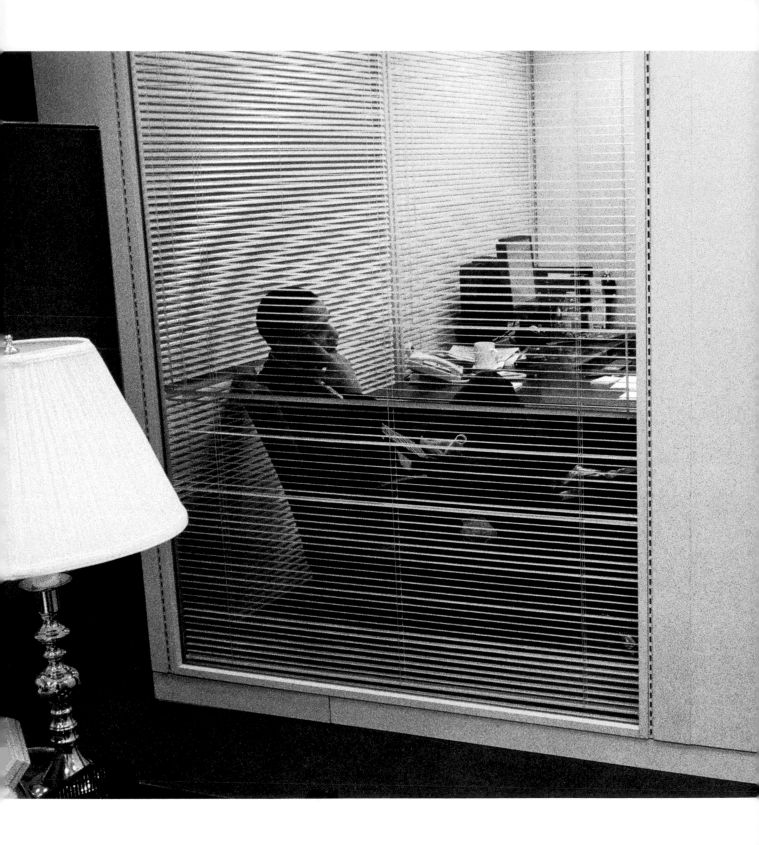

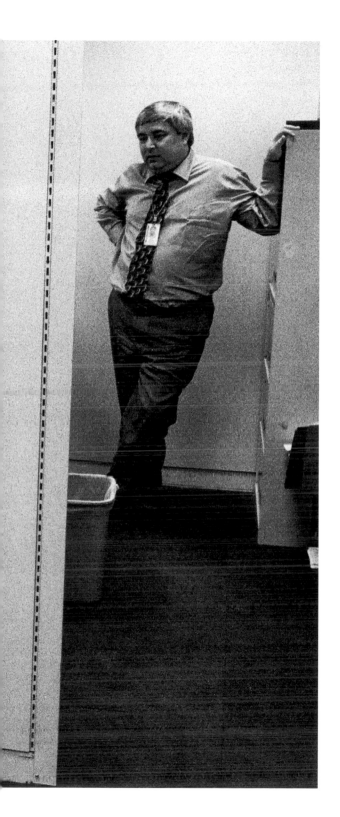

SITTING IN YOUR OFFICE

Some bosses call you into their office when they want to talk. Obama would do that on occasion, but just as frequently he would plop himself down in your office, even if you worked in a cubicle or at a small desk in an open seating area. Pete Rouse, Obama's Senate chief of staff (pictured left), affectionately nicknamed the 101st Senator, was often the beneficiary of that. Rouse said, "Most senators don't know the names of the junior people in the office. Obama knew everyone's name. In the Senate if you don't spend the money allocated for your office during the fiscal year, you have to give it back. Obama was always encouraging us to give out staff bonuses to the junior staff with the leftover money." In 2004, the salary for most young Senate staffers ranged from $28,000 to $35,000 per year, so they had very little spending money. During one of his casual sit-downs among staffers, Obama noticed that one legislative aide, Nick Bauer, had holes in his shoes. At first he gently poked fun at Nick, but later that day he and I took a walk to a shoe store inside Union Station where he purchased a pair of shoes for Nick and hand-delivered them to his desk. Nick was embarrassed that his boss, a US senator, had bought him replacement shoes, but he also knew it would make for a great story to tell his grandkids.

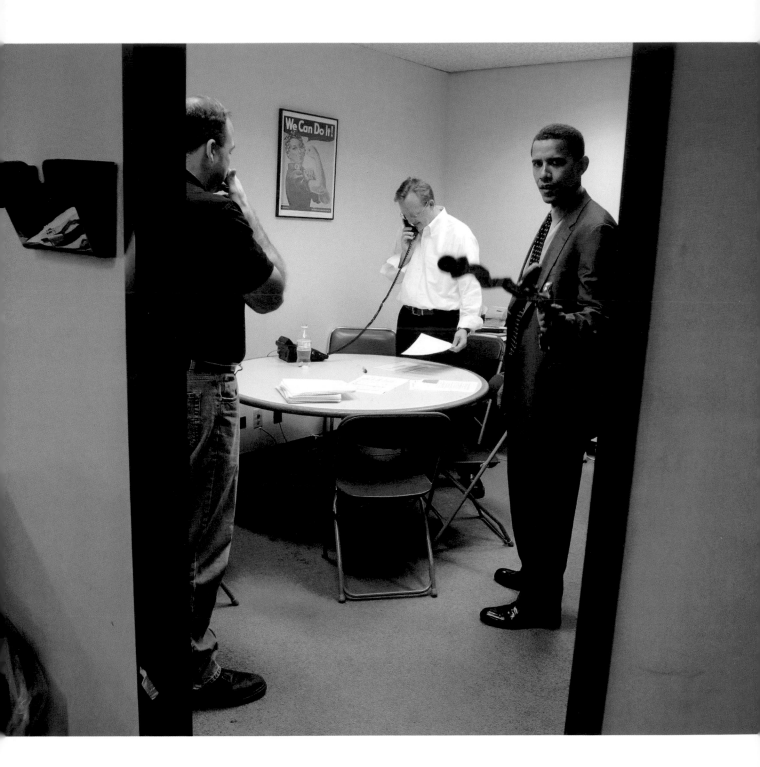

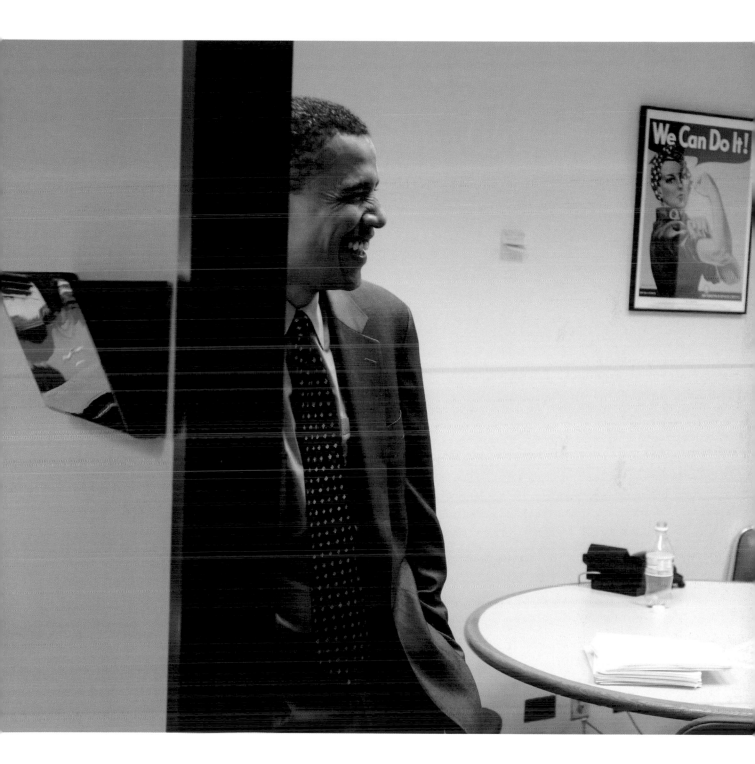

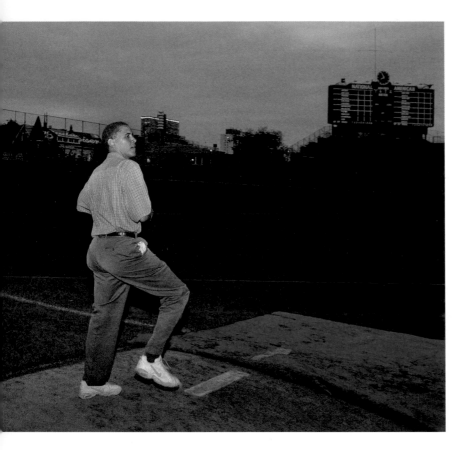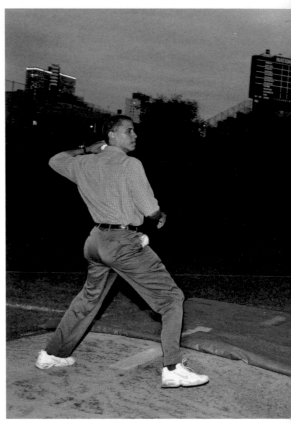

BRING IN THE LEFTY

In 2004, the Kane County Cougars, a single-A farm team for the Arizona Diamondbacks based fifty miles northwest of Chicago, asked the campaign if candidate Obama would throw out the first pitch at their next home game. The campaign leadership obliged, knowing that it would be a good opportunity to connect with suburban voters, but then panic ensued. Had Obama played baseball before? How would he do throwing from the mound? The campaign, knowing that I'd pitched in high school, suggested I practice with

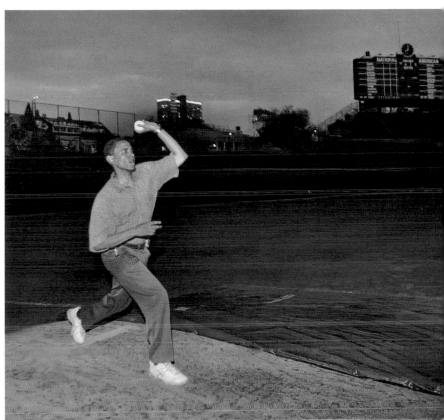

Obama. Our director of scheduling, Peter Coffey, learned that a twelve-year-old Little League all-star would be throwing a ceremonial pitch right before Obama. "She's definitely going to throw a strike," he quipped. The pressure was on, so we had to find a place to practice. We needed to find a regulation-size mound, so a park district diamond wouldn't work. Coffey put in a call to a friend from his days on the Clinton-Gore campaign in 1992 who now worked for the Cubs. After he opened the left field bullpen for us, we had Wrigley Field to ourselves. As we left, Obama, an avid White Sox fan, bit his tongue and signed a few balls for the staff: "Go Cubs!"

The family jokes around with each other on the set of a photo shoot for a direct-mail piece in the Hyde Park neighborhood of Chicago in 2004.

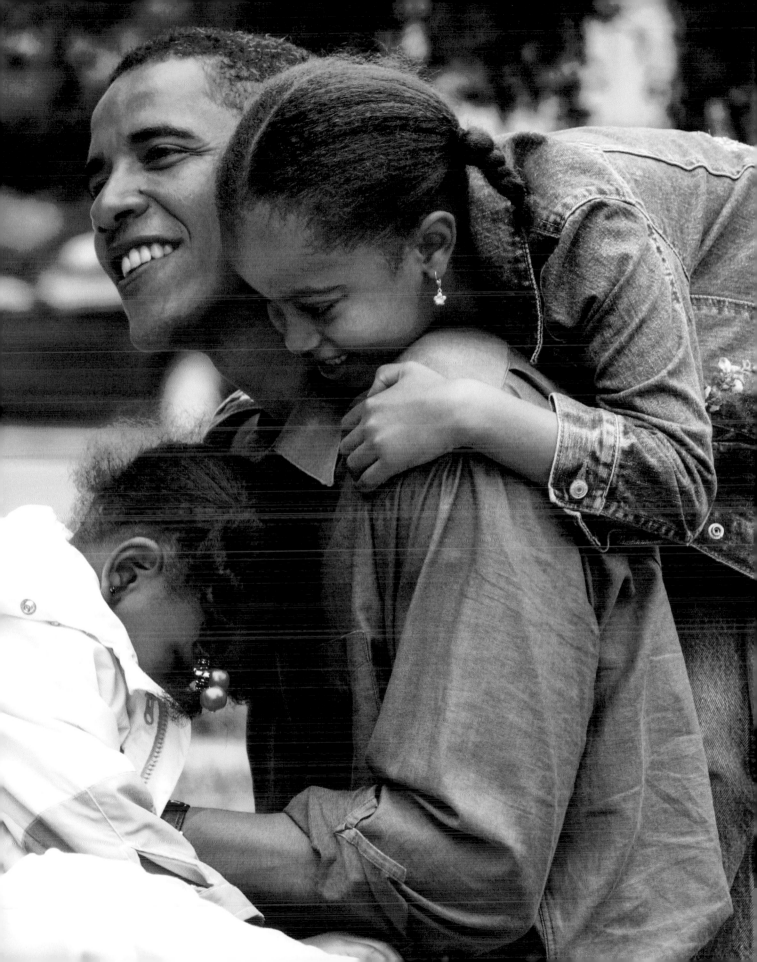

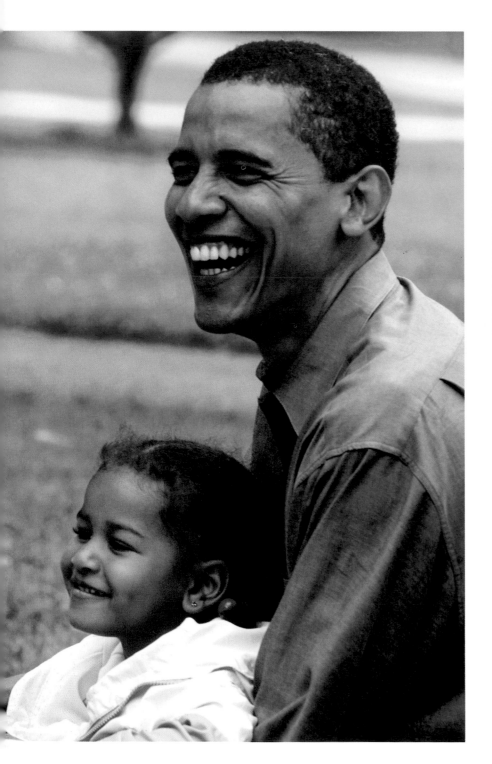
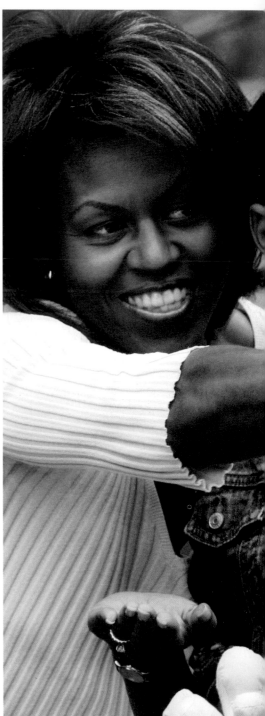

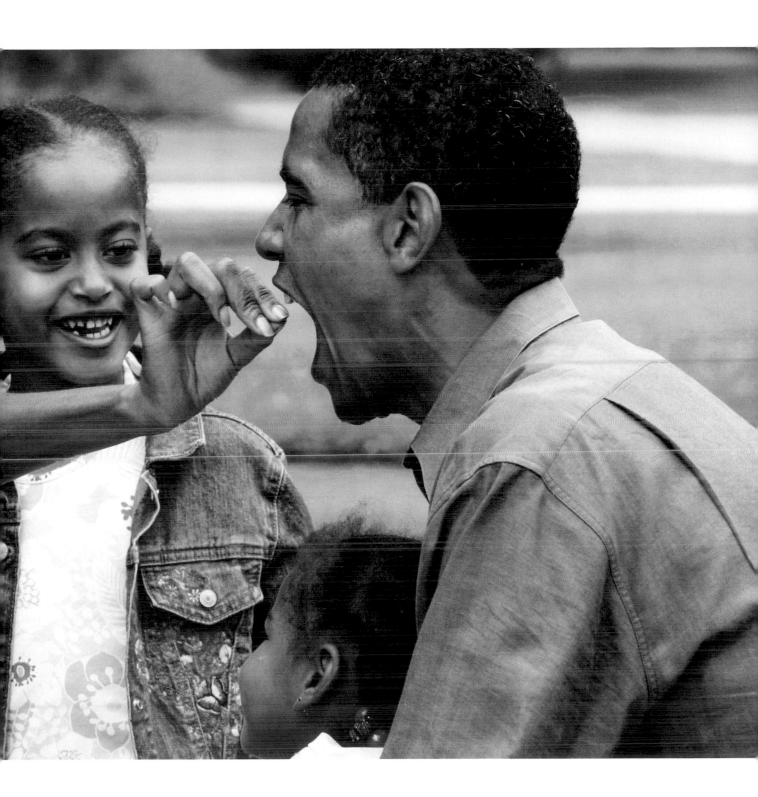

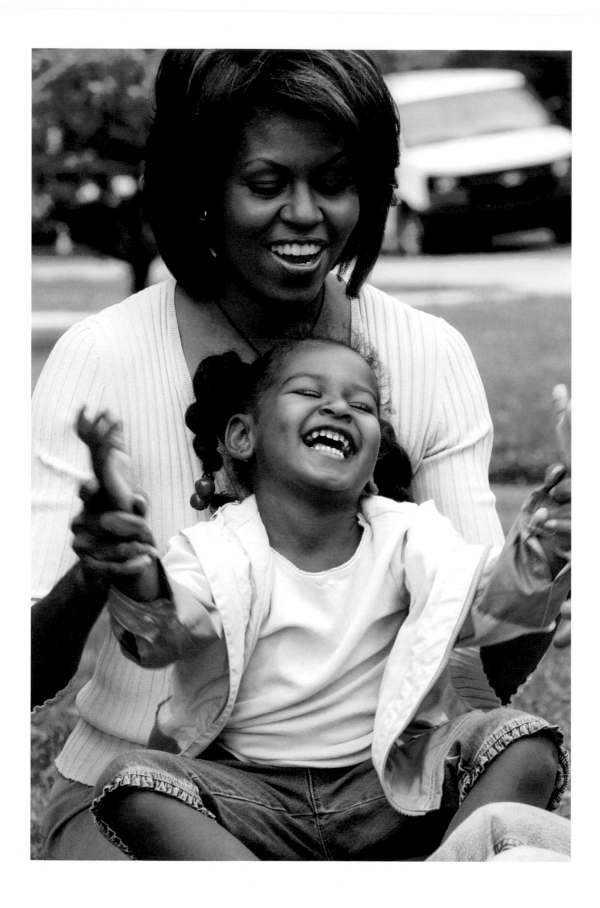

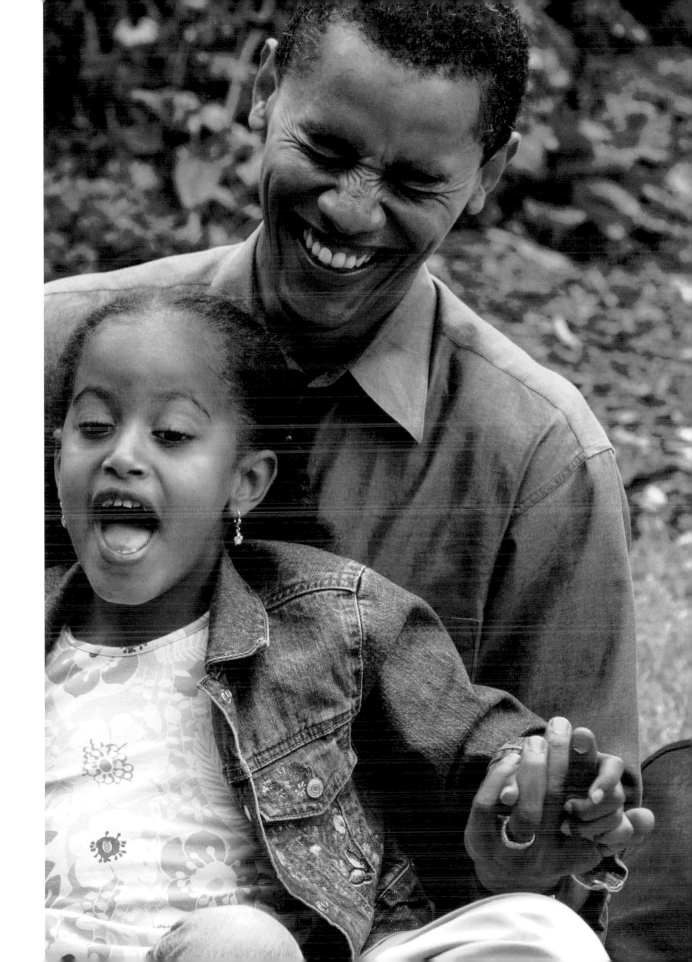

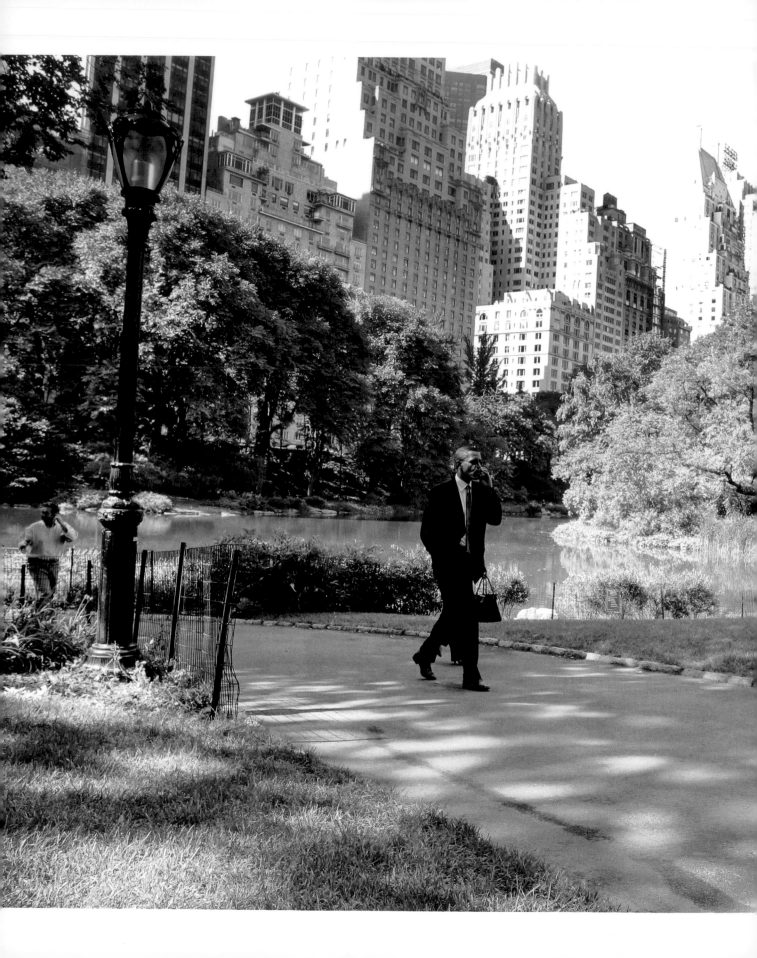

CENTRAL PARK

In 2004, we made a number of trips to New York to raise money. Our campaign deputy finance director back then, Jenny Yeager, reminded me how much Obama loved New York City. "He especially loved his visits to Central Park. If we were even remotely near Central Park, he would want to jump out of the car and walk to wherever we were going. He would beam like a proud New Yorker pointing out landmarks, reminiscing about his time at Columbia, and correcting us on directions. We made one last visit to New York after his famous DNC speech, but before he was elected to the Senate. He would tell us that walking through Central Park made him feel like a normal person."

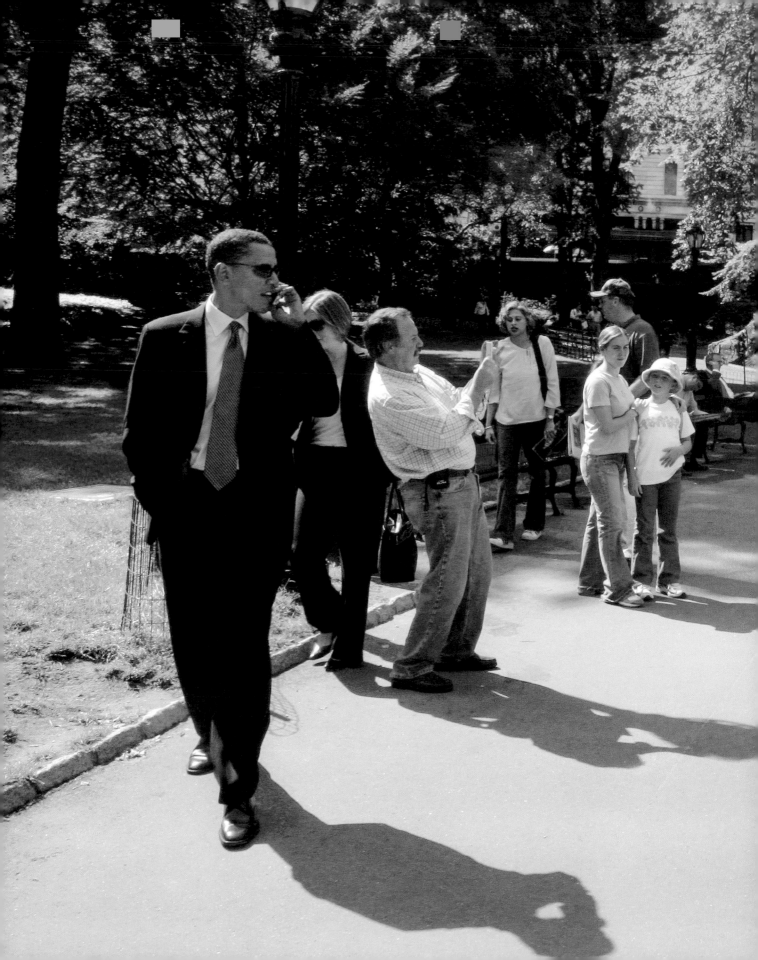

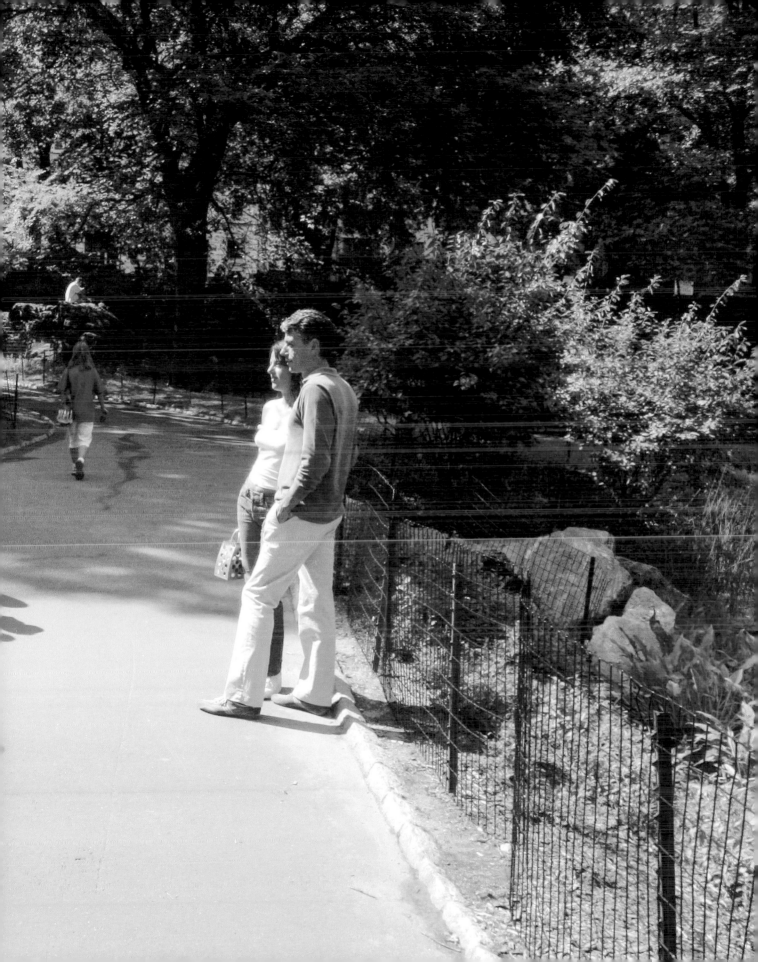

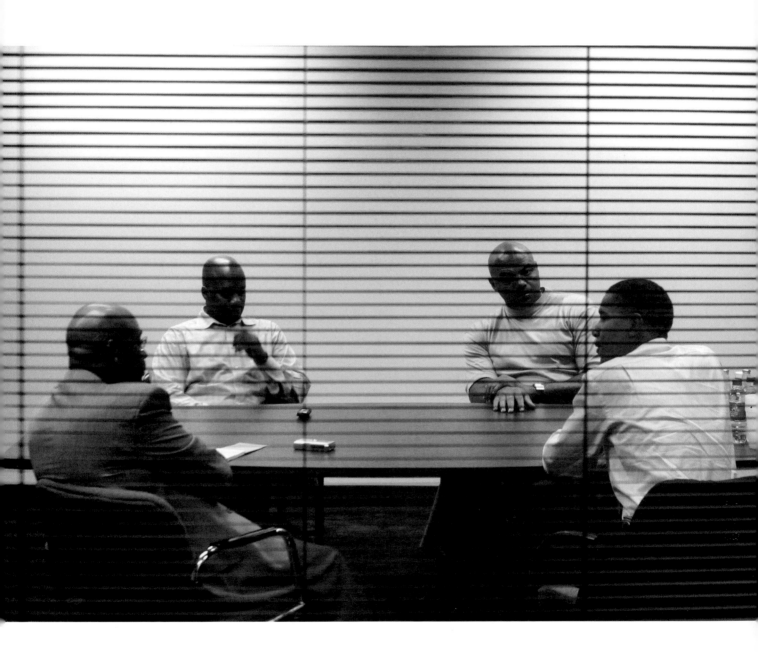

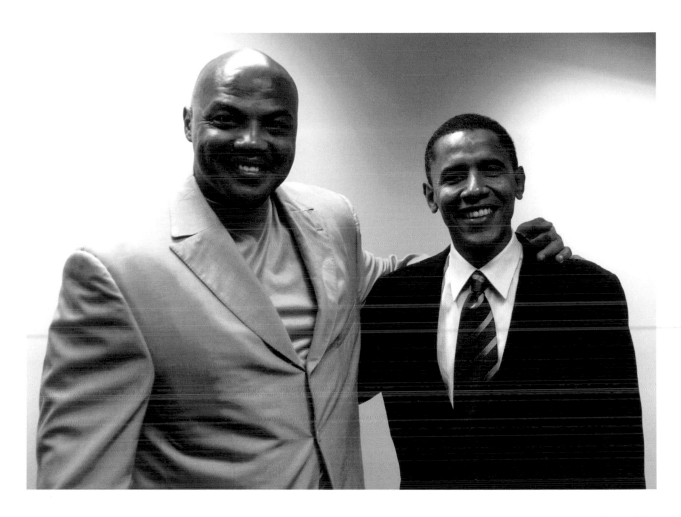

When Charles Barkley came to visit our campaign office with sports journalist Michael Wilbon, Obama was a rising star, but for the staff, everyone wanted a glimpse of Sir Charles. Charles was considering entering politics at the time as a Republican, and Obama encouraged him to change his party affiliation.

WHO'S AFRAID OF VIRGINIA WOOLF?

During the 2004 Senate campaign, I volunteered to find a venue for debate preparation. Obama had never debated with so much at stake before, so the campaign wanted to simulate the real experience as much as possible. The practice venue needed to have a stage and theater lights, and it had to be large enough for two podiums. Both Obama and I lived in Hyde Park and were familiar with the Court Theatre, which was connected to the University of Chicago. A production of *Who's Afraid of Virginia Woolf?* was running there at the time, but the Court graciously allowed us to do our debate preparation on the set while the show was dark. David Axelrod has reminded me that this particular prep session got prickly because Forrest Claypool (standing at the podium on page 133), an associate of David Axelrod's, played the role of Alan Keyes, and he so tore into Obama that he felt blindsided by the attack, unprepared.

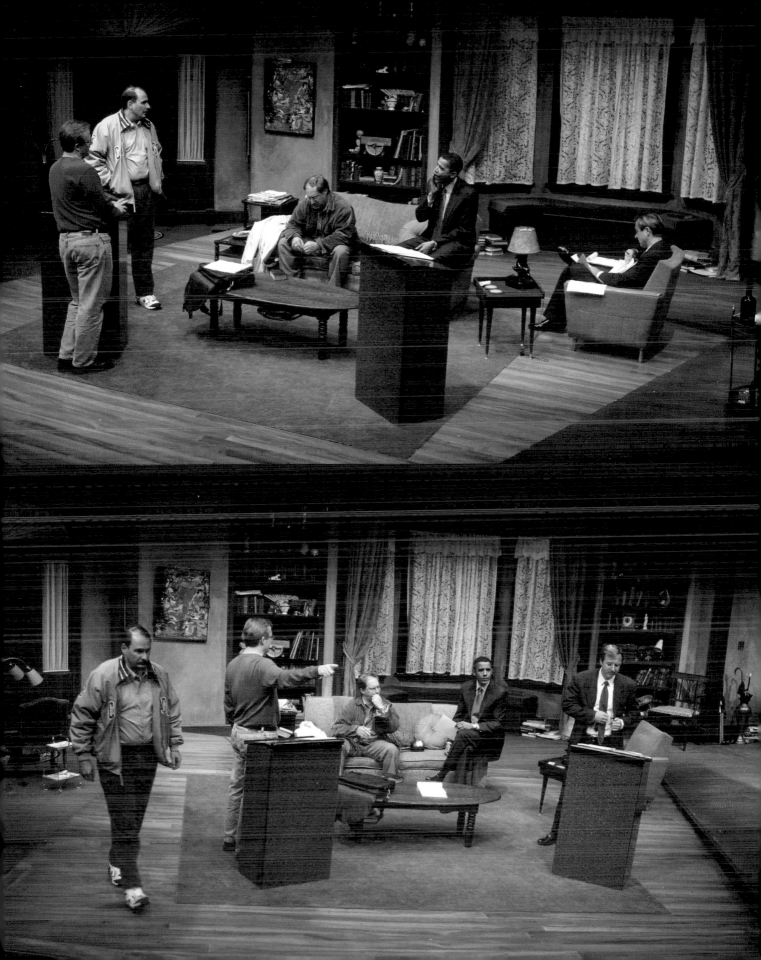

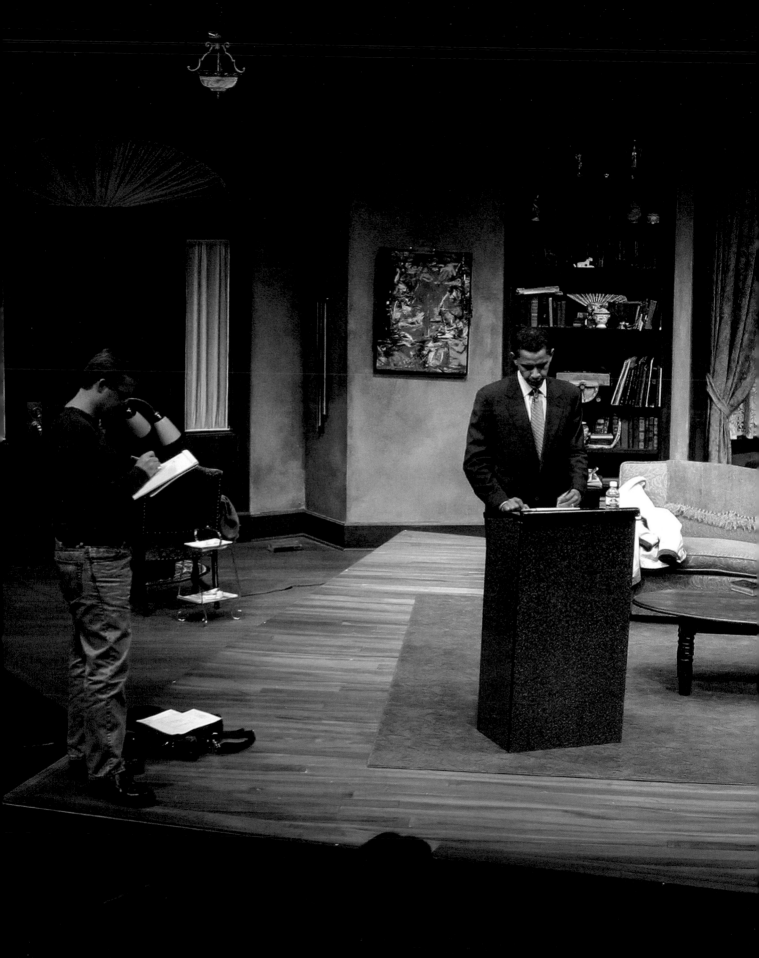

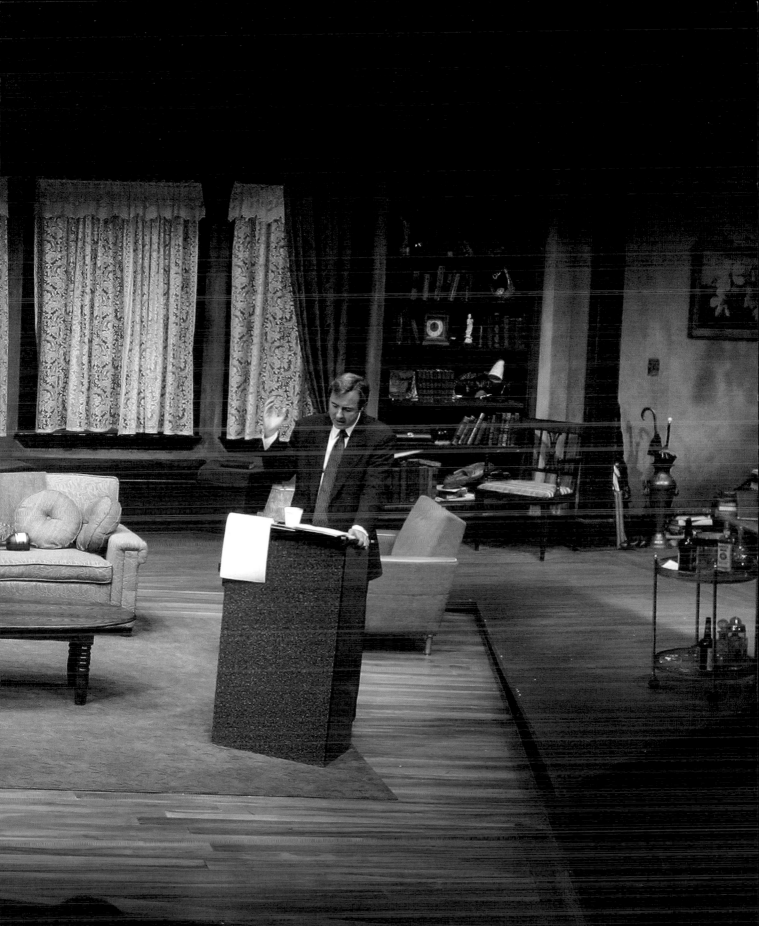

DNC SPEECH

Obama was not a shoo-in to be the DNC keynote speaker in 2004. The campaign spent weeks lobbying the Kerry campaign for the coveted spot. "He was an untested candidate to the Kerry folks, so we put together videos, presentations, and had political and donor types call and lobby for us," said David Plouffe. "We made the case that his youthful, diverse background and magnetism would jump off the screen. I give the Kerry people a lot of credit for seeing the potential and choosing Obama. After Obama got the call from Kerry, he was actually quite nervous. He really wanted to deliver for John."

He started rehearsing his famous "Red State, Blue State" speech weeks ahead of the 2004 convention. He had never given a speech in an arena before, certainly not to eighteen million people on television. David Axelrod has reminded me that during those prep sessions Obama felt like he had to orate and project his voice loud enough so that everyone could hear him in the arena. "He was bellowing," said Axelrod. When we arrived in Boston, the DNC's speech coach, Michael Sheehan, told Obama that he was mainly having a conversation with people at home on their televisions, and that the microphone would do all the work in the arena. Sheehan coached him to continue his speech during the applause, no matter how awkward that might seem, because the television viewers could not hear the crowd.

Obama loved the challenge of improving, so he practiced each day until he grew confident. He had written the speech himself and knew it so well that even if the teleprompters had failed, he could have recited it. As I photographed him backstage while he was waiting to be announced, he turned to me and said, "I'm going to sink this putt." He and I had played a lot of golf together, so I wasn't surprised by the reference, but I was shocked that he said it so calmly before the speech that would change his life. Valerie Jarrett recalls, "I was extremely nervous before he began to speak. Two minutes in and I began to relax. He had the audience in the palm of his hand, including me."

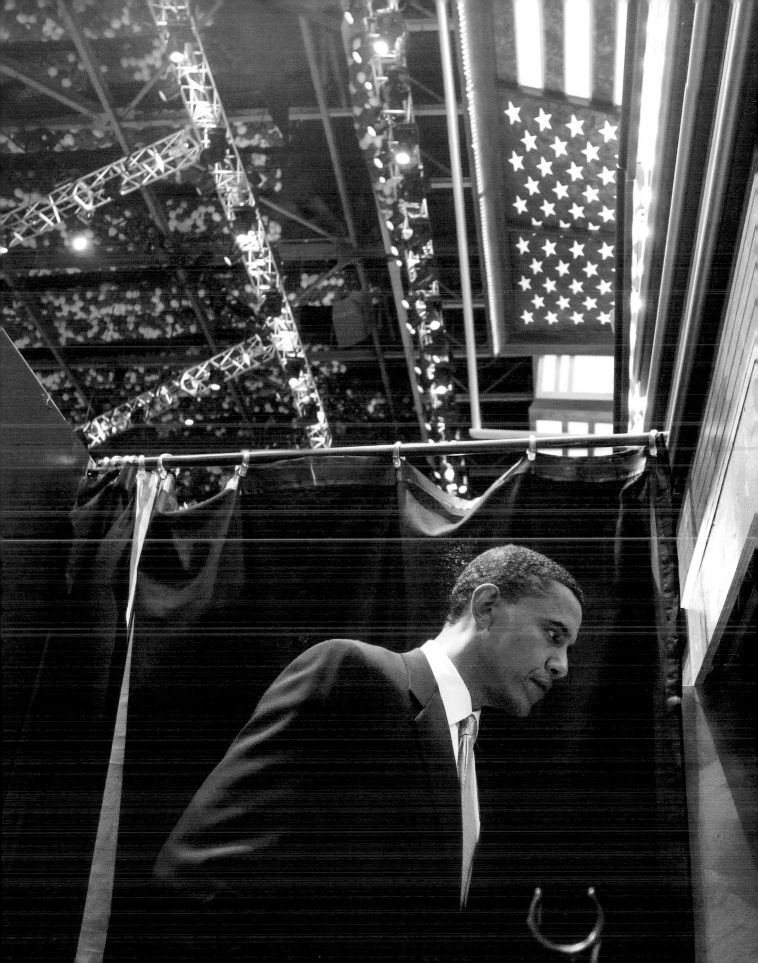

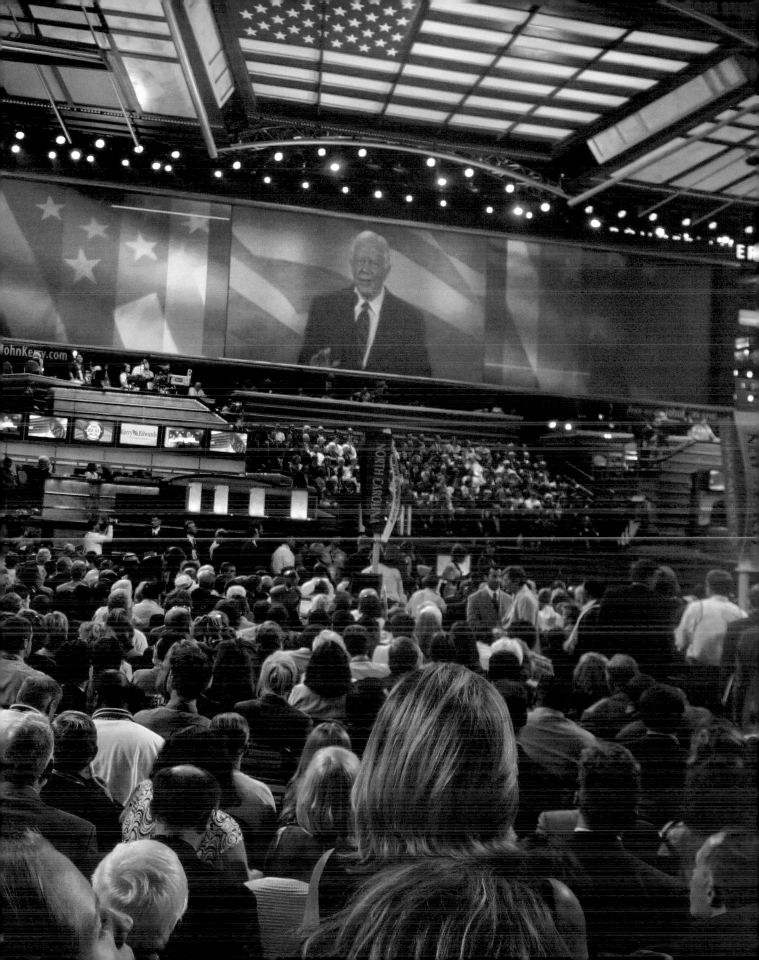

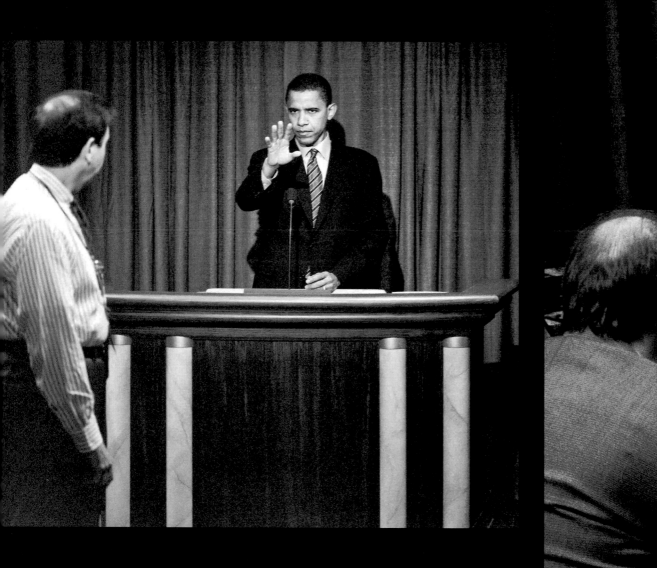

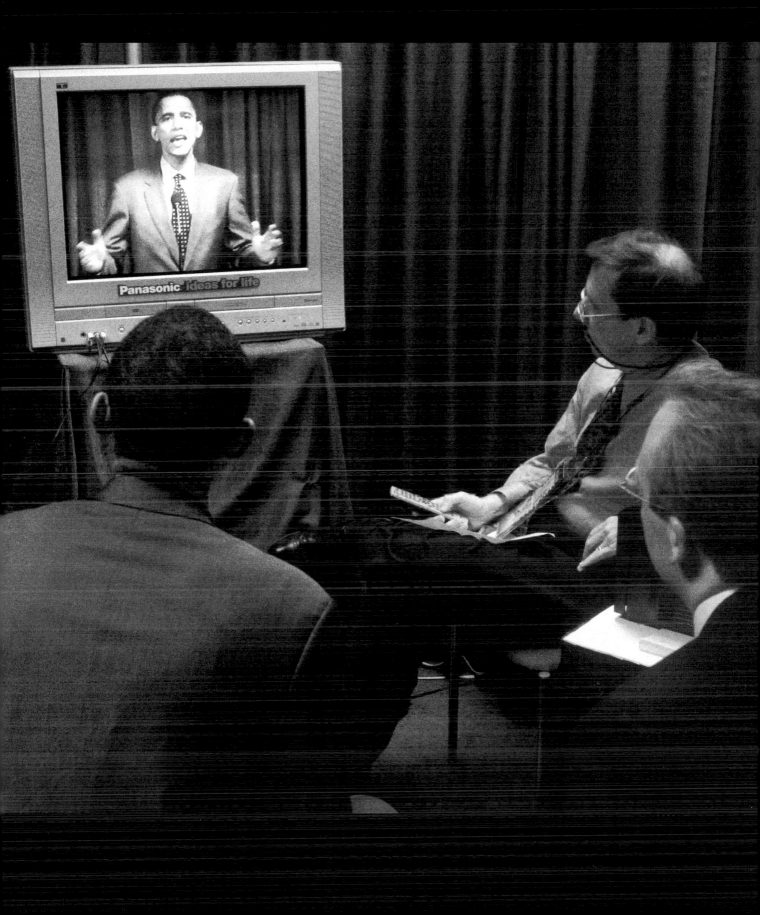

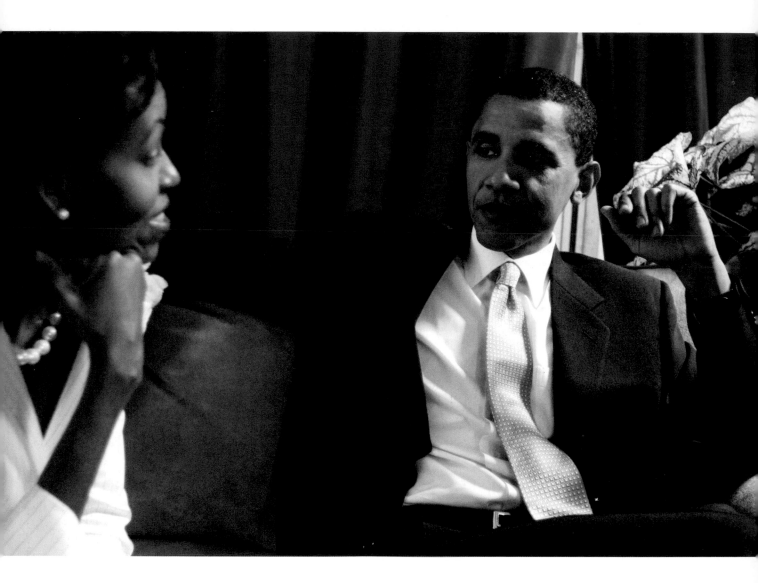

The Obamas share a laugh backstage,
prior to Barack delivering his famous
DNC speech in 2004.

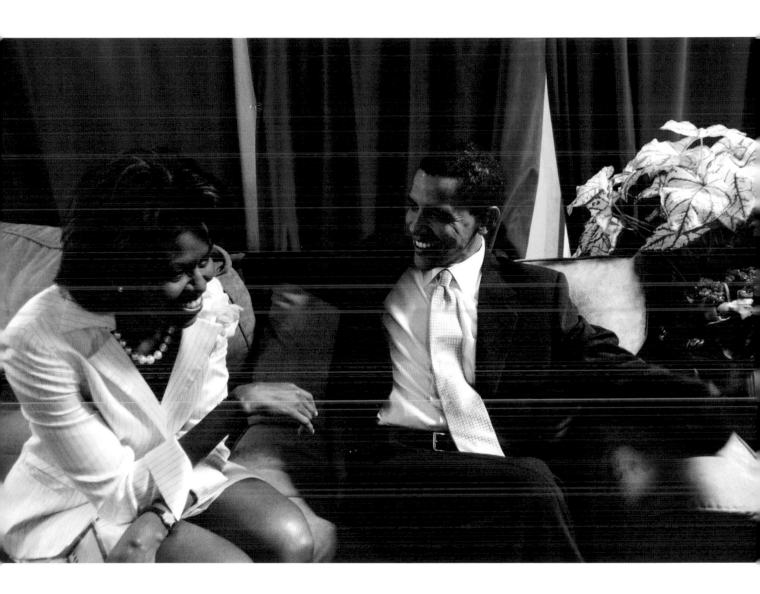

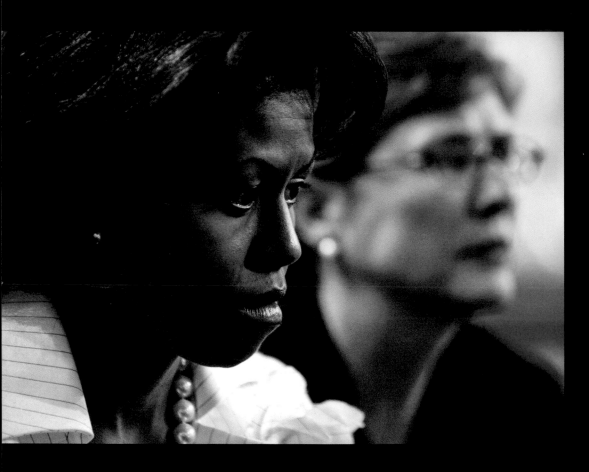

"Well, I say to them tonight, there is not a liberal America and a conservative America—there is the United States of America. There is not a Black America and a White America and Latino America and Asian America—there's the United States of America. The pundits, the pundits like to slice-and-dice our country into Red States and Blue States; Red States for Republicans, Blue States for Democrats. But I've got news for them, too: We worship an awesome God in the Blue States, and we don't like federal agents poking around in our libraries in the Red States. We coach Little League in the Blue States and yes, we've got some gay friends in the Red States. There are patriots who opposed the war in Iraq and there are patriots who supported the war in Iraq."

—Barack Obama, Democratic National Convention;
Boston, Massachusetts; July 27, 2004

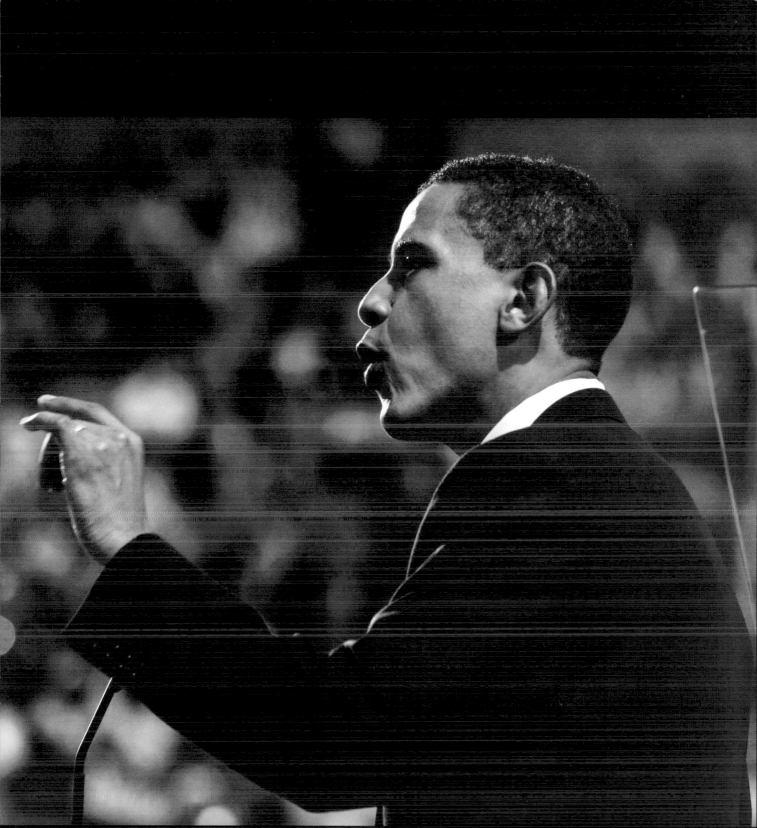

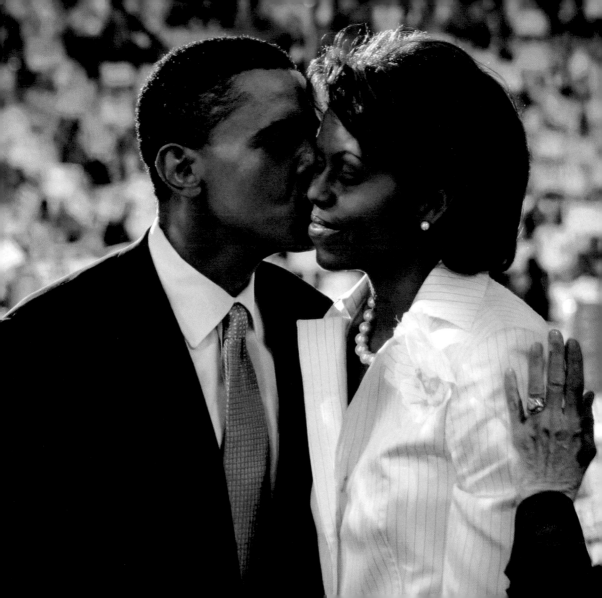

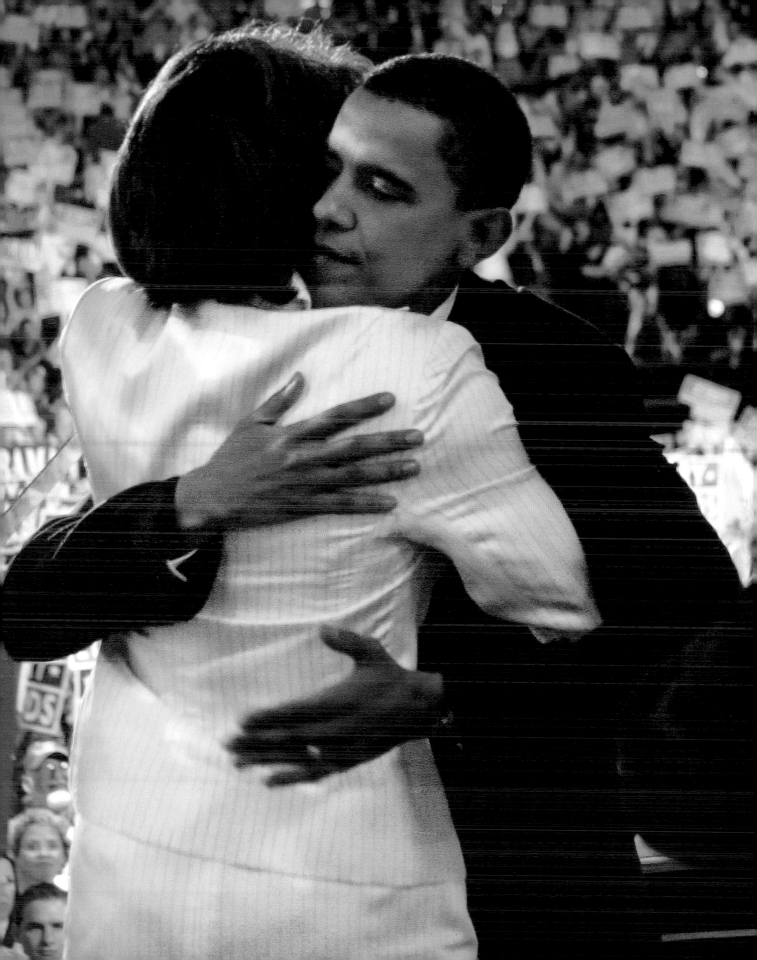

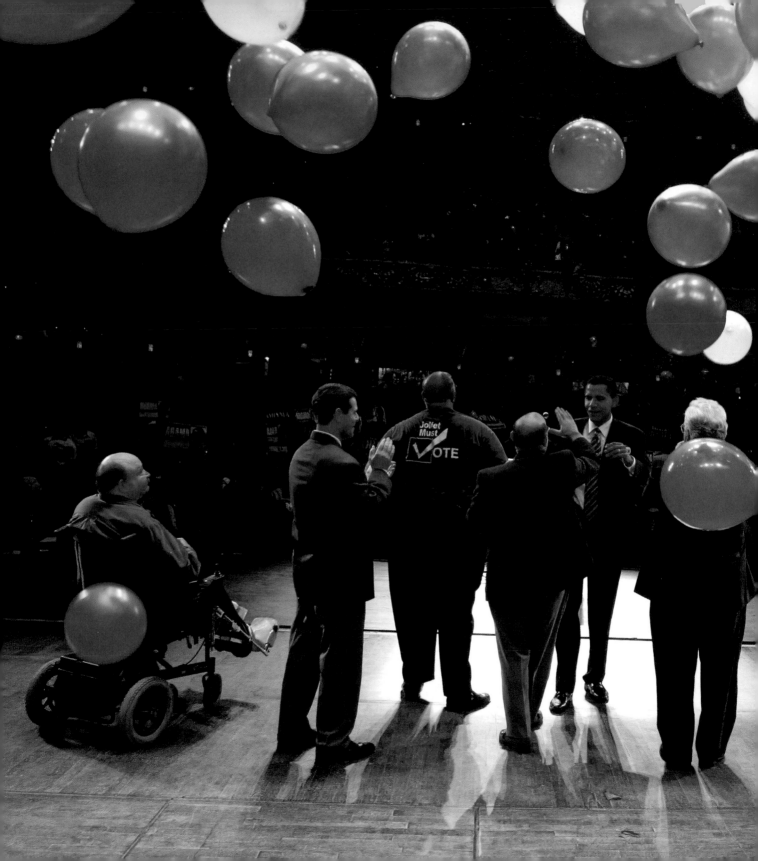

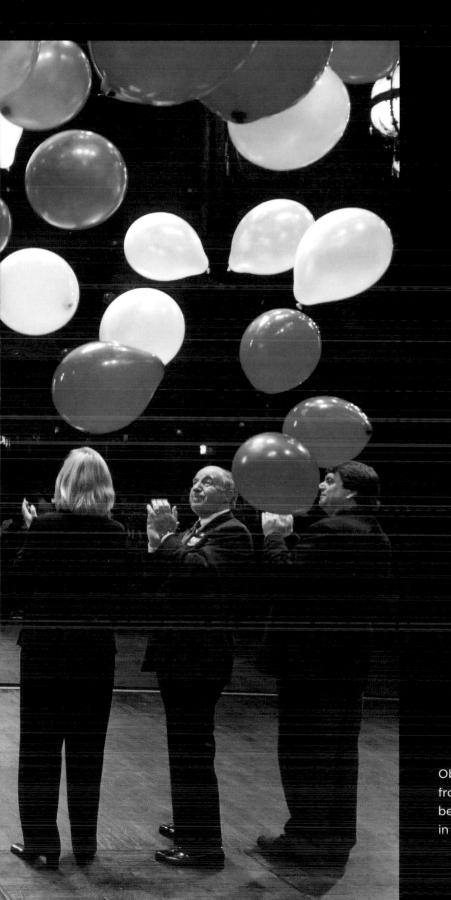

Obama and supporters watch balloons drop from the ceiling after a campaign rally days before the 2004 general election for Senate in Illinois.

149

The Obamas share a lighthearted moment
prior to a campaign rally on November 1,
2004, the day before he would be elected
the junior senator from Illinois.

ELECTION NIGHT 2004

Election nights can be very stressful. There's a lot of anticipation, movement from one event to another, and pressure to deliver for your supporters, family, and friends. During these intense election nights, the Obamas would inject humor and joke with each other, which I'm sure made them relax, but it also put everyone else around them at ease.

Maya Soetoro-Ng, Barack's sister, remembers passing her newborn daughter around to the family for the first time. "I relished the opportunity to have Suhaila exposed to so many different faces and voices that were part of our extended family. Living in Hawaii, we hadn't been able to witness his charisma, servant leadership, and community mobilization to such an extent, and that night we recognized for the first time that my brother would now belong to so many."

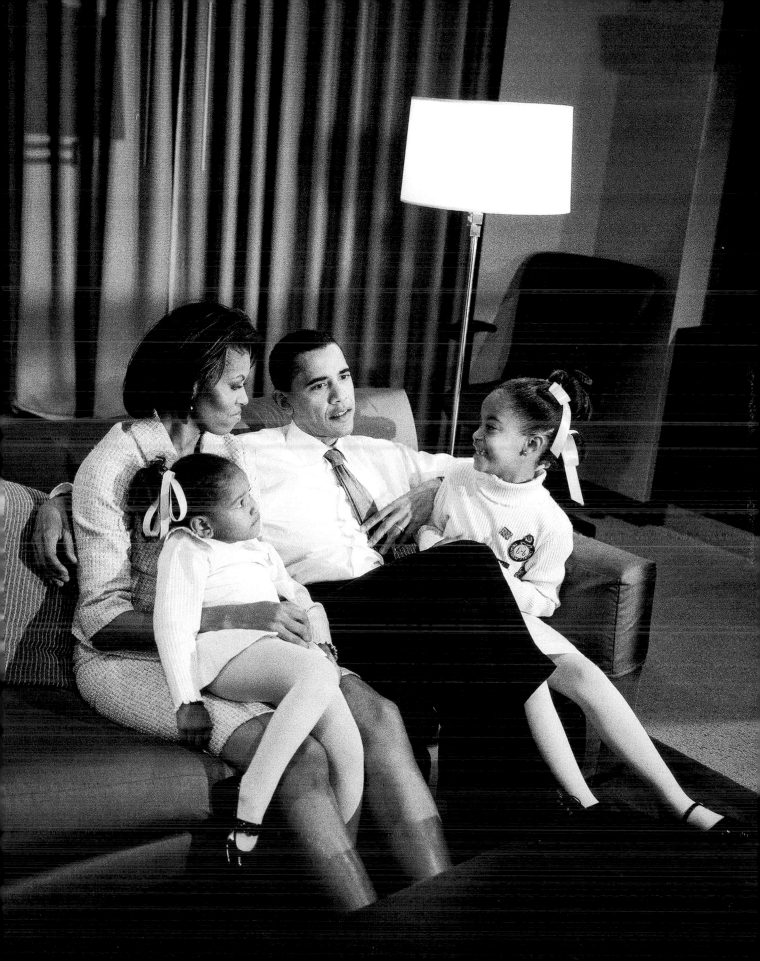

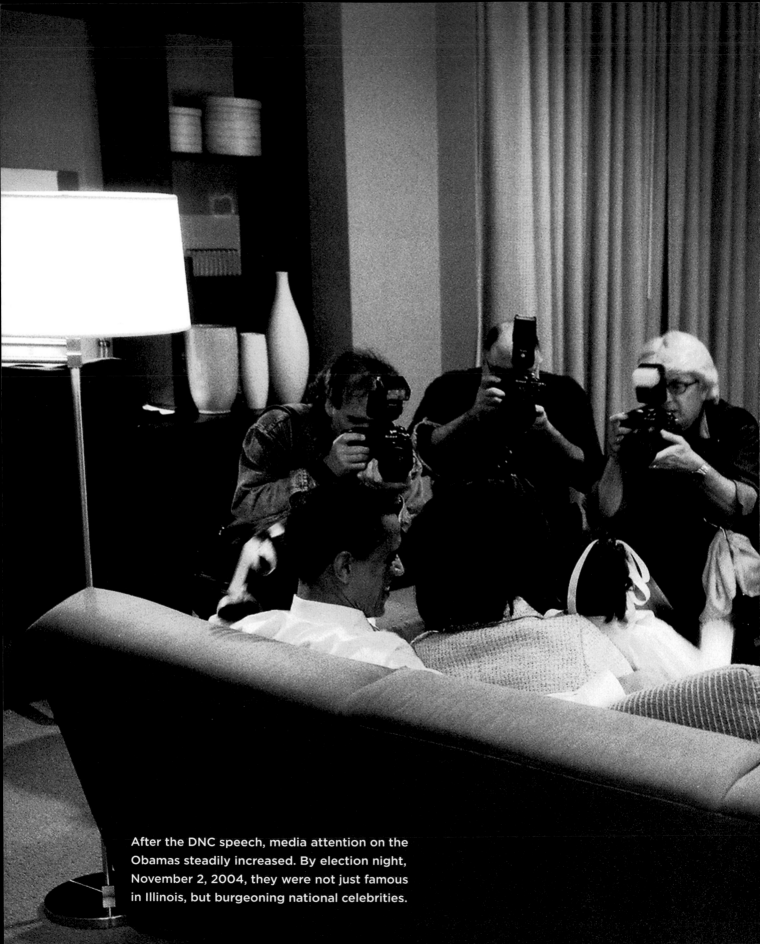

After the DNC speech, media attention on the Obamas steadily increased. By election night, November 2, 2004, they were not just famous in Illinois, but burgeoning national celebrities.

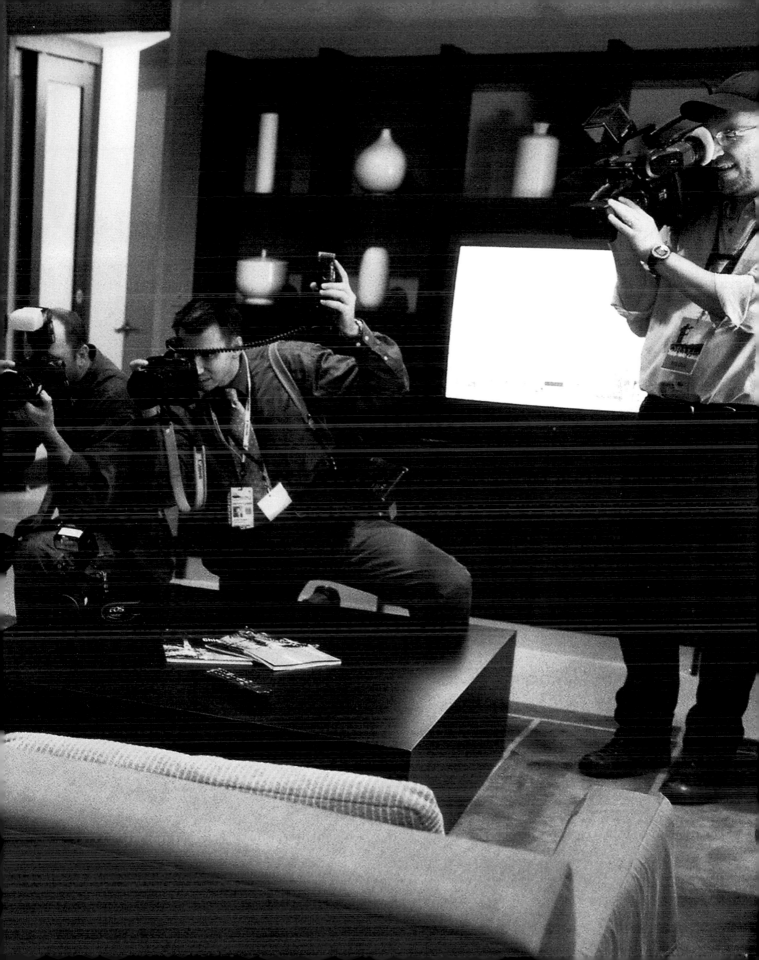

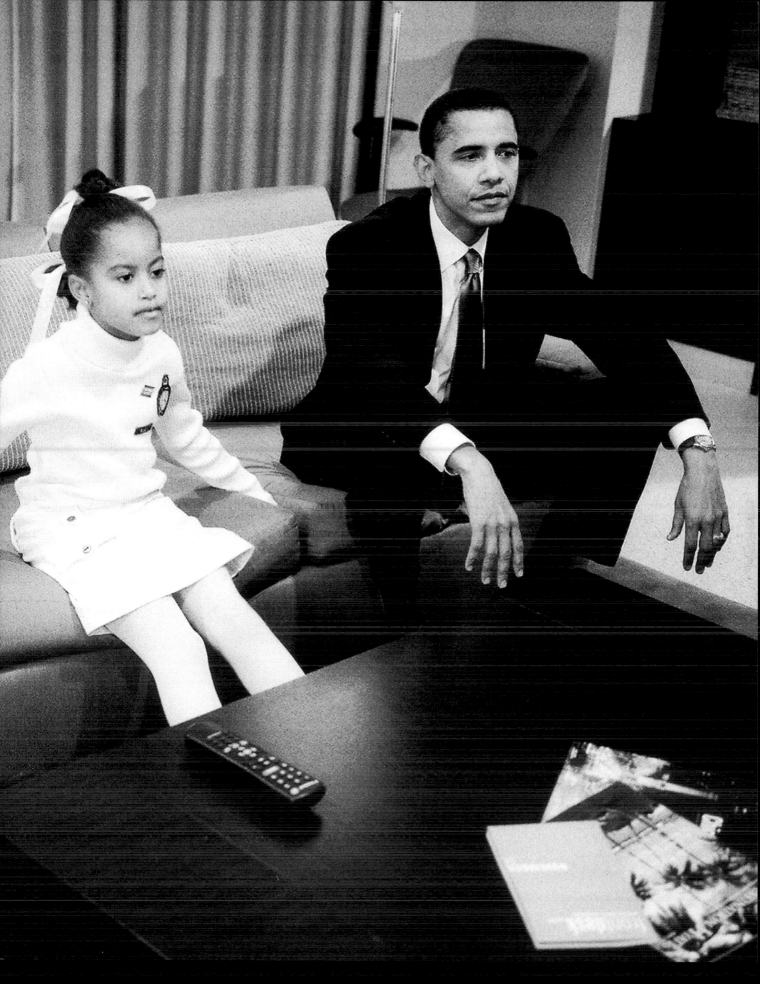

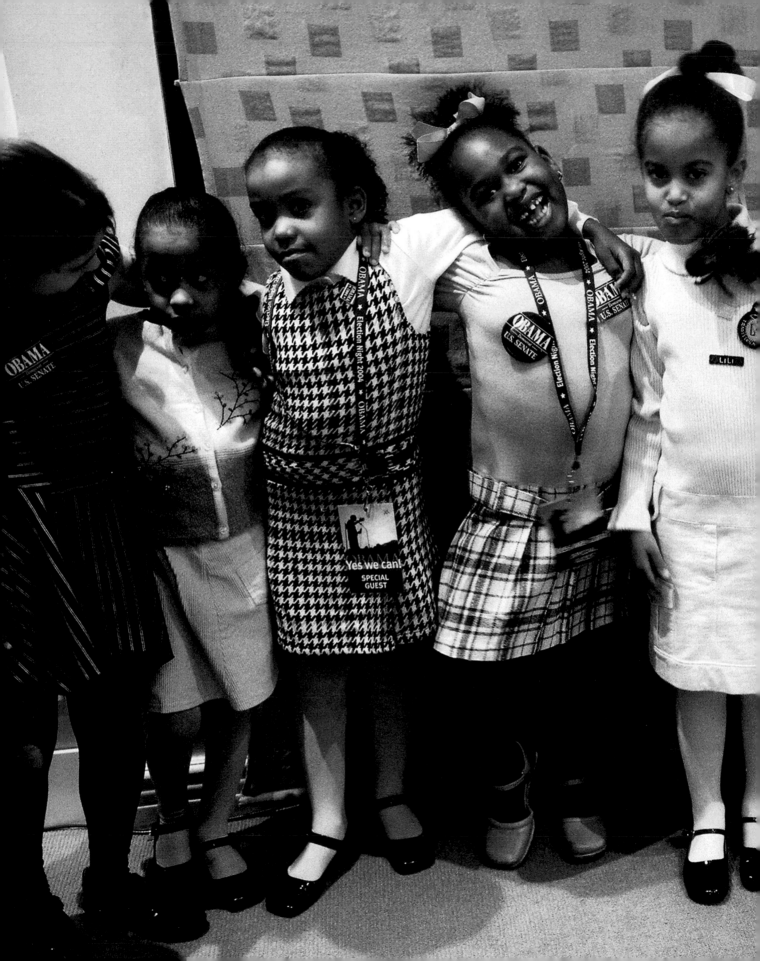

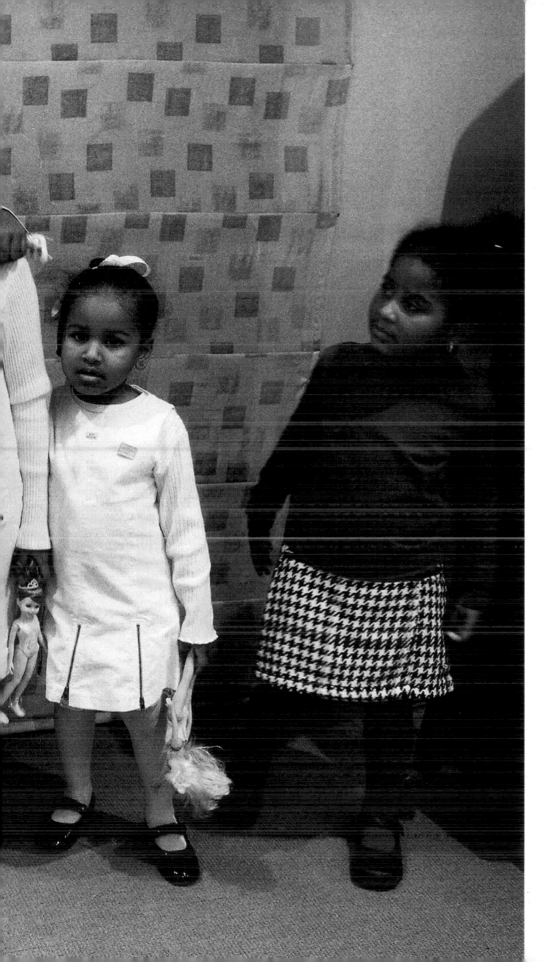

Sasha and Malia loved
having their cousins and
friends with them on
election night.

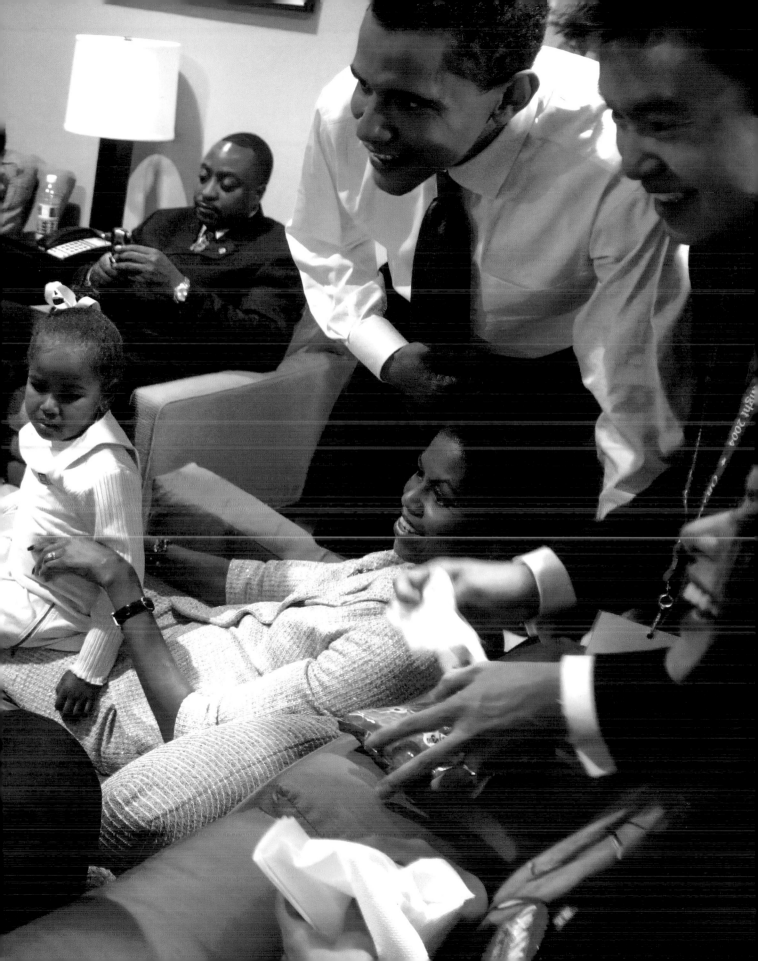

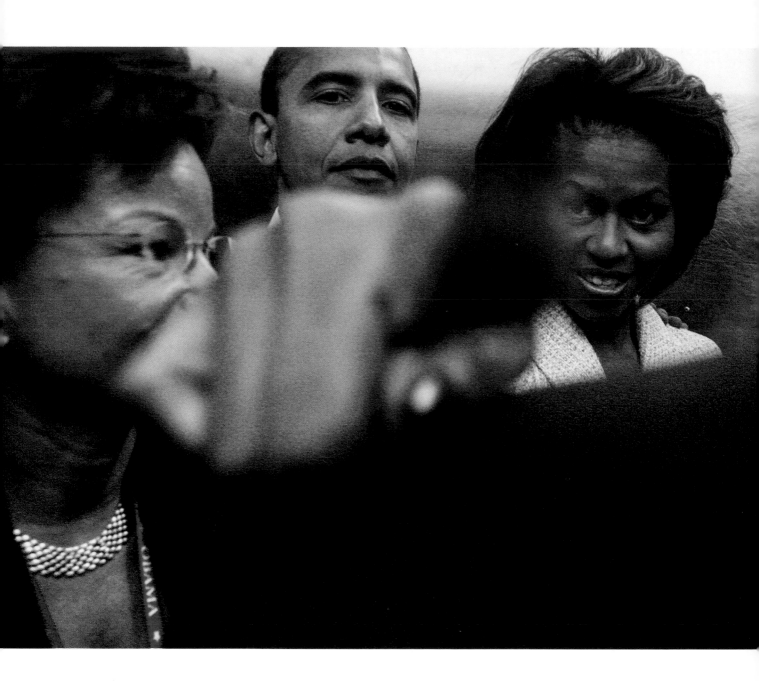

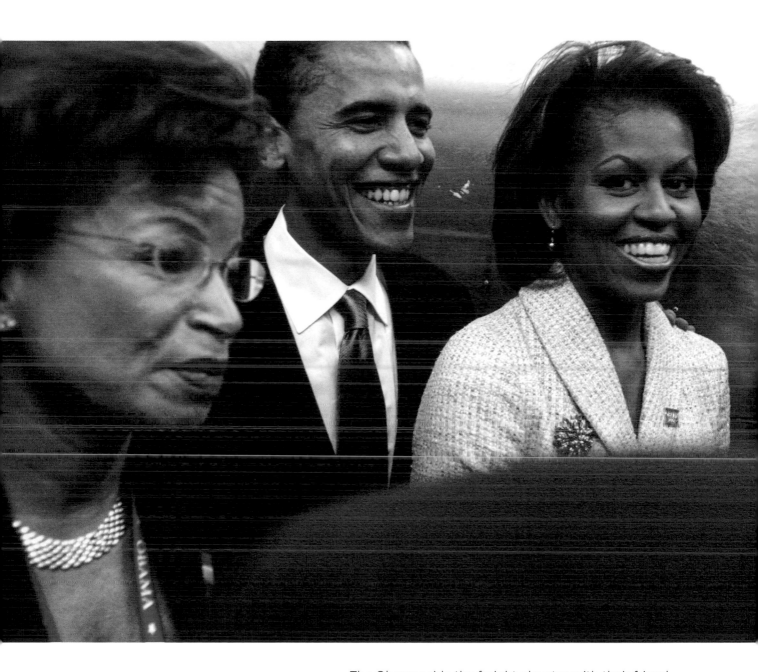

The Obamas ride the freight elevator with their friend Valerie Jarrett en route to their election night party. Obama had just defeated Alan Keyes to become Illinois's junior senator by a 43 percent margin, the largest in US Senate election history. It was also the first time in US history that two African American candidates squared off against each other for a Senate seat.

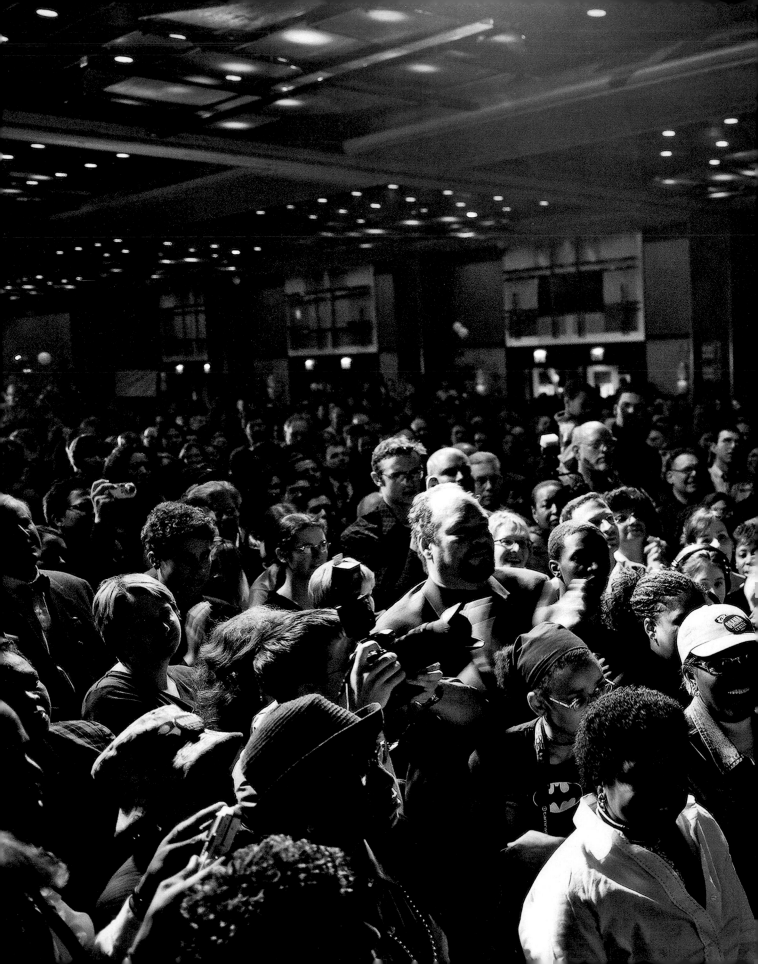

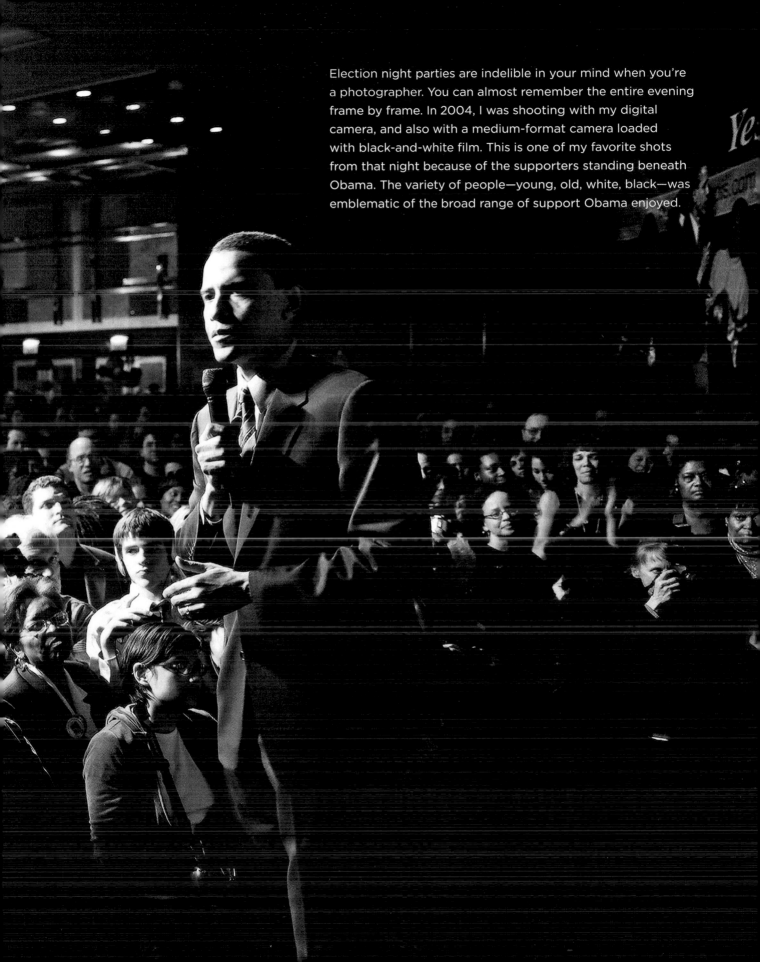

Election night parties are indelible in your mind when you're a photographer. You can almost remember the entire evening frame by frame. In 2004, I was shooting with my digital camera, and also with a medium-format camera loaded with black-and-white film. This is one of my favorite shots from that night because of the supporters standing beneath Obama. The variety of people—young, old, white, black—was emblematic of the broad range of support Obama enjoyed.

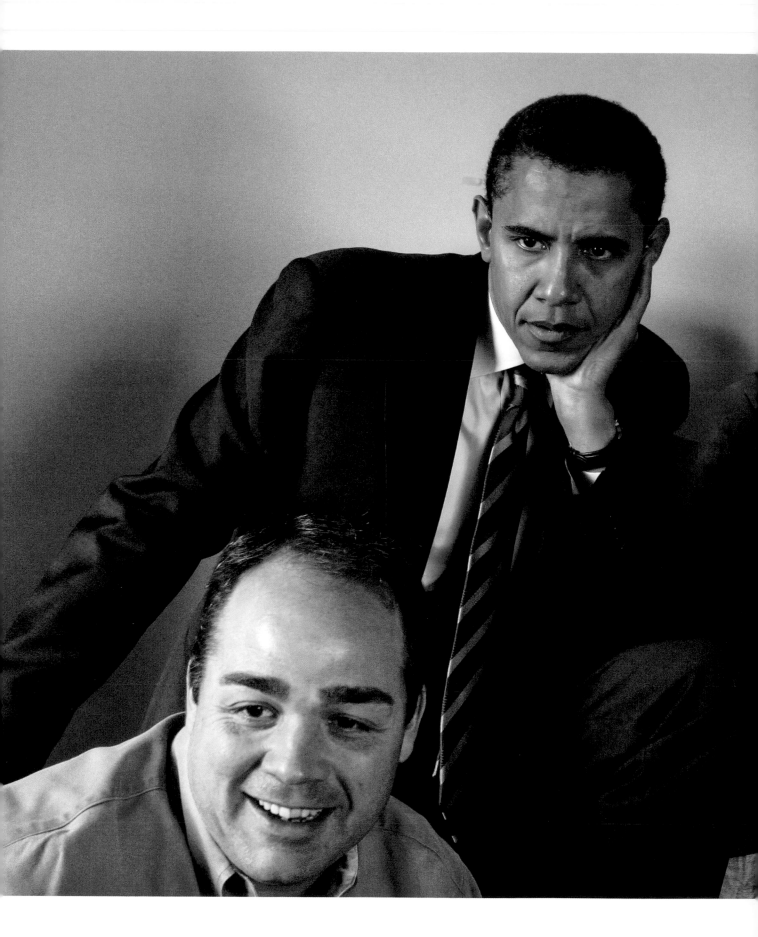

The US Senate is an institution built on hierarchy and tenure. What rank you are in the Senate (1 to 100) determines matters ranging from your committee assignments to what office location you are granted. In 2004, based on a number of factors, Obama was supposed to be ranked dead last in terms of seniority. Nobody wanted that, so when an opportunity arose due to another senator's early retirement, Senate leadership informed the Obama campaign that he would now be ranked ninety-ninth instead of hundredth. In this photo, campaign manager Jim Cauley (left) and campaign strategist David Axelrod (right) look at an email informing the team of this new development.

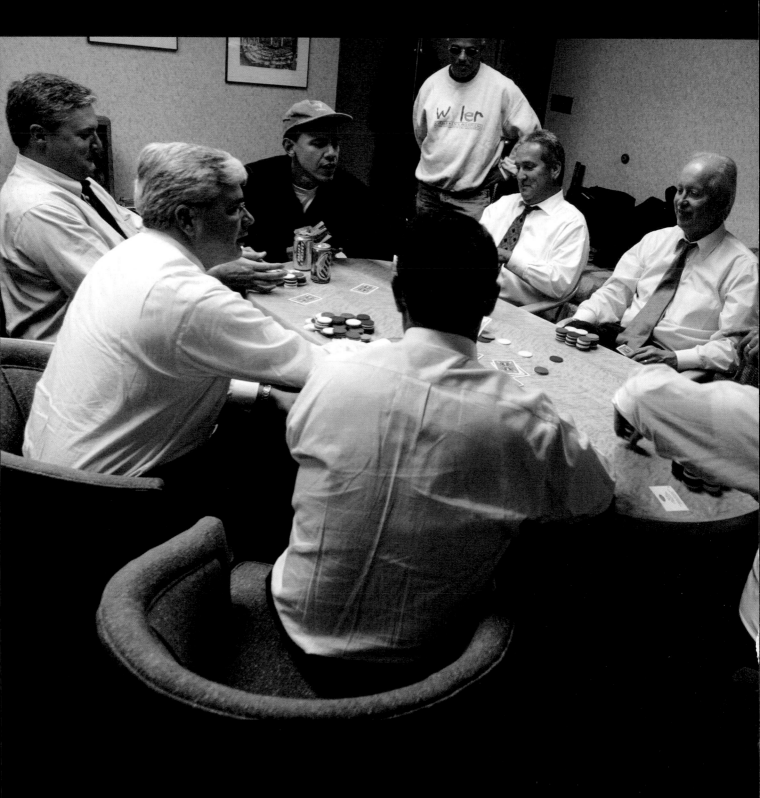

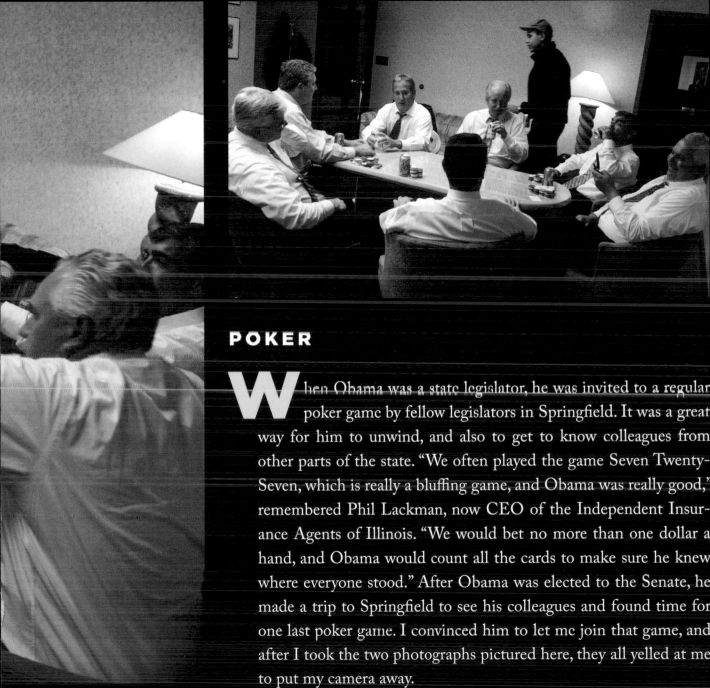

POKER

When Obama was a state legislator, he was invited to a regular
poker game by fellow legislators in Springfield. It was a great
way for him to unwind, and also to get to know colleagues from
other parts of the state. "We often played the game Seven Twenty-
Seven, which is really a bluffing game, and Obama was really good,"
remembered Phil Lackman, now CEO of the Independent Insur-
ance Agents of Illinois. "We would bet no more than one dollar a
hand, and Obama would count all the cards to make sure he knew
where everyone stood." After Obama was elected to the Senate, he
made a trip to Springfield to see his colleagues and found time for
one last poker game. I convinced him to let me join that game, and
after I took the two photographs pictured here, they all yelled at me
to put my camera away.

Jon Favreau's first assignment as a newly hired speechwriter for Senator-elect Obama was to draft a statement about the nomination of Condoleezza Rice as secretary of state. Favreau recalls, "I remember being extremely nervous. Obama came over to me and said, 'I know you're nervous. I'm a writer just like you, so don't worry if you get stuck.' After submitting my draft to him, he returned it to me saying, 'I hope these edits are OK with you.' I thought to myself, 'Of course they're OK . . . you're Barack Obama.'"

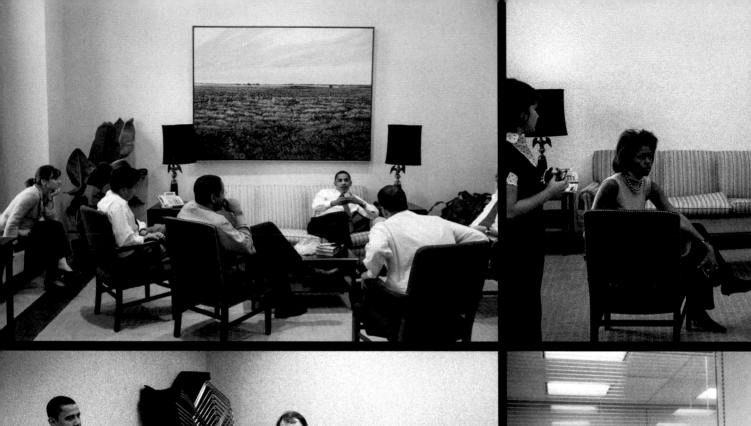
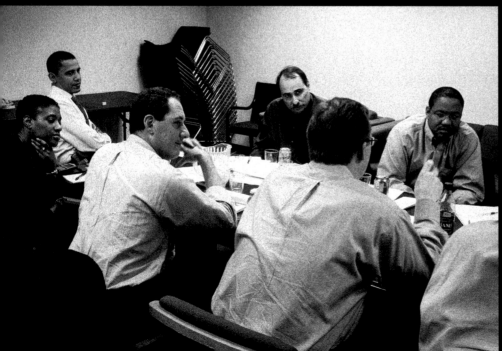

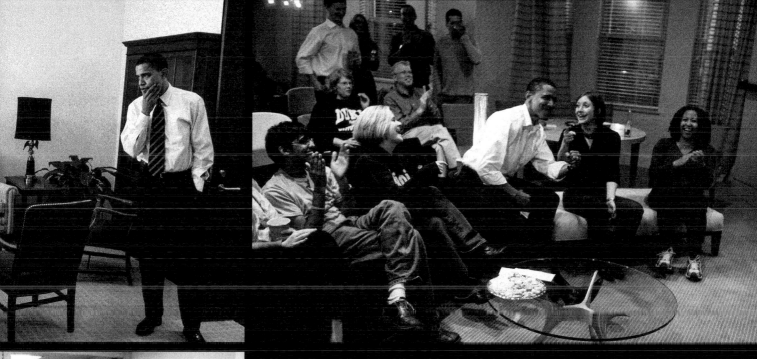

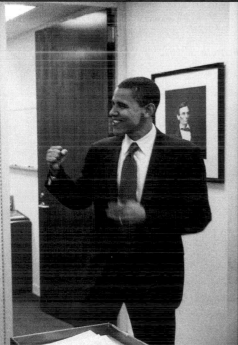

Our Senate staff was a mix of young staffers who had worked on the campaign and veteran DC policy wonks. I remember thinking that those more established people in the office really had it all figured out. They had families and owned homes, and Senator Obama really listened to their advice. Now that I'm about their age, with a family and a mortgage of my own, I know that life for them was probably much more complicated than it seemed at the time. Though everyone worked really hard, the staff had fun, too, including a viewing party in the lounge of Obama's apartment building to watch the 2005 championship NCAA basketball game (above), between Illinois and North Carolina.

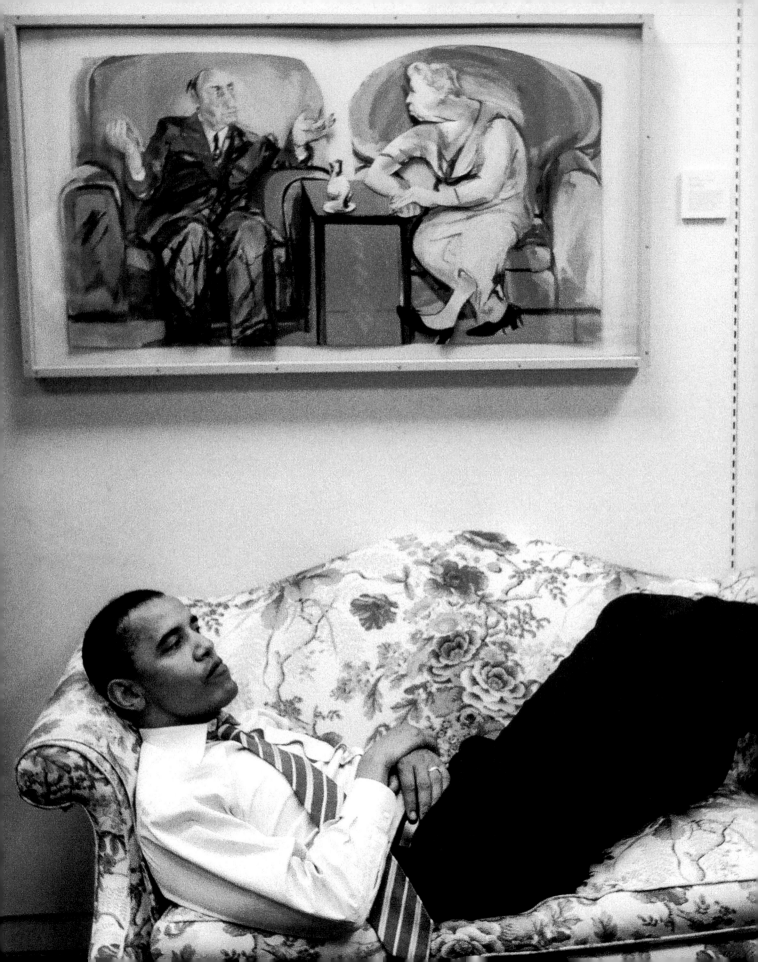

About three months after being sworn in as a senator, our Senate office still had no artwork. It was starting to get a bit depressing, and embarrassing to host constituents, so I volunteered to find some. Senators can borrow paintings from artists of their home state. A docent at the Smithsonian helped me curate work from Illinois, including this one above Obama, of Adlai Stevenson and Eleanor Roosevelt by Illinois State University Art Professor Emeritus Harold Boyd.

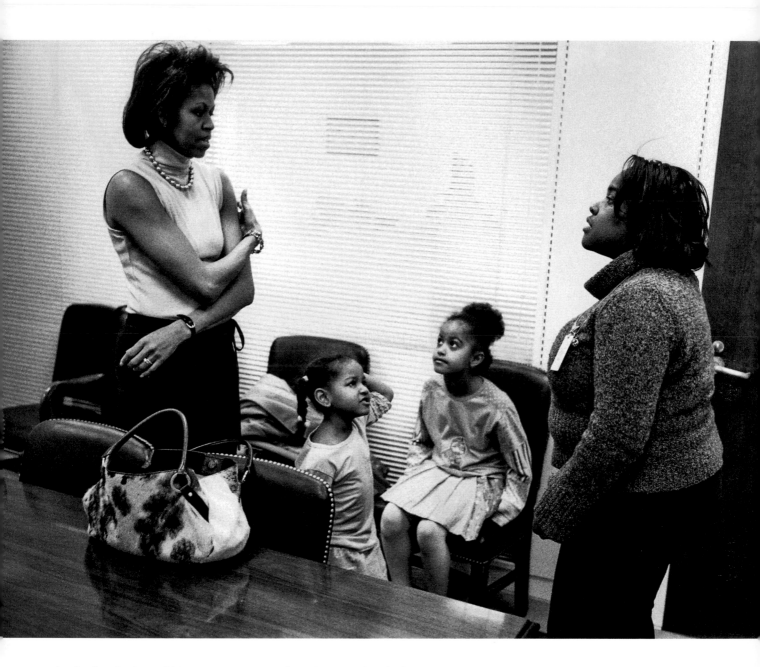

At the beginning of his Senate tenure, the Obamas decided to keep their home in Chicago so that Sasha and Malia could remain in their school there, but Michelle and the girls made trips to DC for special events. One of their first was to attend the Congressional Black Caucus gala. Ashley Tate-Gilmore (pictured above) was Obama's executive assistant at the time, and she arranged for a fun outing for the girls. "Malia really wanted to see the movie *The Incredibles*, and Barack's request to me was to not let them eat too much sugar or they won't go to bed tonight."

MANDELA

I n 2005, I was serving as Senator Obama's personal aide and not as his
photographer, but I always kept my camera nearby, even though it meant
lugging it with me in the car. On May 16, 2005, I was driving Obama to an
event in northwest DC when I got a call from our scheduler, Michael Rob-
ertson. "Nelson Mandela wants to meet the boss. We've canceled his next
meeting. Head straight to the Four Seasons." When we arrived, I grabbed my
camera out of the back seat, but noticed the battery icon flashing. I thought
to myself, *Are you really going to miss this historic moment because your battery
wasn't charged?* We rushed to Mandela's room, where we found the eighty-six-
year-old leader sitting in an armchair with his legs propped up on an ottoman
and with his cane to his side. His wife and a few staffers were huddled around
him. Just as Obama reached down to shake his hand, I saw his silhouette
emerge in the window as light flooded in. I took thirty pictures in ten seconds.
I looked at my camera, saw I had captured the image I wanted, and then the
battery died.

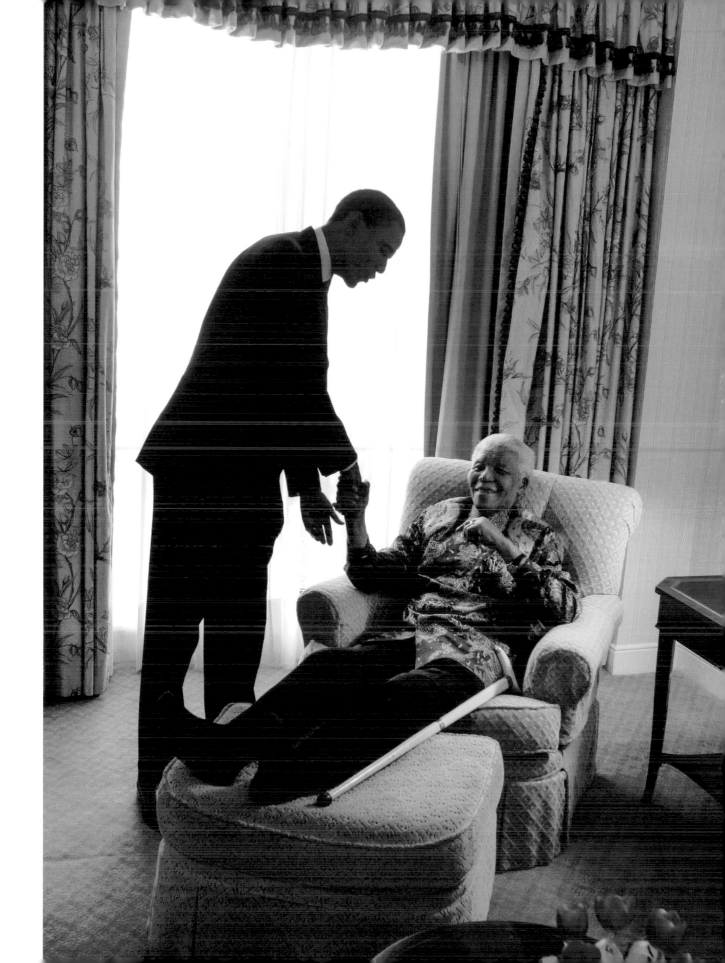

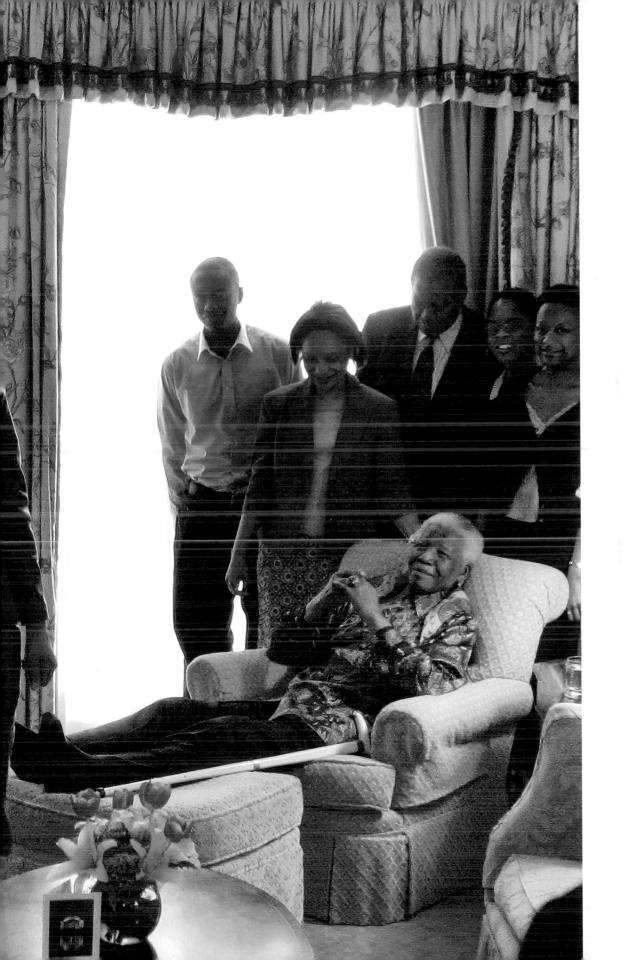

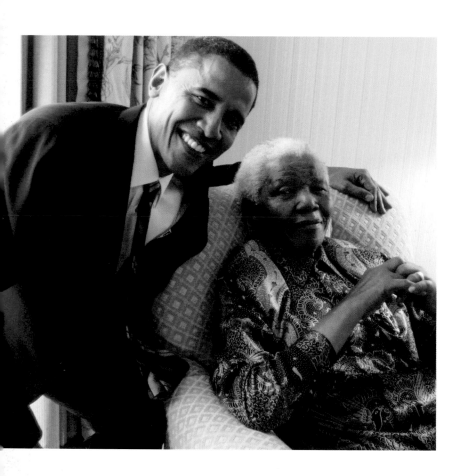
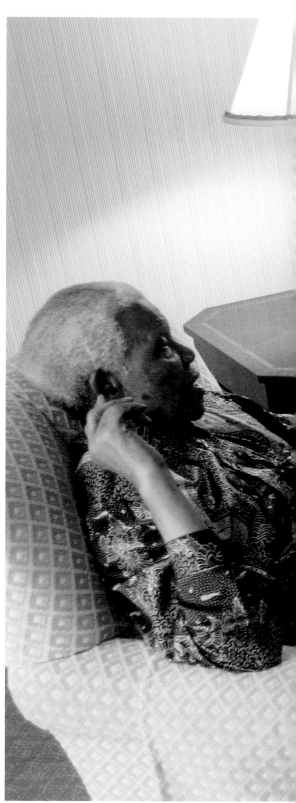

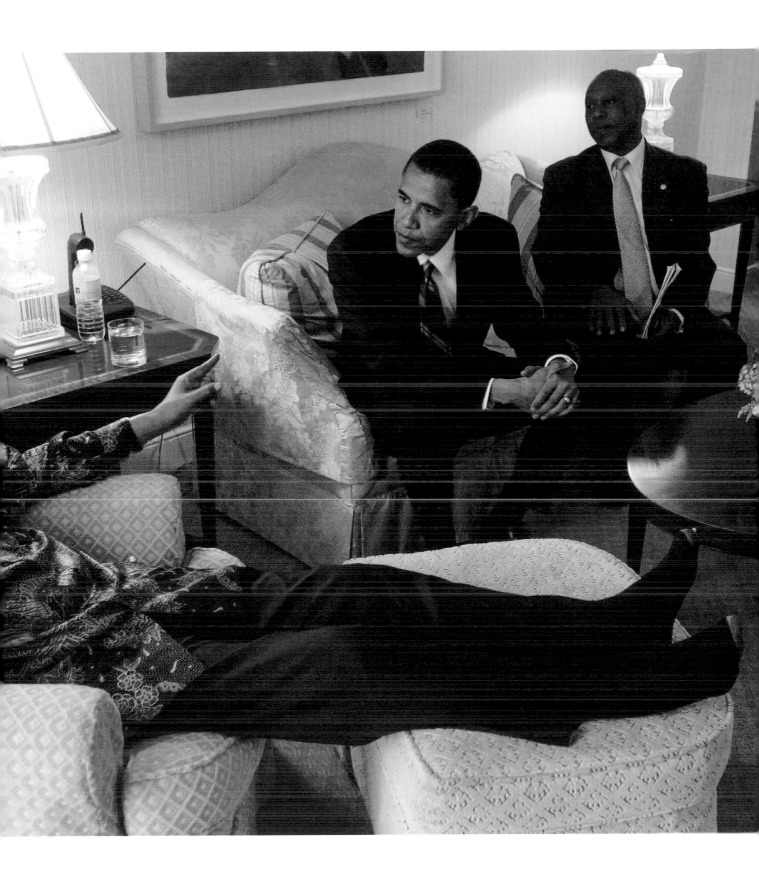

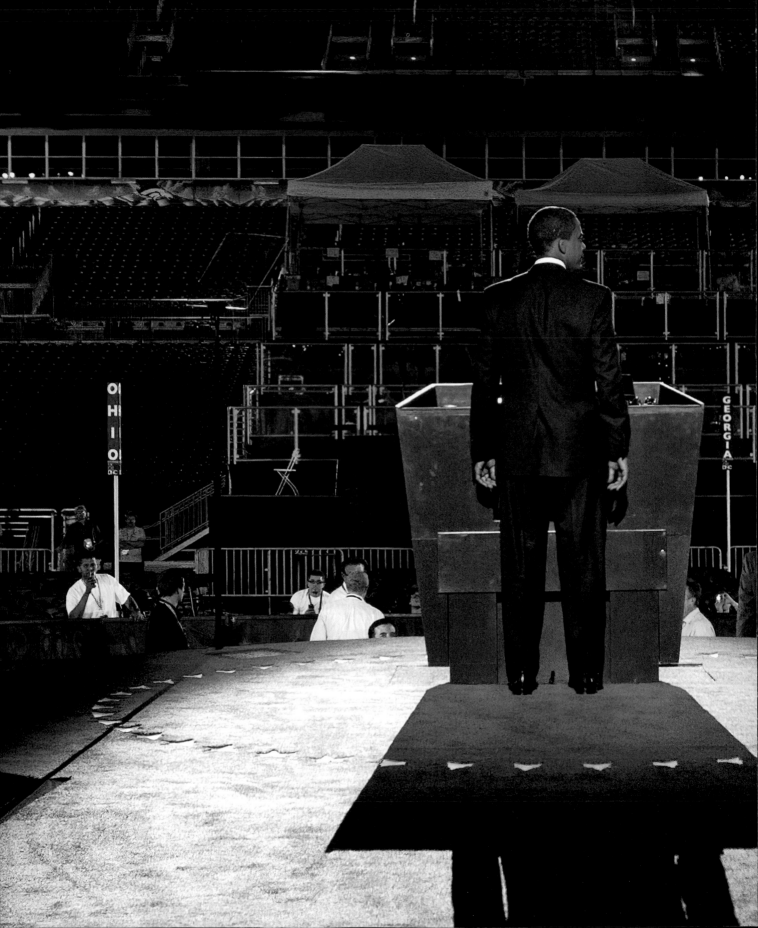

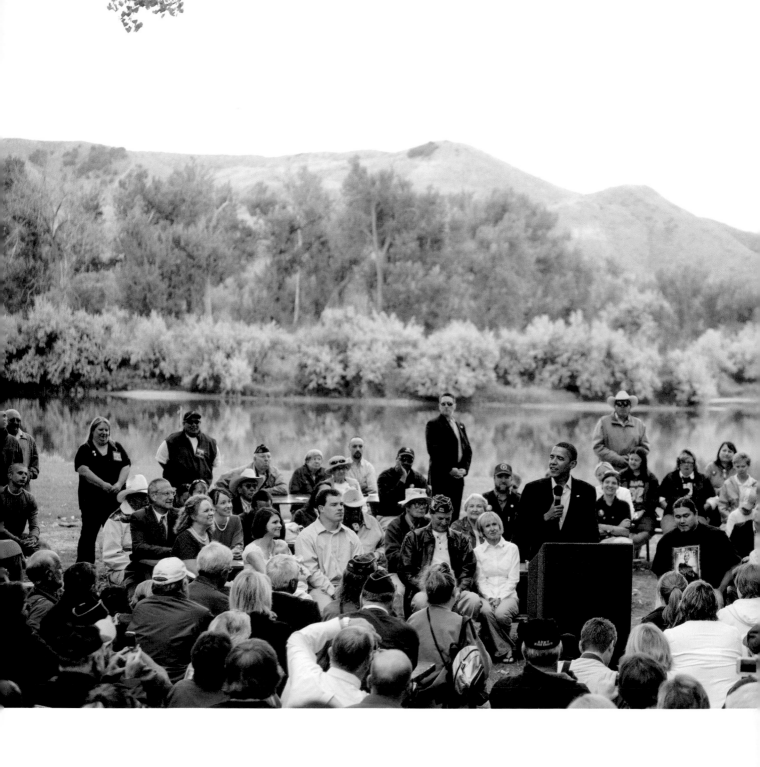

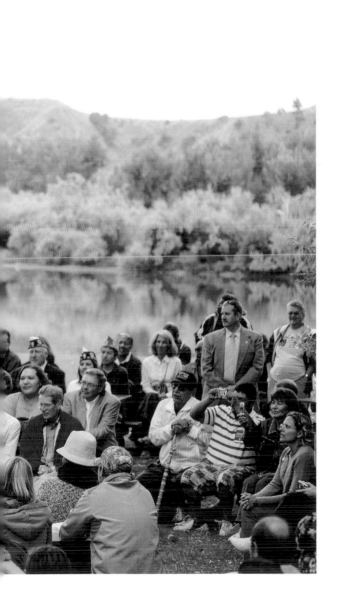

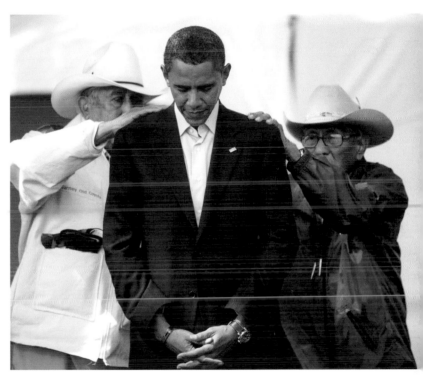

One of the most serene and beautiful moments on the 2008 presidential campaign came at a stop in Billings, Montana. Two elder statesmen from the local Native American tribe blessed Obama. It was such a nice change of pace from campaign rallies that typically started with the catchy country song "Only in America."

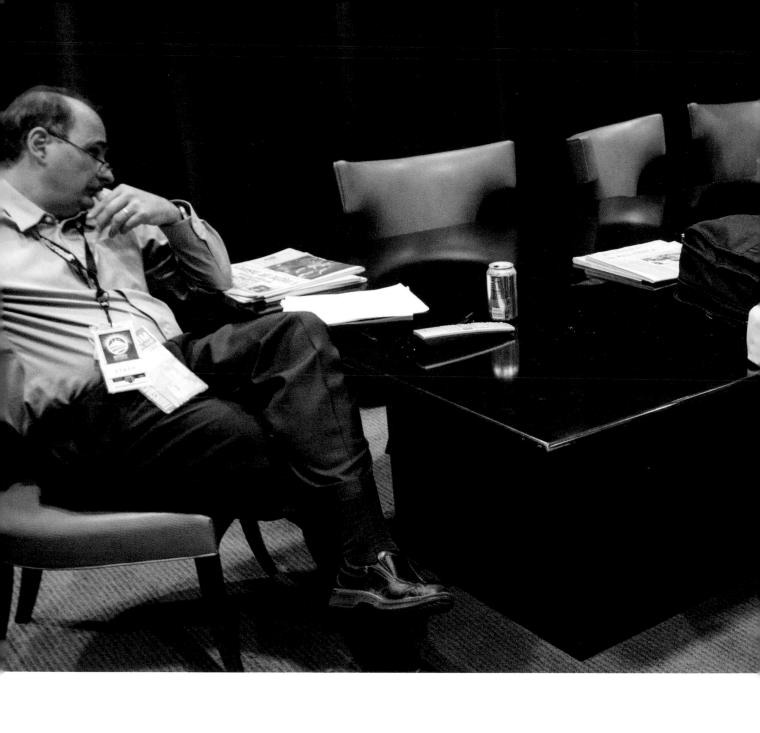

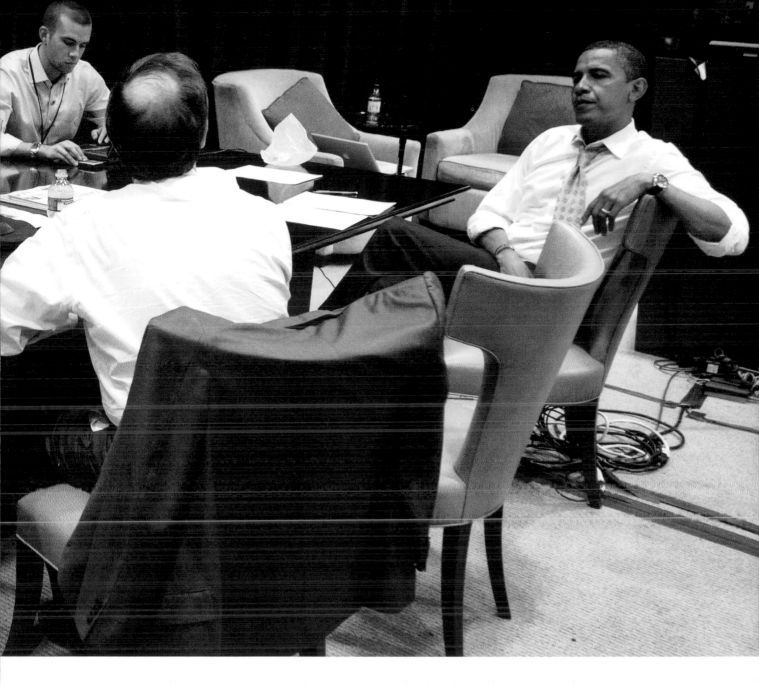

As Obama and his advisers were preparing for his nomination speech at the 2008 DNC, the team wanted to highlight that his speech coincided with the forty-fifth anniversary of Martin Luther King Jr.'s "I Have a Dream" speech. "We wanted to make an allusion to MLK's speech without directly referencing it," said Jon Favreau. "When Obama read the line 'And it is that promise that 45 years ago today brought Americans from every corner of this land to stand together on a mall in Washington, before Lincoln's Memorial, and hear a young preacher from Georgia speak of his dream,' he choked up, went to the bathroom to compose himself. When he returned, he told us that it finally hit him that he was going to be the first African American nominee of the party."

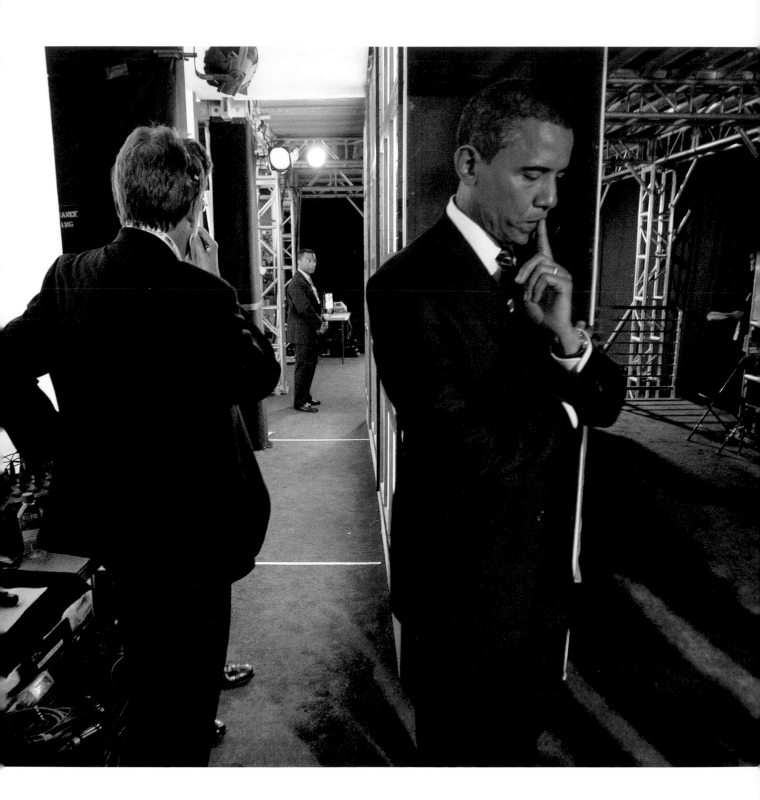

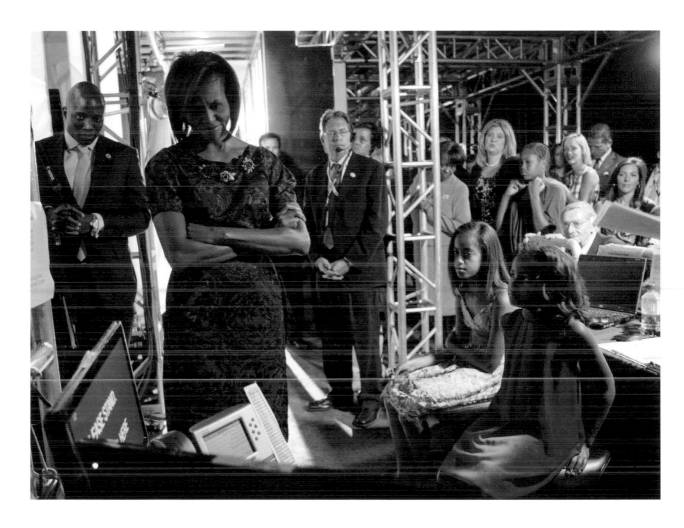

◀ Obama gathers his thoughts moments before delivering his nomination speech at the Democratic National Convention in Denver, August 2008.

▲ Michelle and family watch backstage as Obama delivers his nomination speech.

▼ We were in Beaver, Pennsylvania, at a rally, and I saw a girl inching her way up to meet Obama and could tell how excited she was to be near the front. I had a feeling she would have a great reaction after meeting him, so I positioned myself behind her and luckily caught the right moment.

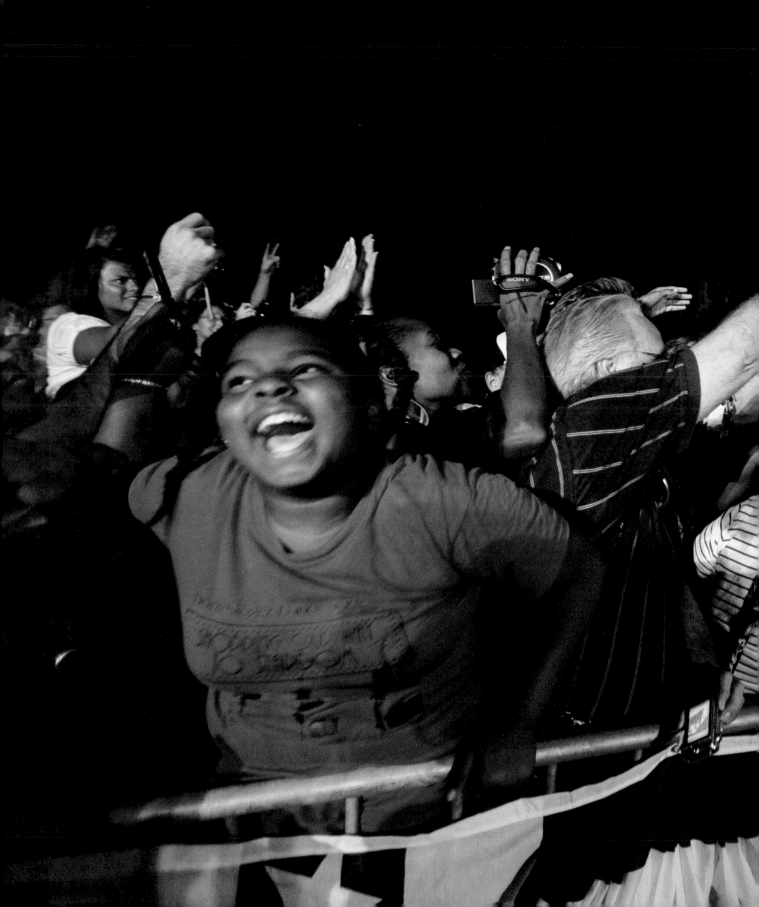

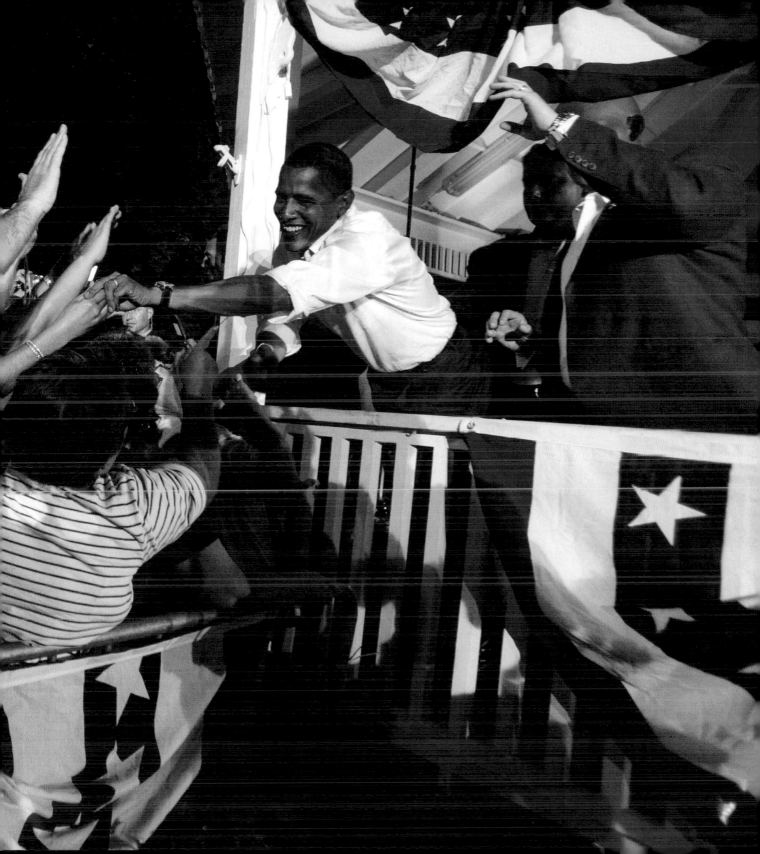

Obama reaches out to shake hands with enthusiastic supporters at a rally at the Dublin Coffman High School football stadium in suburban Columbus, Ohio. This was particularly memorable for me because it was the first time I had met Joe Biden. We were in the locker room of the stadium waiting before the event when Barack introduced us. He said to Biden, "David is a University of Michigan grad and it really pains him to be this close to Ohio State."

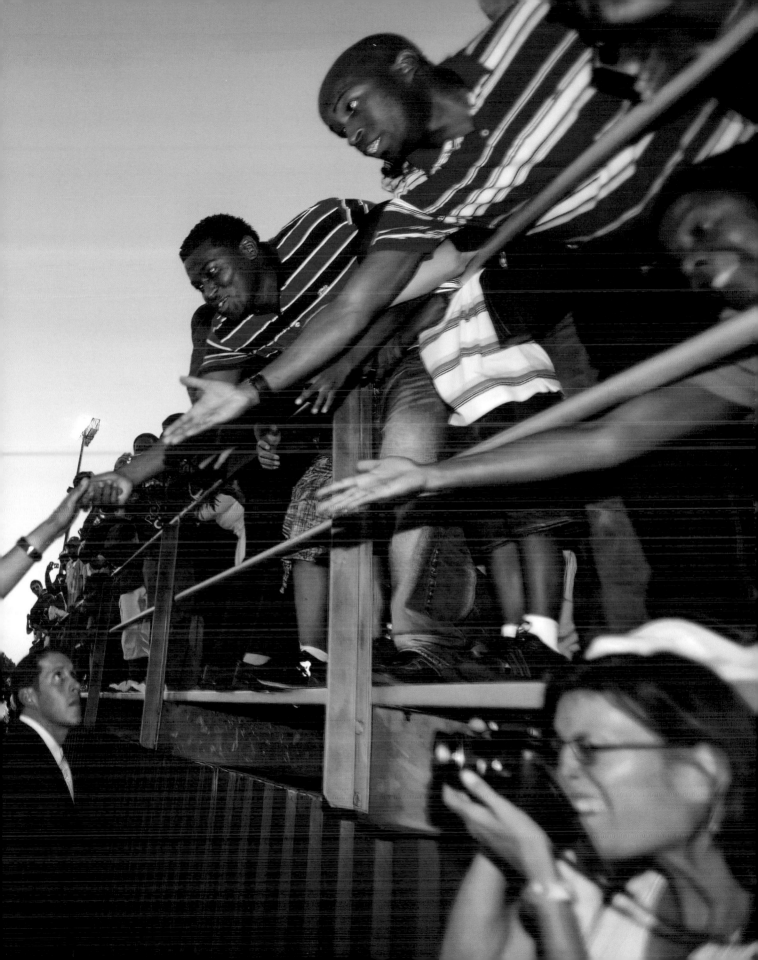

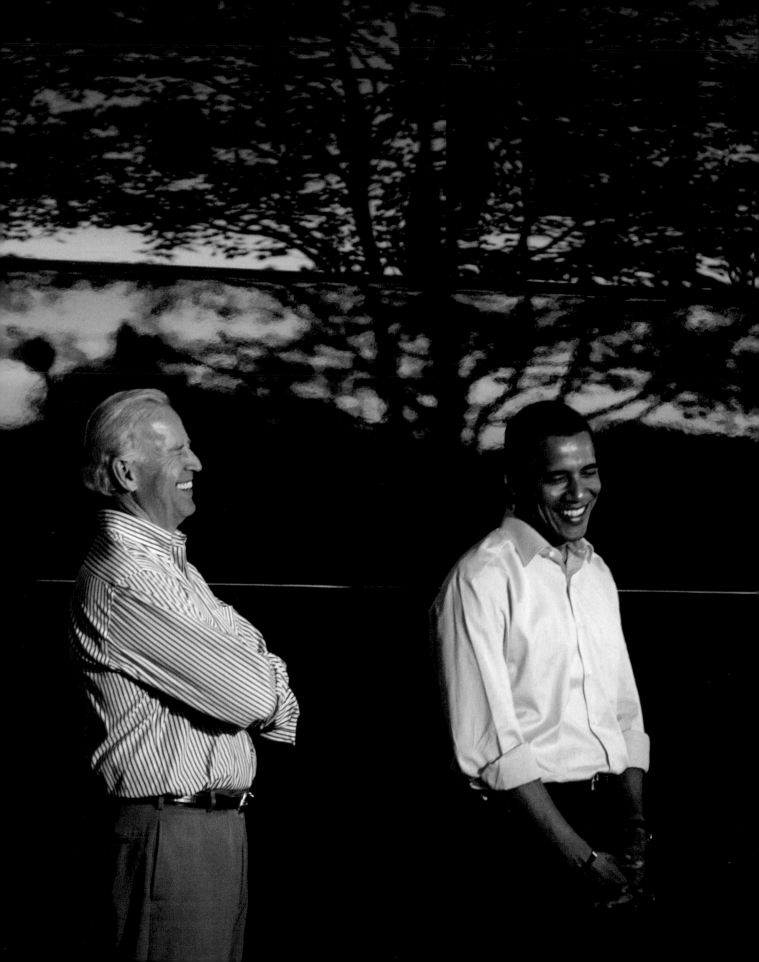

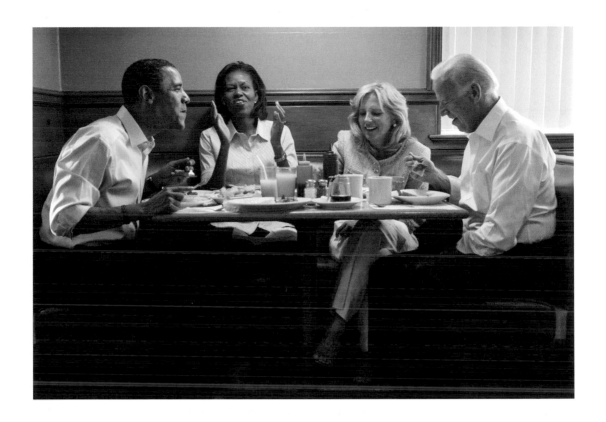

THE OBAMAS AND THE BIDENS

Elected to the Senate at twenty-nine, Joe Biden never really had a boss until he became Barack Obama's vice president. They had similar policy perspectives and visions for the country, but it was actually their families that brought them closer personally. "Hunter's and Beau's children went to Sidwell Friends School with Malia and Sasha, and they played basketball and volleyball together. The Obamas and Bidens really developed their friendship through their kids and grandkids," observed Kenny Thompson, a lead Obama advance staffer on the 2008 campaign and Biden staffer during his second term in office. Biden has a very distinct speech preparation style that is more similar to Obama's than people might think, according to Thompson. "The VP prepares at length for every speech he gives. He could be giving a fifteen-minute address to the Rotary Club that he's given many times and he'll still edit and practice that speech at length. Biden also wants to personalize everything. When he's signing books, he'll ask detailed questions about who the book is for, where they are from, and anything else he can add to the inscription."

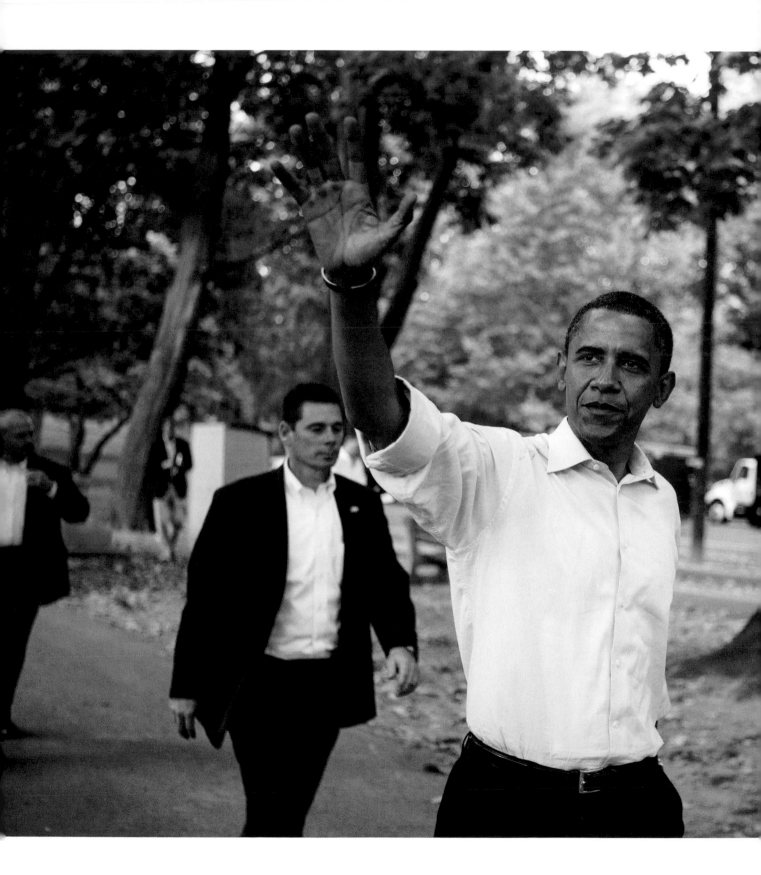

◄▼ Obama beat John McCain by about 10 percent in Pennsylvania in 2008. We spent quite a bit of time campaigning there, including at parks in Lancaster, Pennsylvania, and the Avenue Restaurant in Wyoming, Pennsylvania.

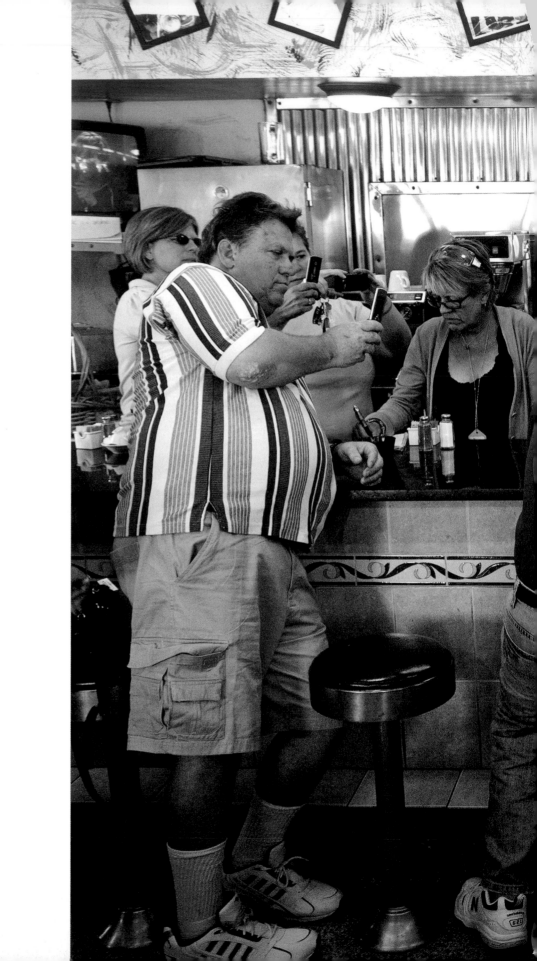

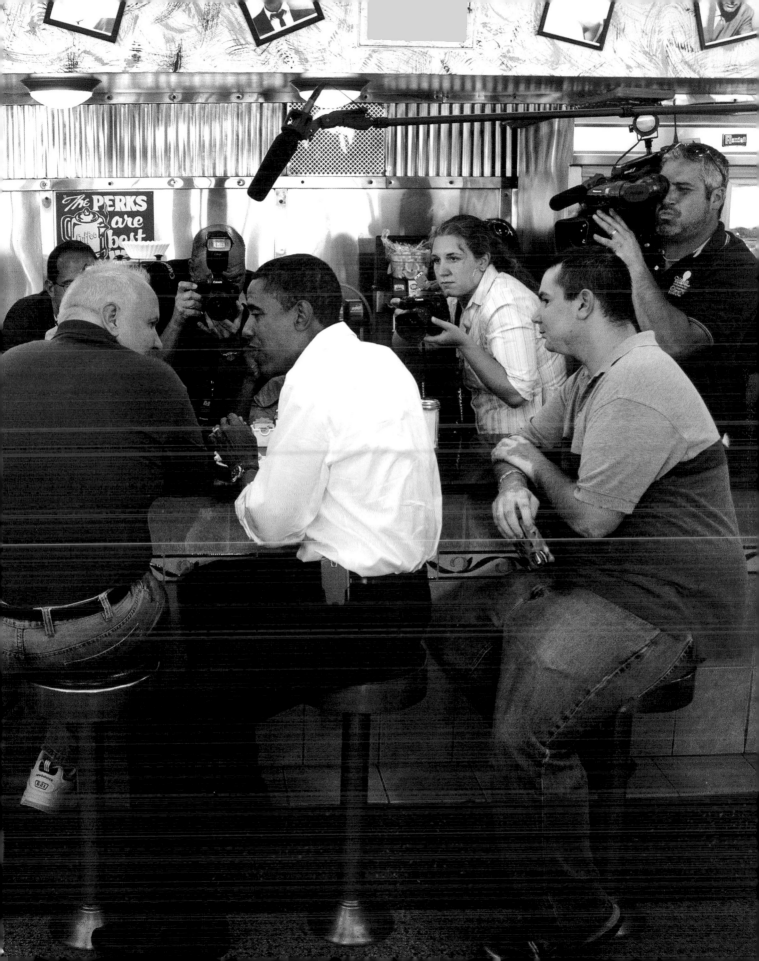

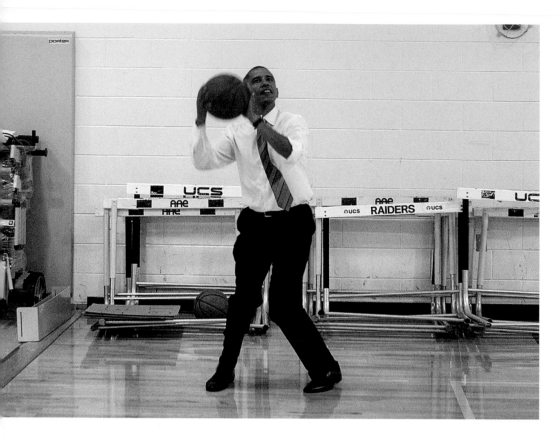

KILLING TIME

Presidential campaign rallies were often held at high schools and colleges, and the hold areas (where Obama waited before speeches) were usually in locker rooms. Marvin Nicholson (far right) was President Obama's travel director. He was a former Augusta National caddy, a windsurfing instructor, an aide to Senator Kerry, a confidant of Obama, and an overall nice guy. He made sure the trains ran on time. He also made sure a rack of basketballs was always available at Obama's rallies in case he wanted to slip out of the locker room and take a few shots. Once, after a well-attended rally at Nashua High School in New Hampshire, the traffic backed up as people tried to exit. With only a single-lane road out, it was going to be a while before Obama could go anywhere, so he and the staff played a pickup game until the traffic subsided.

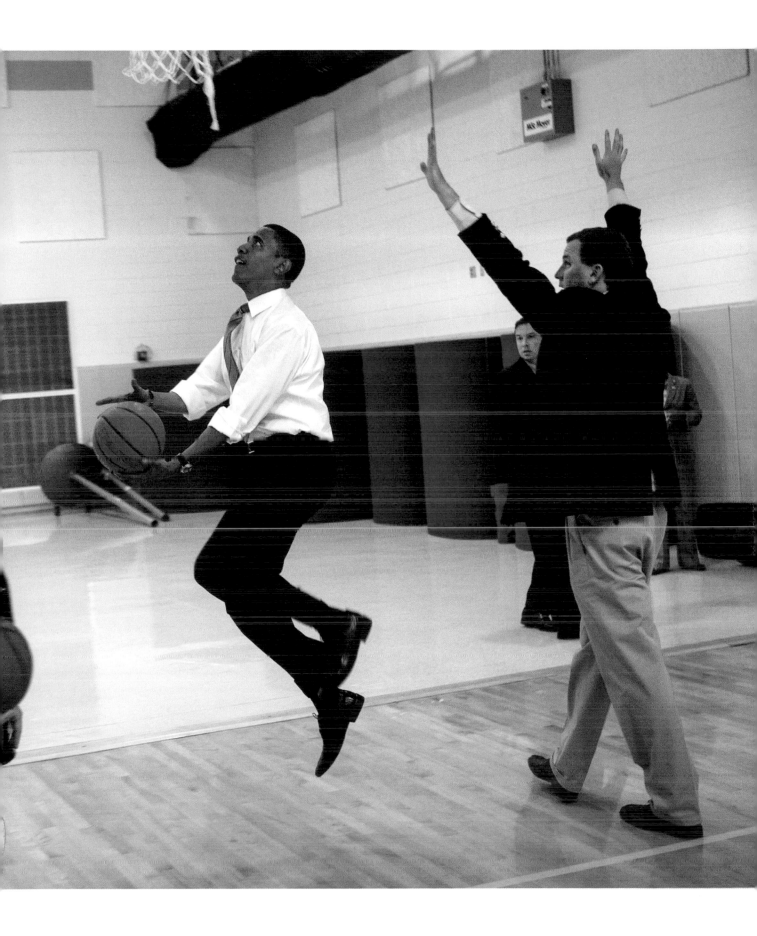

Obama shows Leonardo DiCaprio and
Usher something funny on his BlackBerry.
The group is joined by Joe Biden;
Tobey Maguire; and Maguire's then wife,
Jennifer Meyer. Obama and McCain
were participating in a presidential
forum at Columbia University hosted by
Service Nation, a nonprofit coalition that
promotes volunteerism.

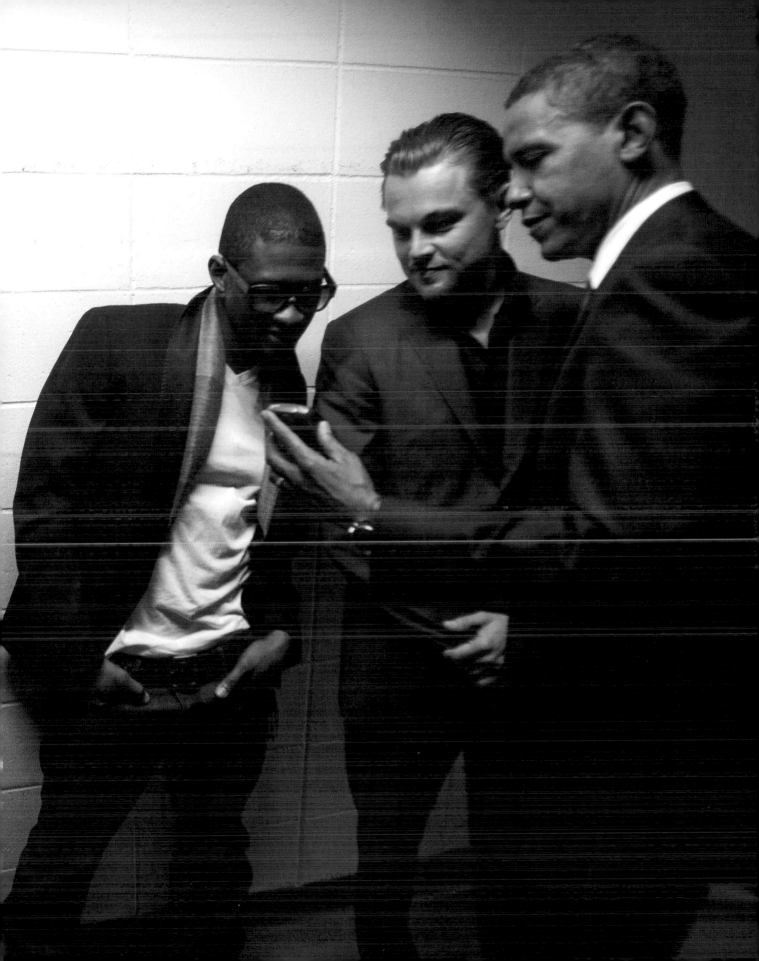

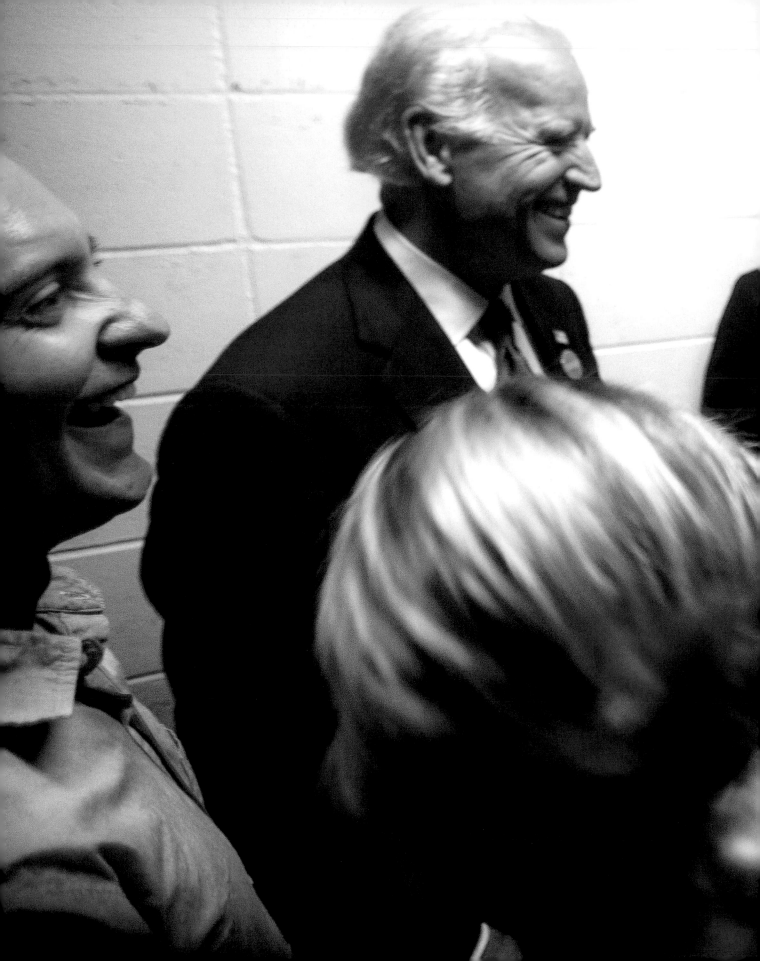

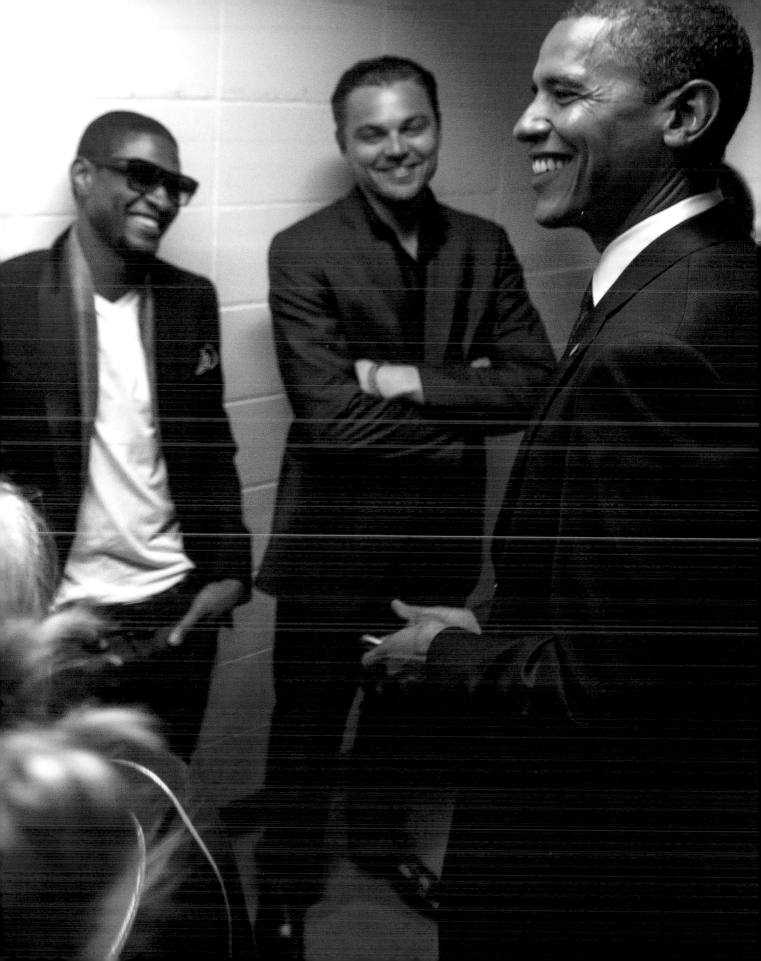

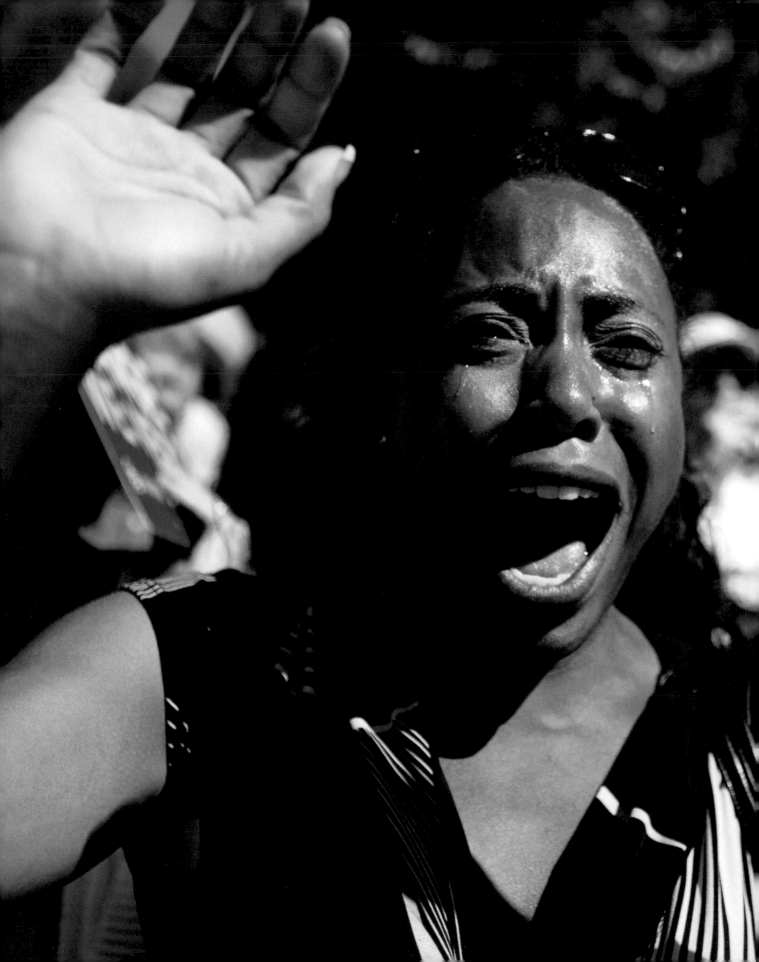

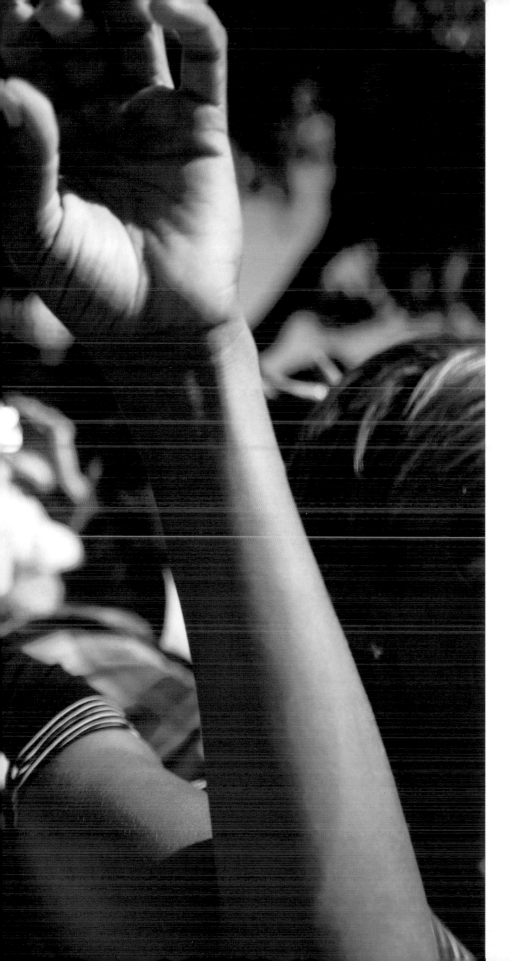

Though Obama touched millions of people, for many African Americans his rise stirred up powerful emotional reactions at every campaign event I attended, including for this woman at a rally in Grand Junction, Colorado.

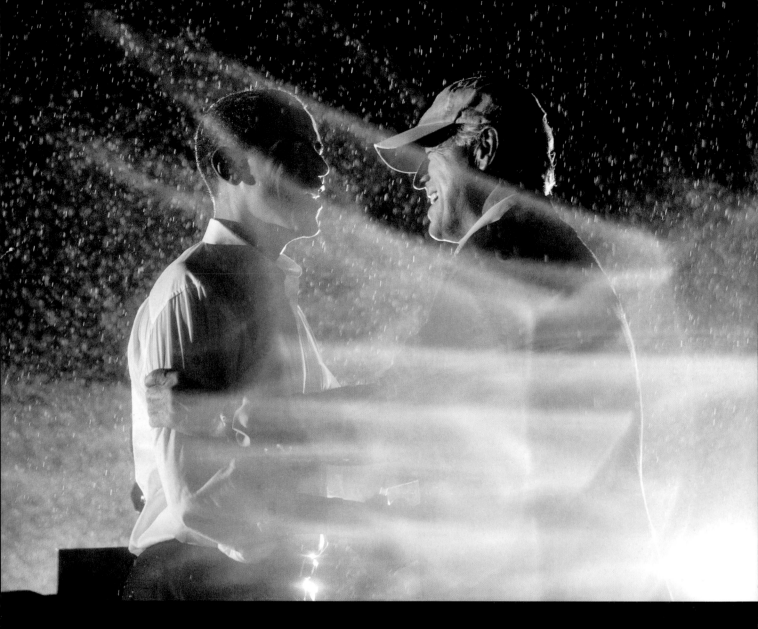

On a warm fall evening in Fredericksburg, Virginia, just as Biden was introducing Obama to the crowd, the skies opened up. It rained harder and harder throughout Obama's speech, but the crowd cheered louder and louder. After the event, Obama, who was soaked, ran through the rope line quickly to get out of the rain. When he got inside, he asked, "Where's Joe?" Biden was still outside greeting supporters in the downpour and enjoying every minute of it.

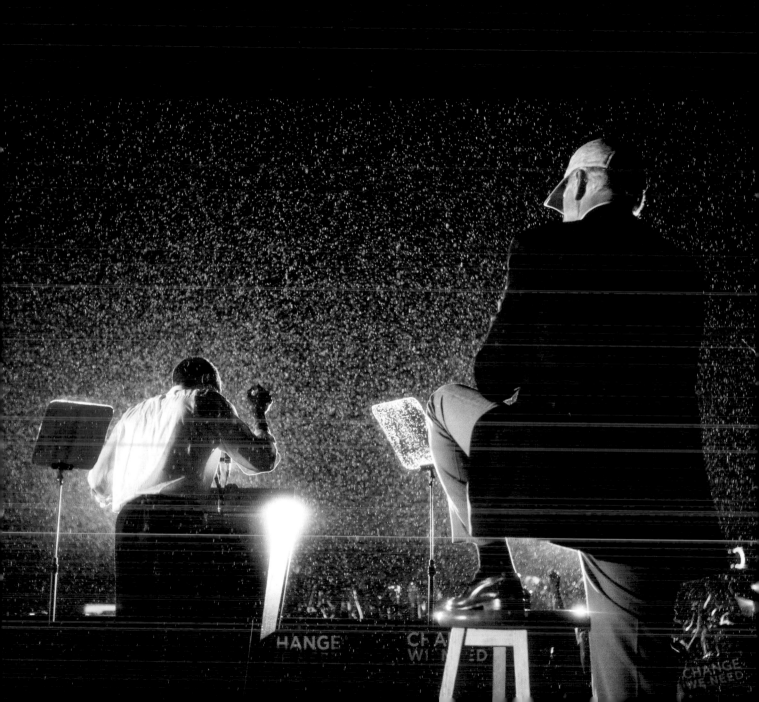

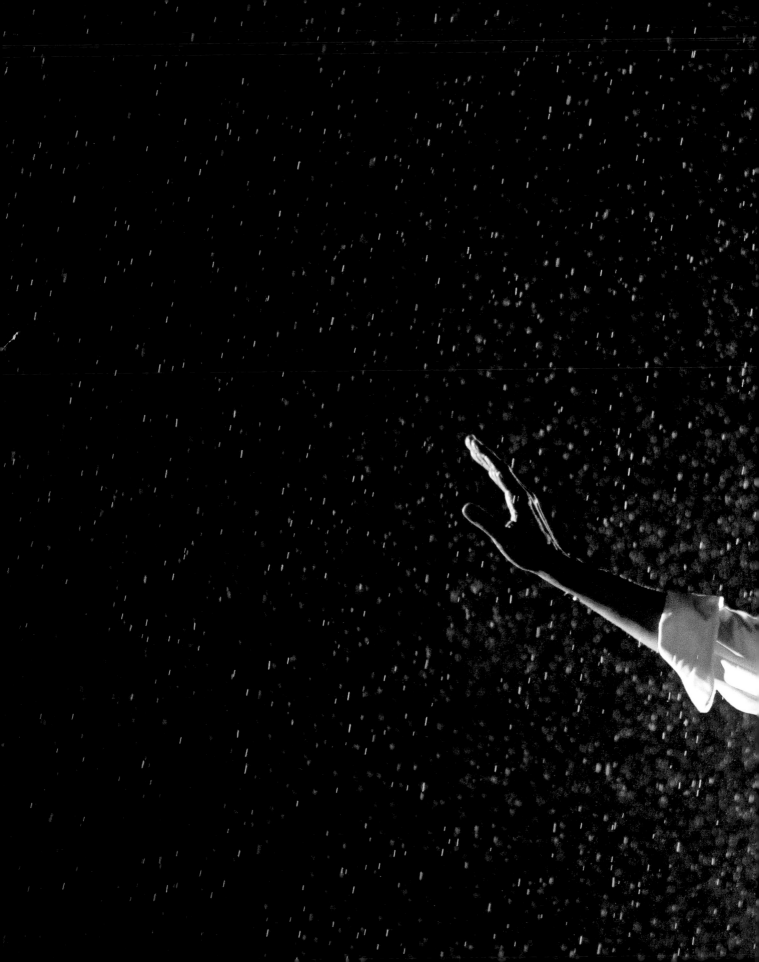

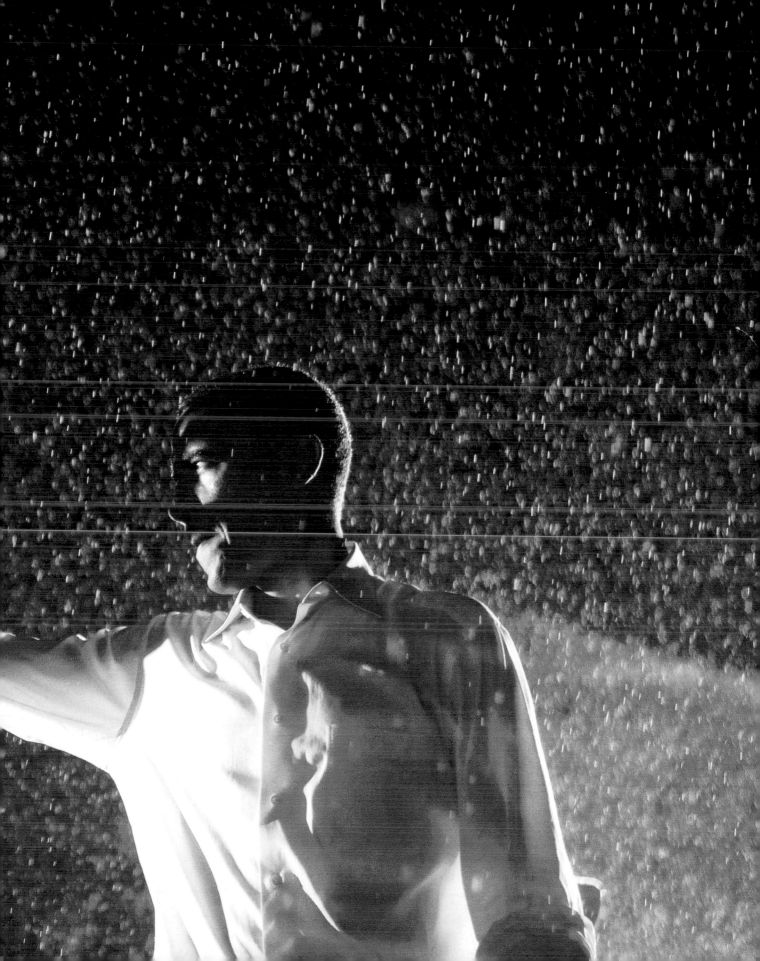

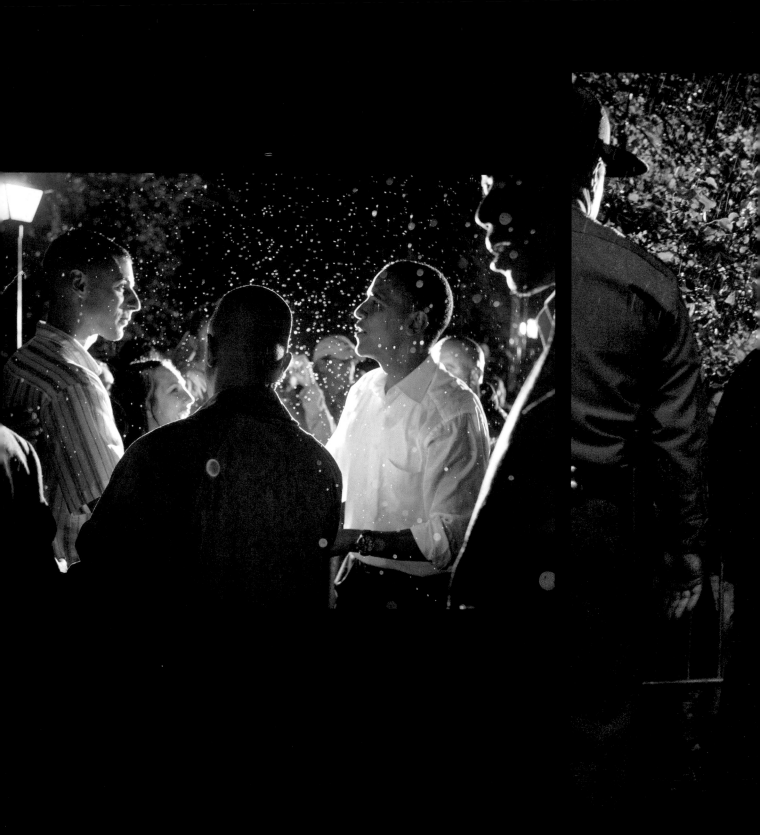

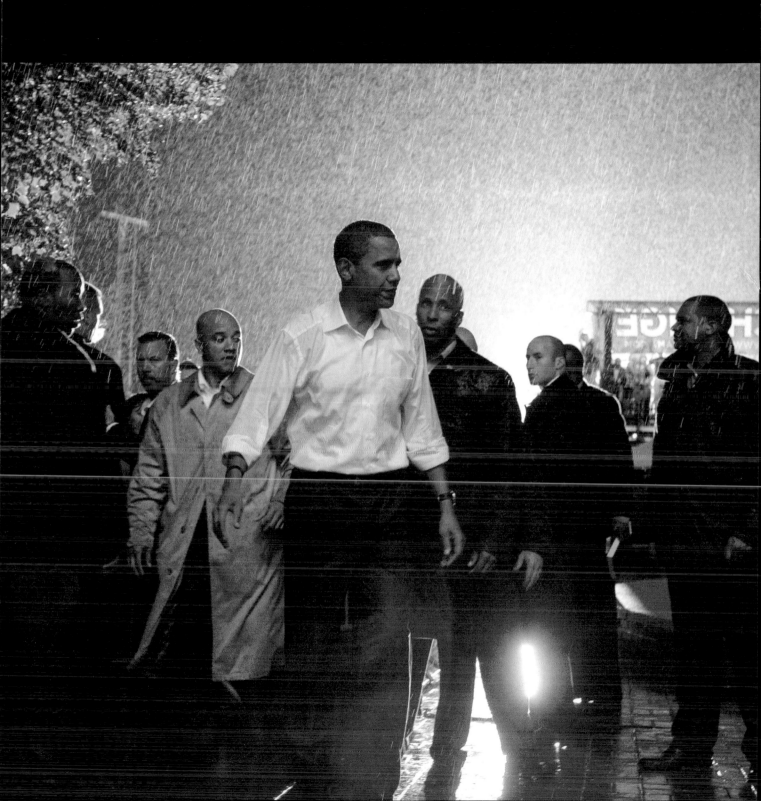

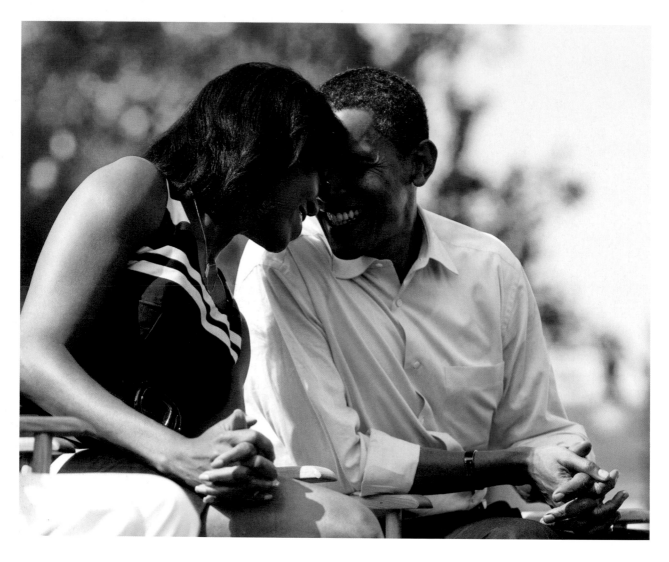

▲ ► The Obamas attended a rally at the Detroit Public Library where tens of thousands of people came to hear Obama and Biden speak, five weeks before the general election. Obama told the Michigan crowd, "Nothing could be more important than us helping our auto companies retool and get the laws they need so that the fuel-efficient cars of the future are built right here in Detroit, right here in Michigan. Not in Japan, not in South Korea, but right here in the United States of America."

▼ On September 29, 2008, the House of Representatives rejected the government's $700 billion Troubled Asset Relief Program (TARP), which eventually passed four days later. Obama was in Westminster, Colorado, about to lead a campaign rally, when he learned about the vote. Robert Gibbs, the communications director, delayed the preprogram of the rally so Obama could consult with his economic advisers to get a deeper understanding of the matter.

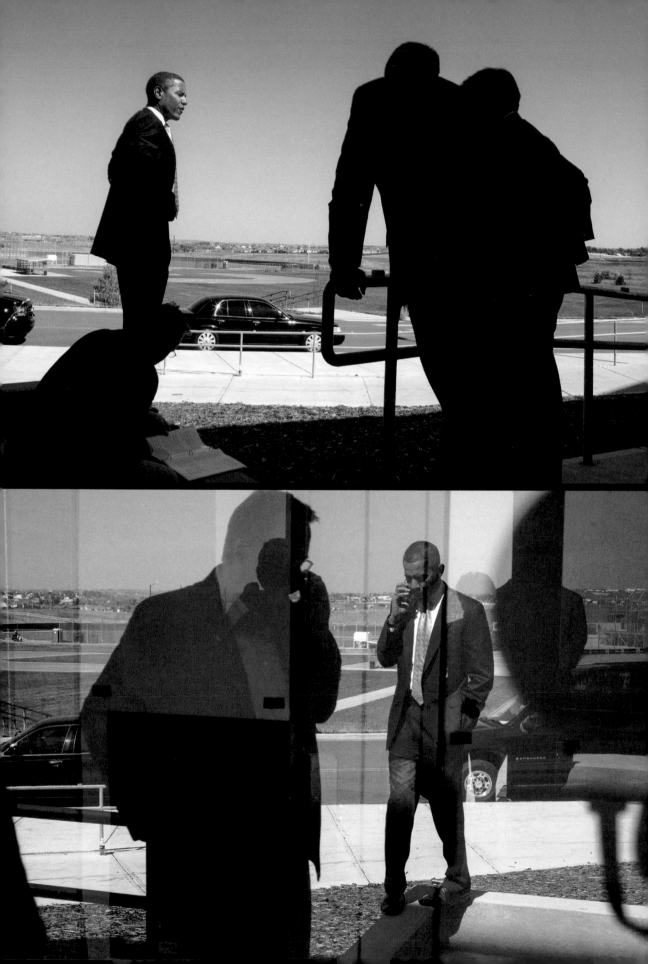

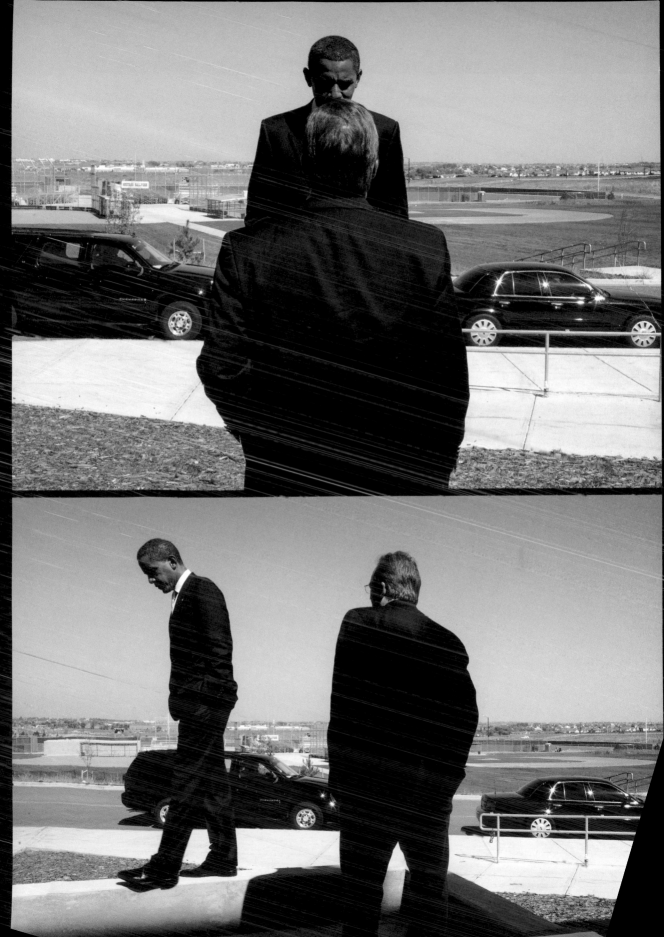

THE PERSONAL AIDE

The personal aide (or body man) is a great role for someone with a lot of energy and a good attitude. I did it for Obama while he was a US senator and loved every minute of it. In 2008, Reggie Love was Obama's body man. Part of the job is to make sure the candidate is always well fed and hydrated. For Reggie Love, this meant finding whatever food you could at events or during the brief intervals between events. It might be a corn dog in Iowa or tacos in Texas, but Obama was always health conscious, so his default meal was usually salmon, brown rice, and broccoli. He didn't have much of a sweet tooth—with the exception of berry pies—and he had amazing willpower, resisting most of the unhealthy foods that are omnipresent on the campaign trail.

His one indulgence was taquitos. Love recalls one time in LA: "We had a packed schedule, a meeting with ministers and then Latino leaders, who gave us these incredible taquitos. The boss told me to save them for later. We then went to two fundraisers and flew on to Seattle. I thought for sure he had forgotten about those taquitos. But, no, he asked for them the minute we got on the plane, and I had thrown them away. This was maybe the only time I saw Obama get the least bit mad. When we landed, I found the best taquitos in Seattle, and when he asked what was for dinner, I said salmon and broccoli. His face sank, and then I opened the box and we both burst into laughter."

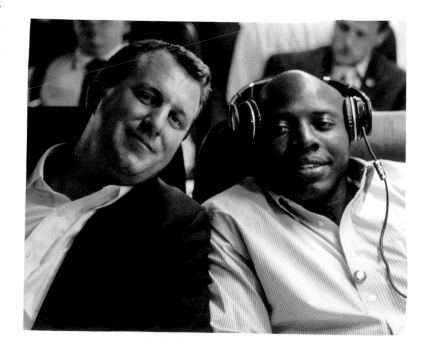

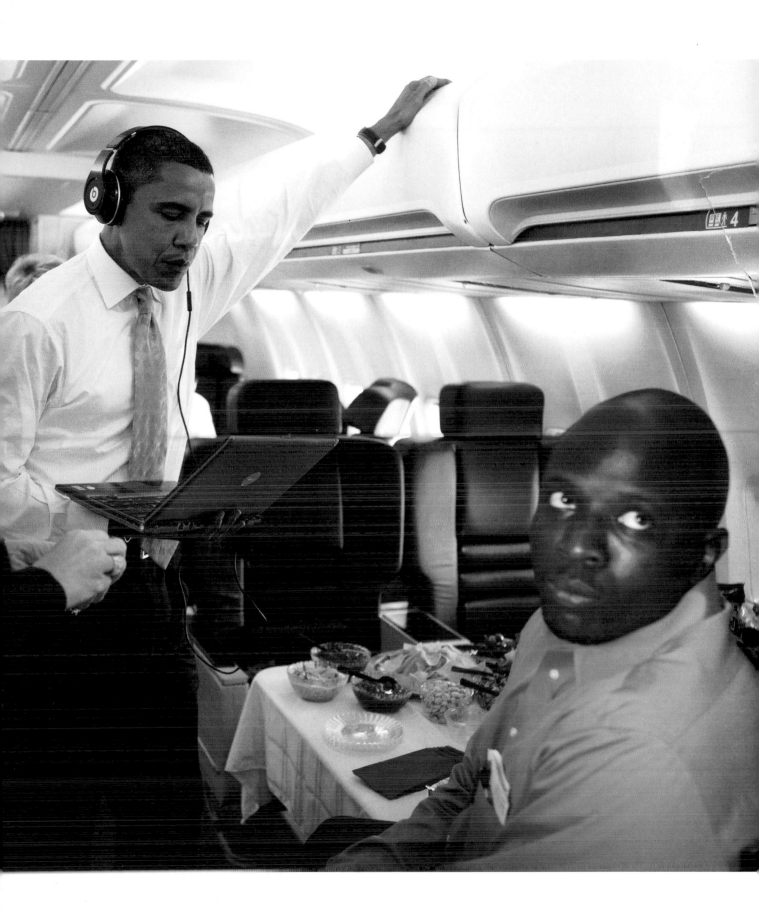

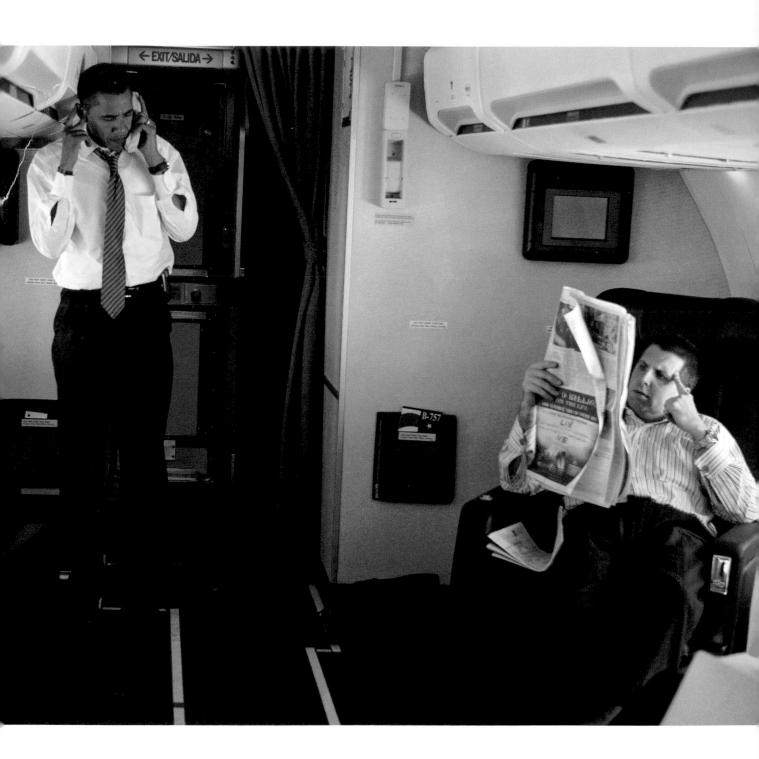

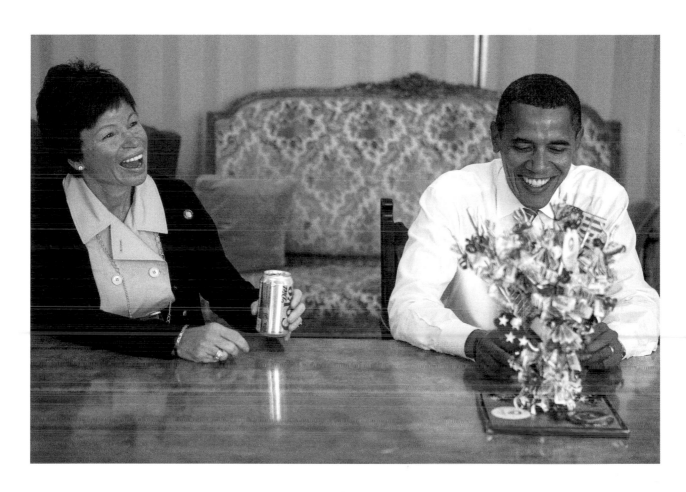

Aboard the campaign plane in 2008, Obama with
Mark Lippert, senior foreign policy adviser (left); and
backstage prior to a rally in Reno, Nevada, with Valerie
Jarrett, his longtime friend and adviser (above). "The
most amazing thing about the Obamas is that no
matter how busy they got, they always had time for
friends," said Jarrett. "Whenever I speak to them, they
always say, 'And how are you?' With the pressure they
were under they could have gotten a complete pass."

The Secret Service has
some of the most selfless
people you will encounter
on the campaign trail. One
of the most senior agents
told me that the young
guys always want to be
stoic and intimidating,
but it is actually the nicer,
engaging ones who are
the best agents because
they're better at getting
information from people.

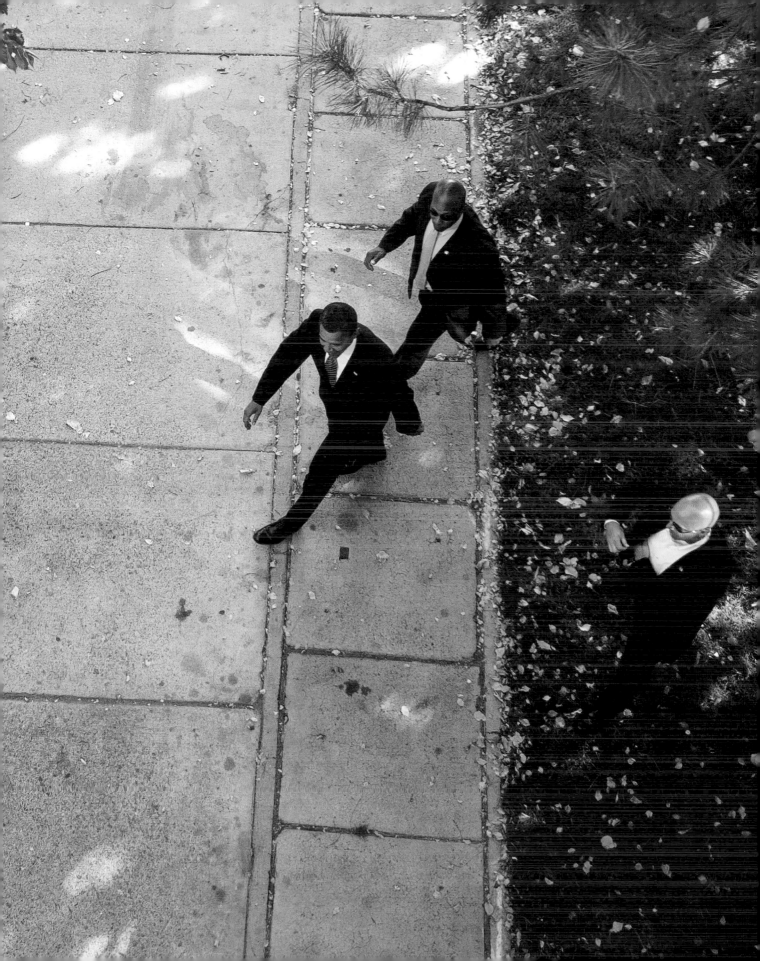

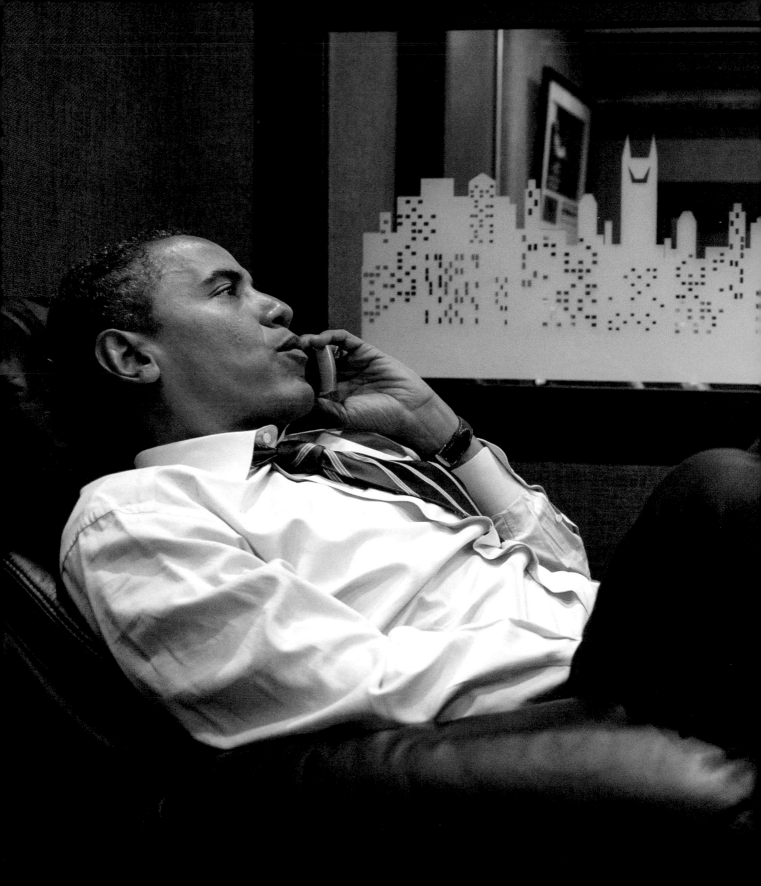

We had arrived uncharacteristically early for a rally at Michigan State University on October 2, 2008, and the vote on the TARP bill was happening the next day. Obama was the de facto leader of the Democratic Party, so the congressional leadership was leaning on him to whip votes in support of the bill, which is what he was doing in this photo on the campaign bus.

Michelle Obama has written at length about how challenging it was balancing her and Barack's careers while still doing a good job raising their young children. Those challenges only became more complex as Barack's national profile skyrocketed after the 2004 DNC speech. Valerie Jarrett recalls having lunch in their Hyde Park neighborhood in Chicago shortly after that. "When we exited the restaurant, there were hundreds of people outside waving and cheering. These are people who have known the Obamas for years and they were just so happy for him. Later that summer while we were vacationing in Martha's Vineyard, someone took a photo of Barack with his shirt off while he was out for a morning jog . . . and that's when I knew life would never be the same. It struck both Michelle and me that he was now so recognizable that someone would want to take his picture."

During Barack's rise, Michelle was also balancing her career. Susan Sher eventually became Michelle Obama's chief of staff in the White House, but they first met in 1991 when Susan interviewed Michelle for a role in the corporation counsel's office of Mayor Daley's administration in Chicago. "Michelle was thinking about leaving her job at Sidley Austin and I really wanted to hire her to be a lawyer on my team, but she said she wanted to do public service, just not as a lawyer. She felt lawyers approach the world with too narrow a perspective." A few years later they did work together, at the University of Chicago, and Susan recalled the challenges Michelle faced in balancing the campaign trail, her own work, and attending to their kids. "Michelle had just spoken at a fundraiser in New York City for Barack and we were waiting at LaGuardia for the last flight back to Chicago. It was very delayed. Malia called her and really needed her help with a science assignment. Michelle was talking her through it and we all were weighing in." Susan said what she admired most in Michelle was her ability to put herself in other people's shoes. "She is so grounded from her mother. She can relate to people regardless of their station, whether that's a CEO or a homeless person. She's absolutely extraordinary at that."

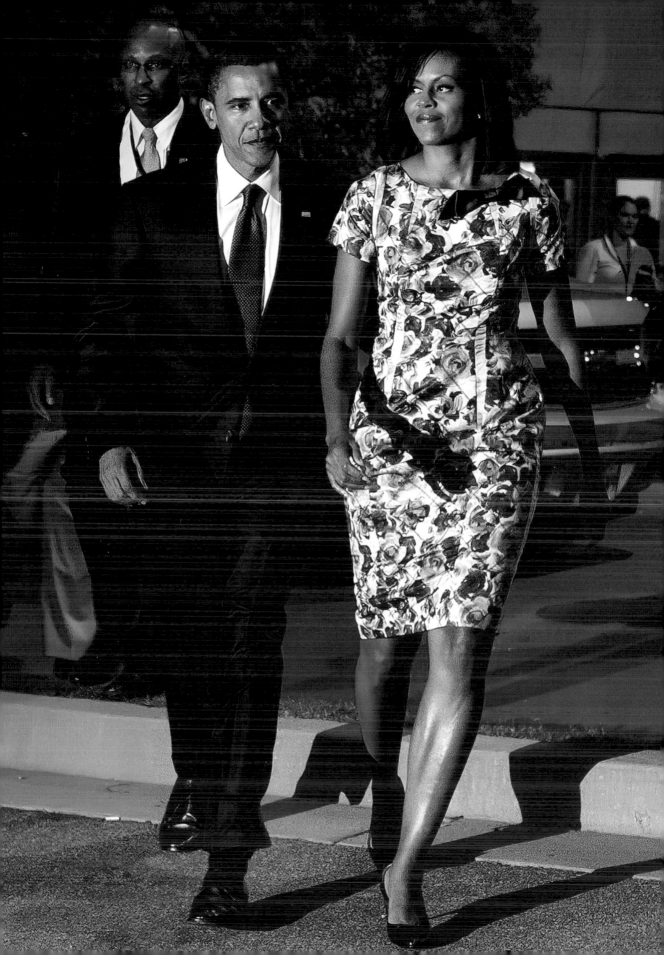

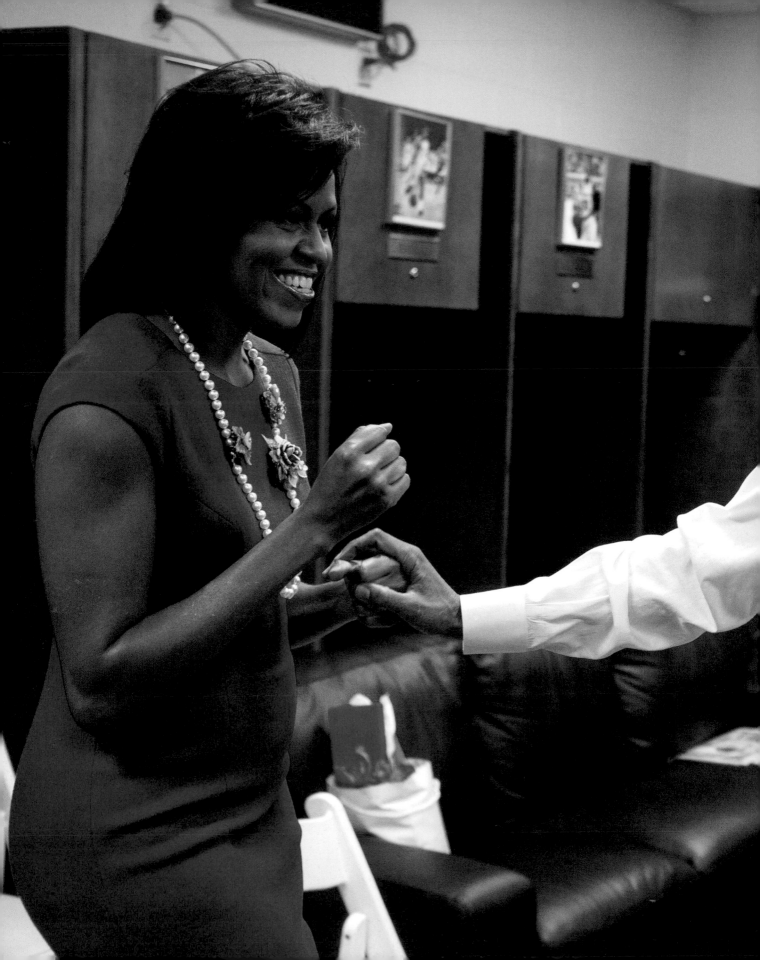

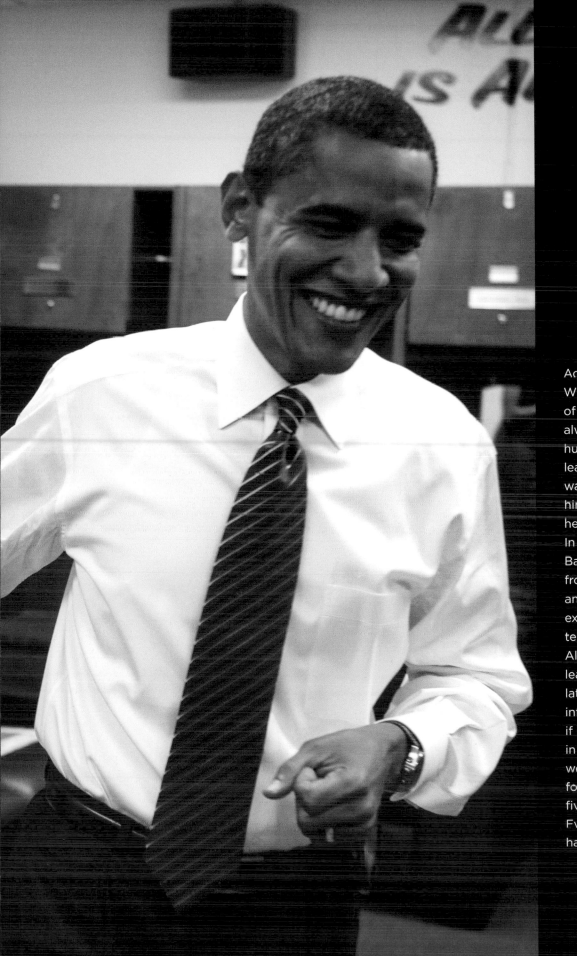

According to Melissa Winter, Michelle's chief of staff, "Michelle would always joke with her husband in the minutes leading up to debates. It was her way of helping him relax. It was also her way of relaxing."

In 2004, I was driving Barack back to Chicago from downstate Illinois, and we were running extremely late to a televised debate against Alan Keyes. I later learned that we were so late that the producer informed Michelle that if Barack did not arrive in thirty seconds, she would have to stand in for him. We arrived with five seconds to spare. Ever since then, Michelle has disdained debates.

231

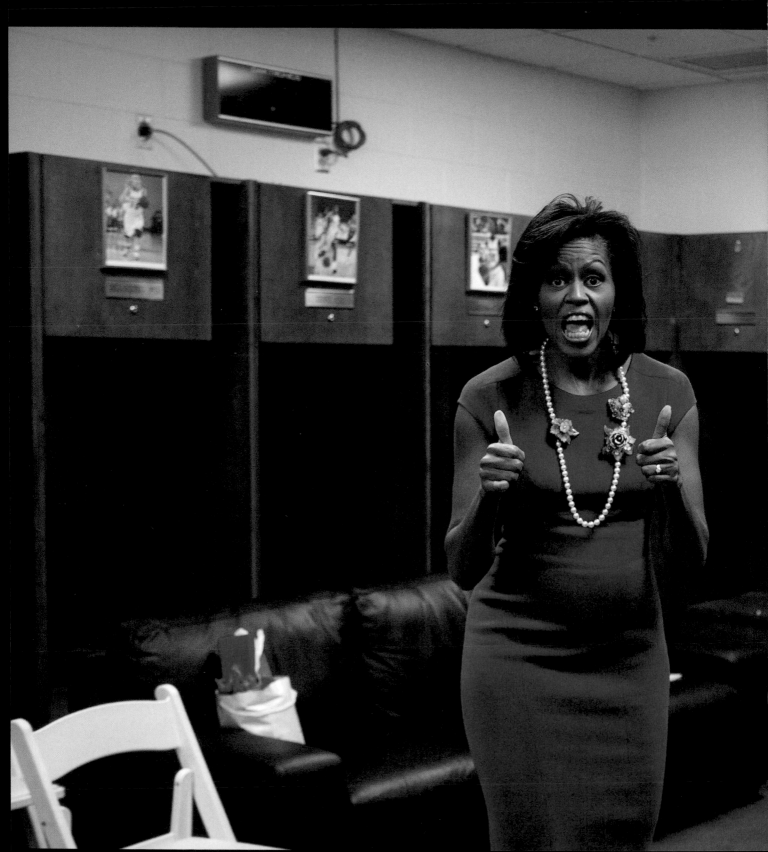

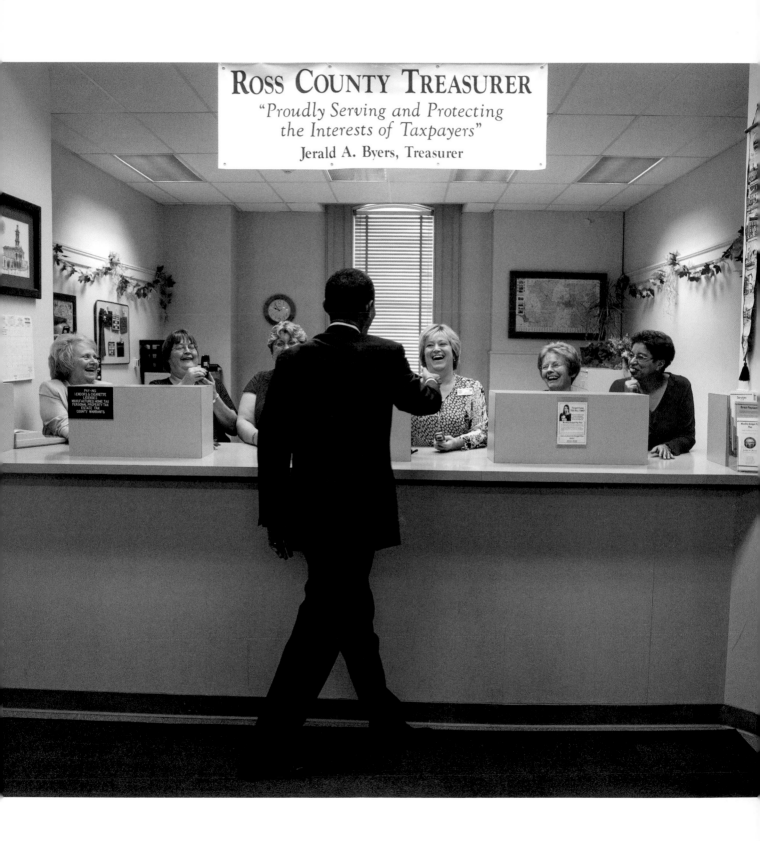

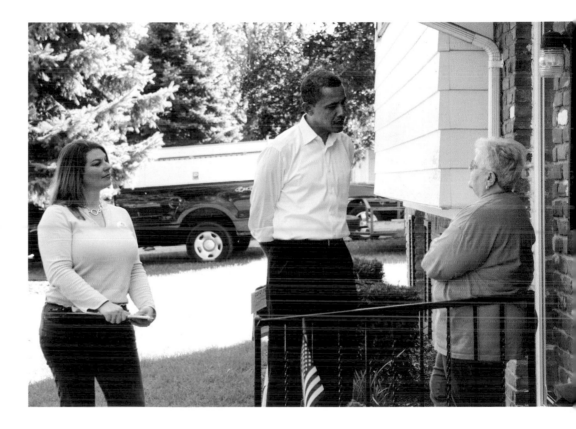

Obama ended up winning Ohio by 4.6 percent
in the 2008 election. In mid-October, we made
a number of campaign stops there, including
to Chillicothe, home of the Ross County
Treasurer's Office, and to this home in Toledo.

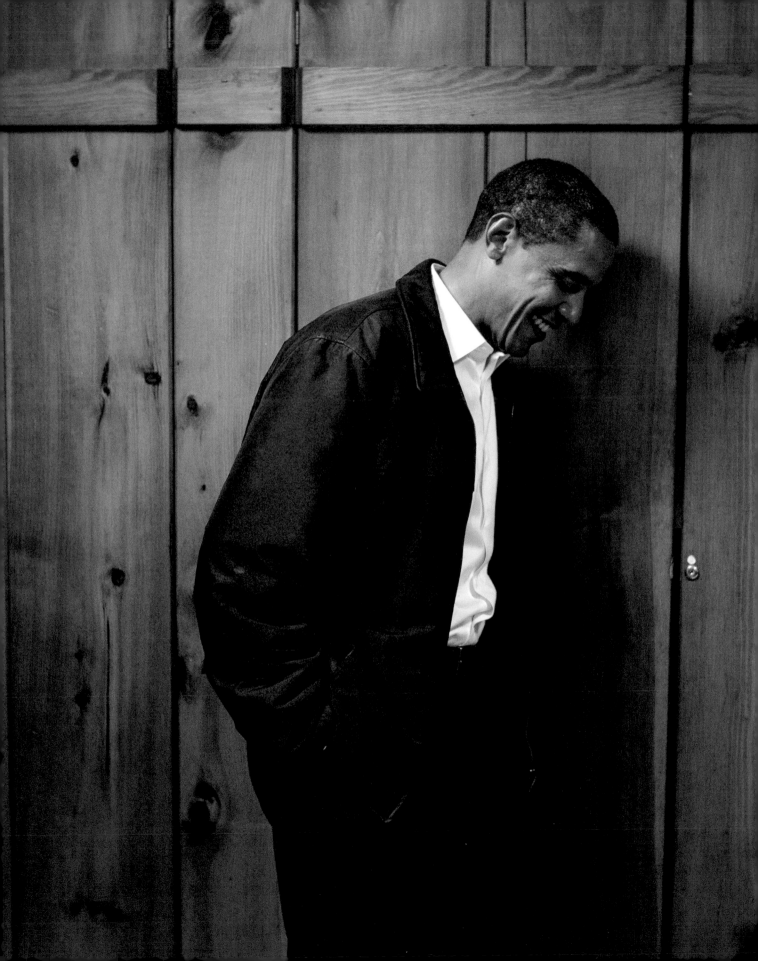

Obama waits to attend a rally at Mack's apple orchard prior to a rally in Londonderry, New Hampshire.

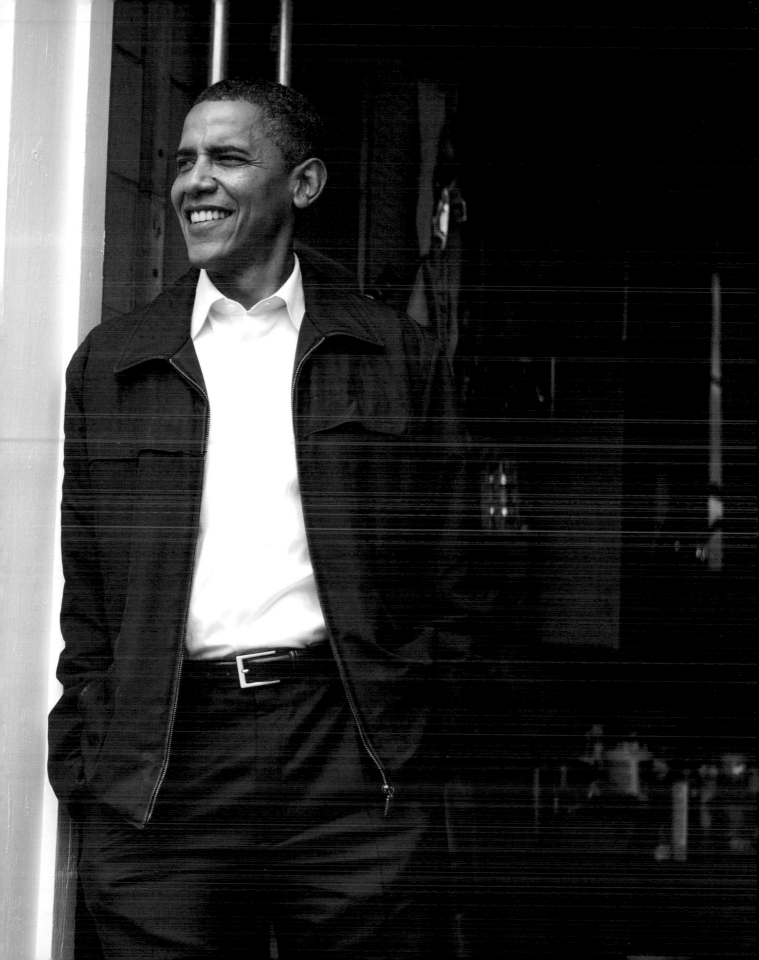

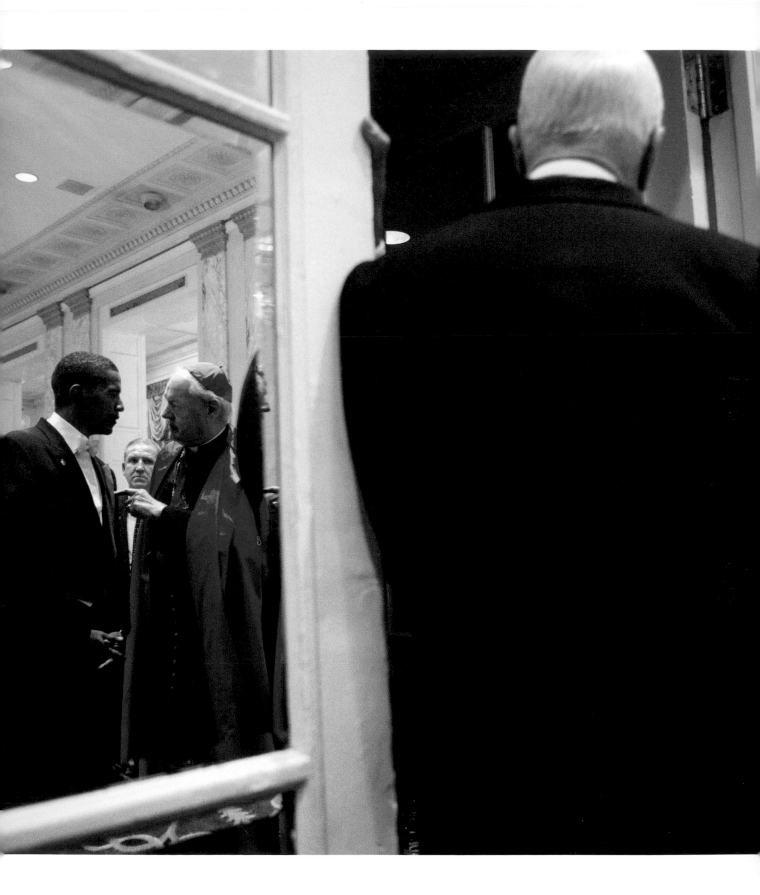

AL SMITH DINNER

The Al Smith Dinner is an annual event in New York City to raise money for Catholic charities. Al Smith was the first Catholic presidential nominee of a major party when he ran in 1928. The dinner is a white-tie affair, and during presidential campaign cycles, candidates attend and roast themselves and each other. In 2008, a day before the event, the campaign realized Obama didn't have the proper attire. From my days as his personal aide in the Senate, I remembered we had in the past rented him a tuxedo from a tailor in Dupont Circle in DC. I called the tailor, who did me a favor to get a tux ready in time. An aide in DC brought us the suit that day in New York. The only problem was that Obama didn't have time to be fitted, so the tailor and I had guessed at his size. Needless to say, we were off. The jacket was about a size and a half too big and the collar drooped off his neck. Obama could tell it was ill-fitted, but to his credit, he only gave me a hard time for about a minute. Then he went out and delivered one of the funniest speeches in the history of the Al Smith Dinner.

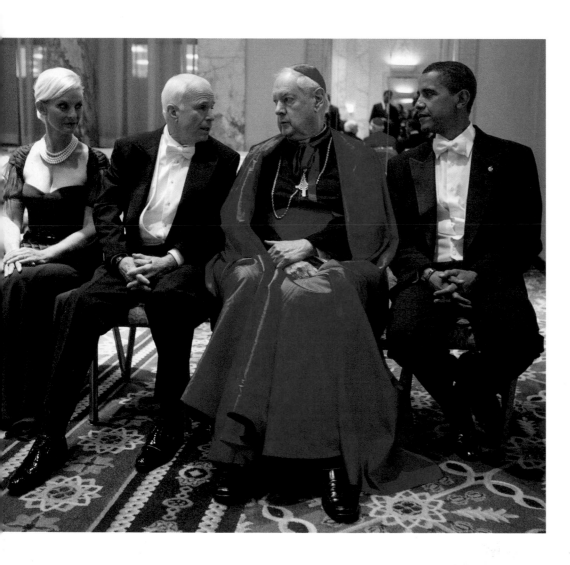

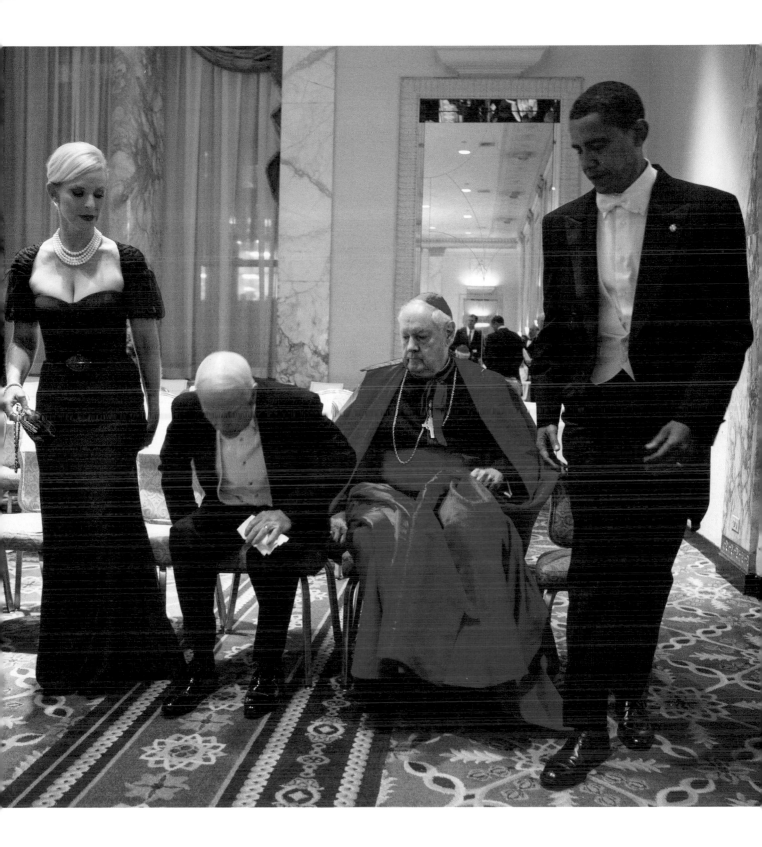

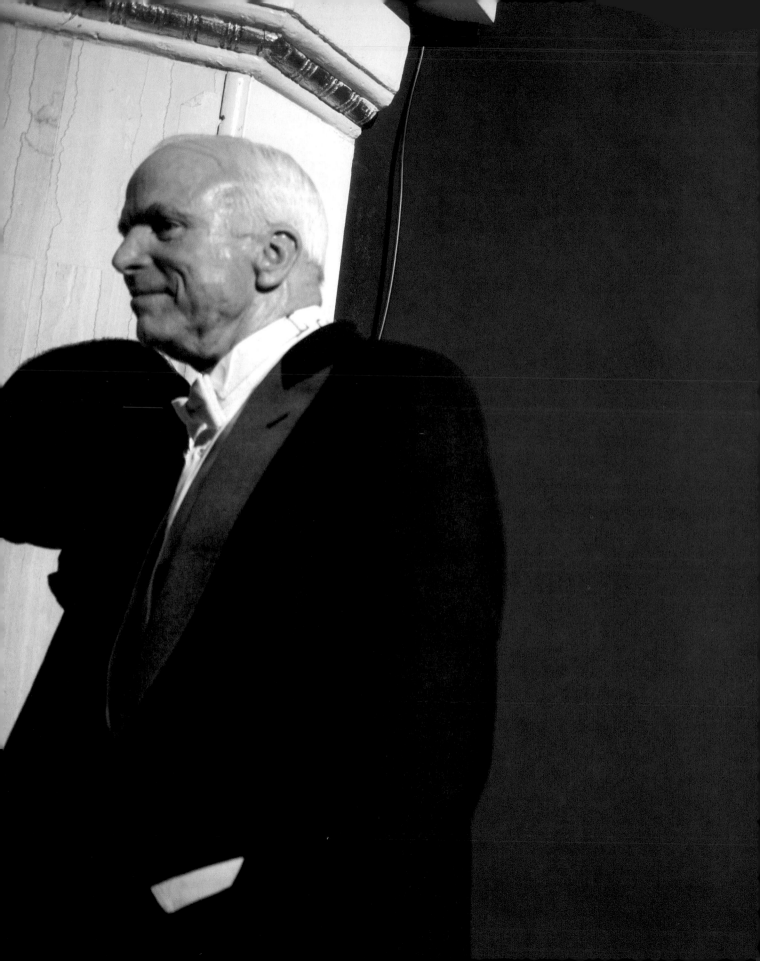

The Obamas watch Billy Joel and
Bruce Springsteen perform at a
fundraising concert in New York City
on October 16, 2008.

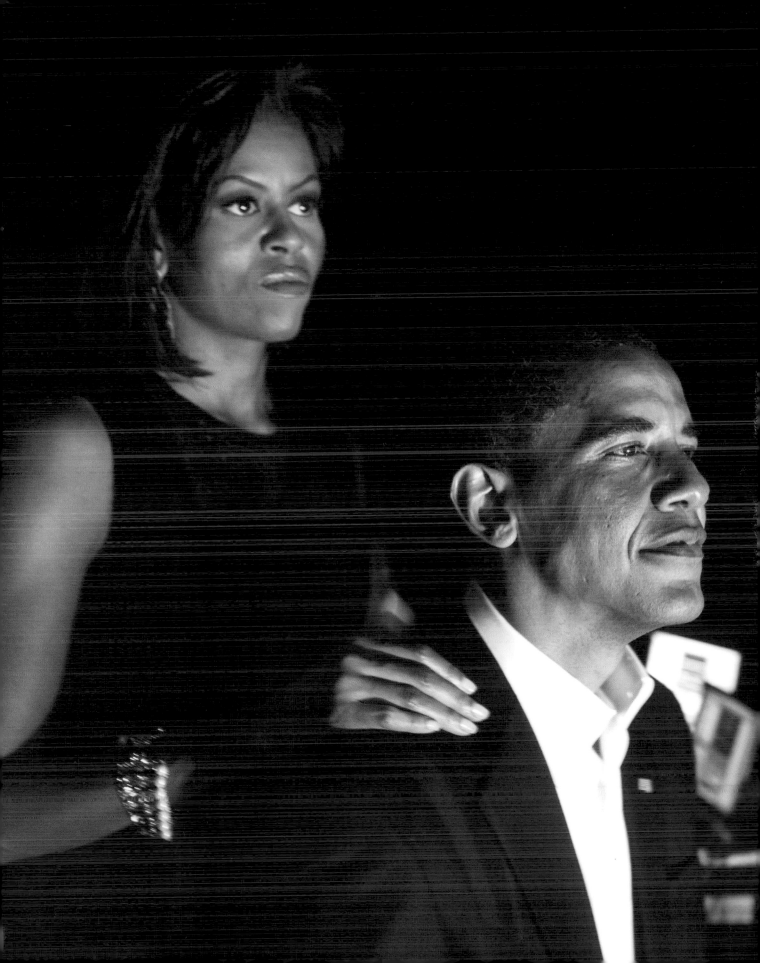

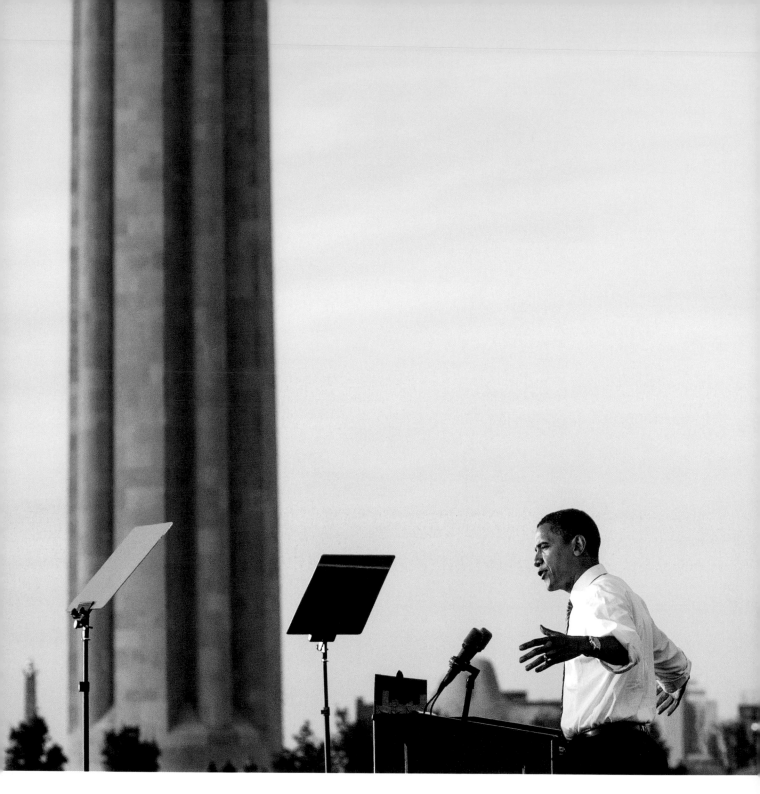

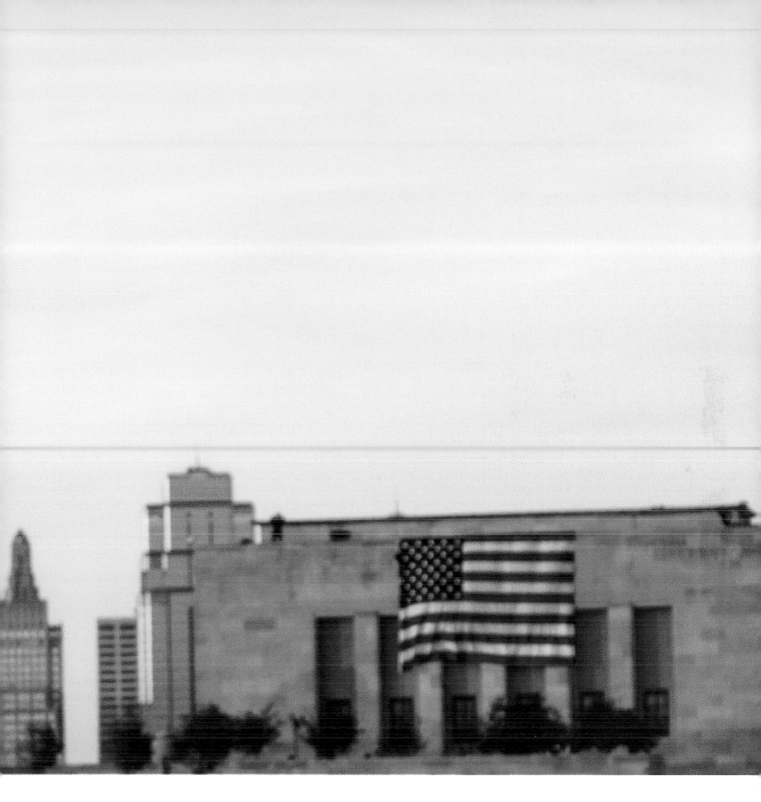

These photographs were taken during the golden hour, just before dusk, at a rally at the Liberty Memorial in Kansas City.

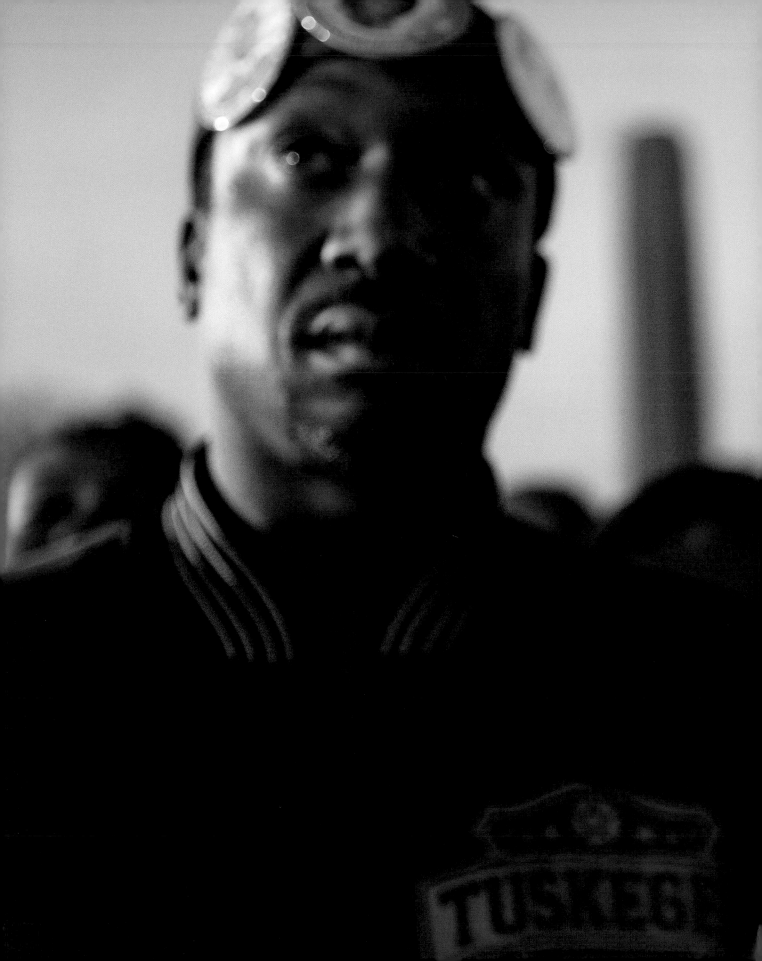

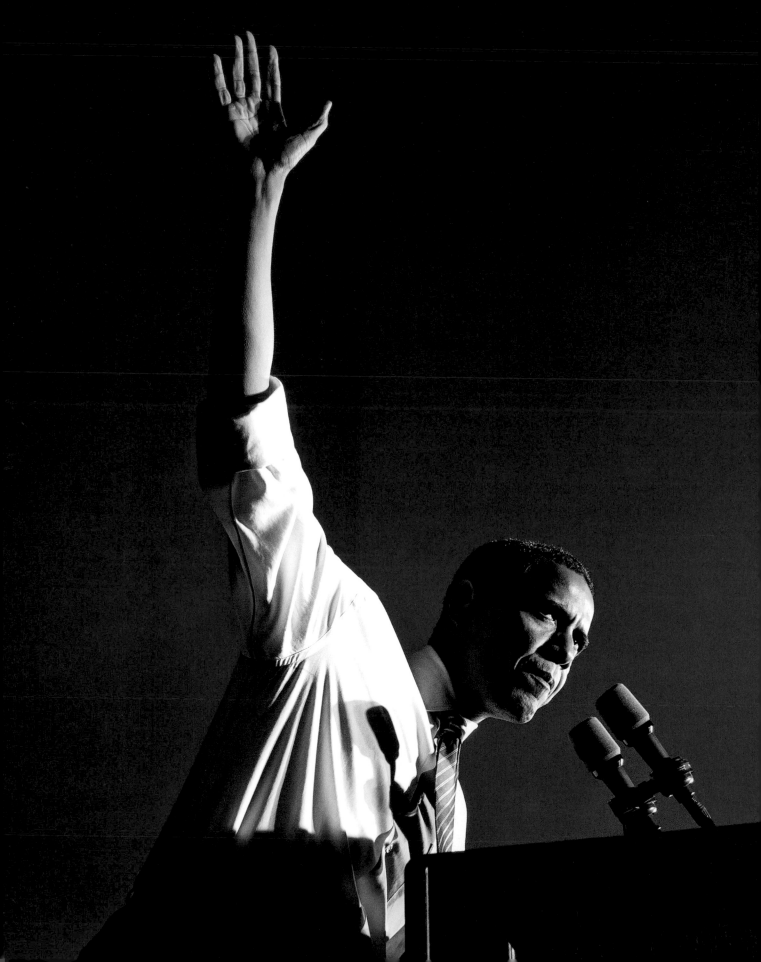

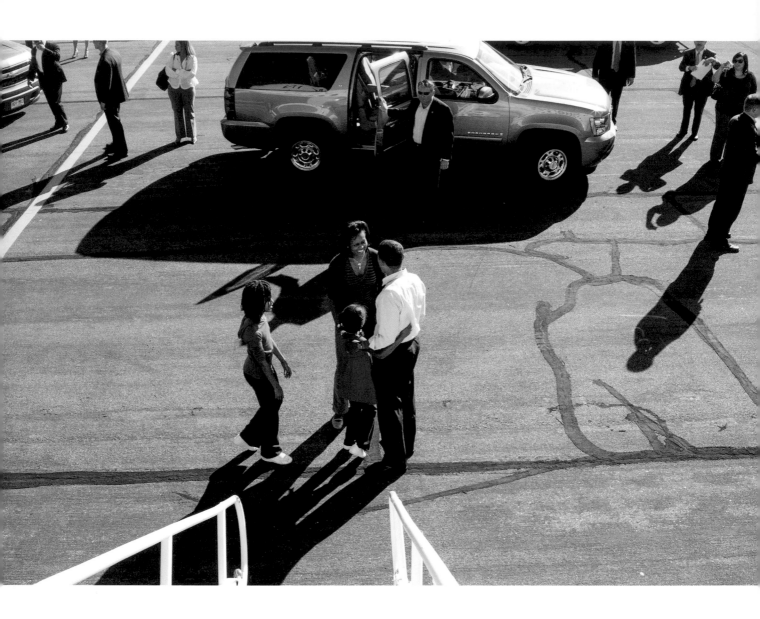

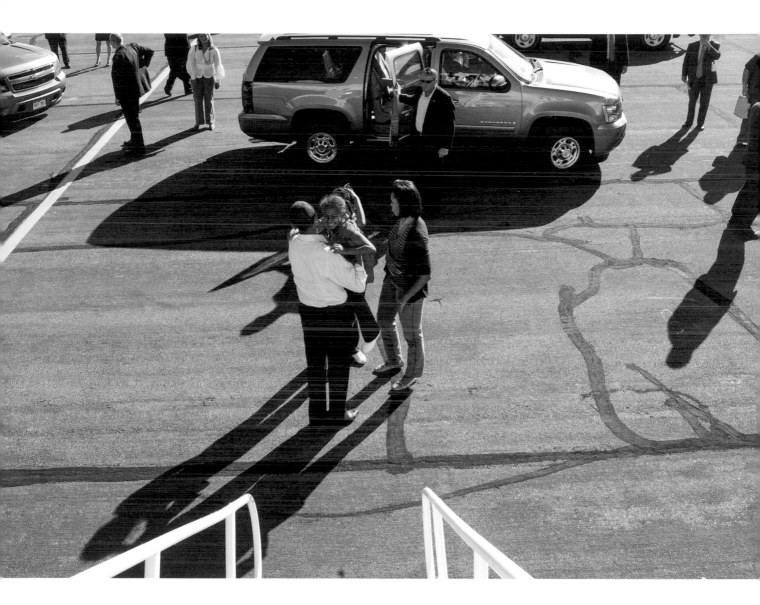

I rarely got the opportunity to photograph Obama from above. When I saw the asphalt patch lines on the tarmac and the family having fun together, it reminded me how different the Obama girls' childhood was from that of most children.

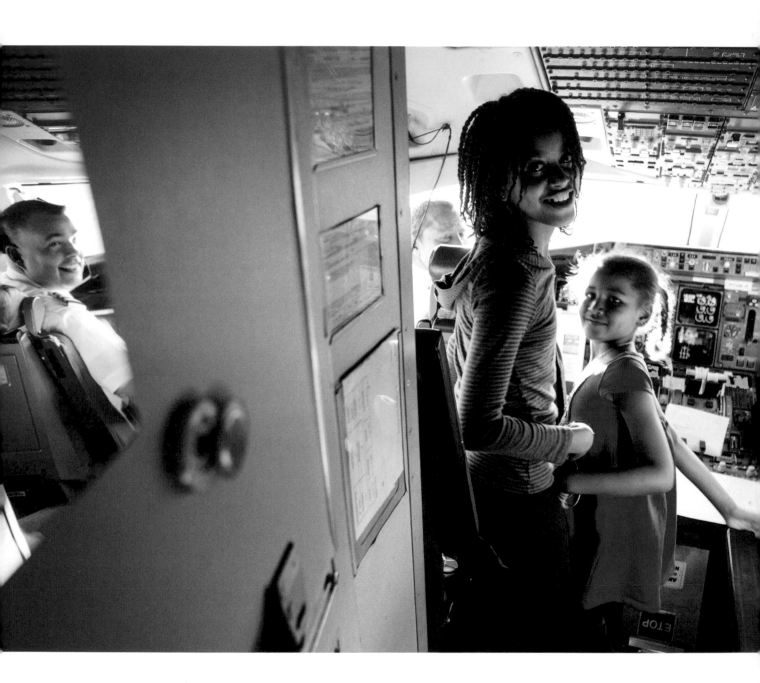

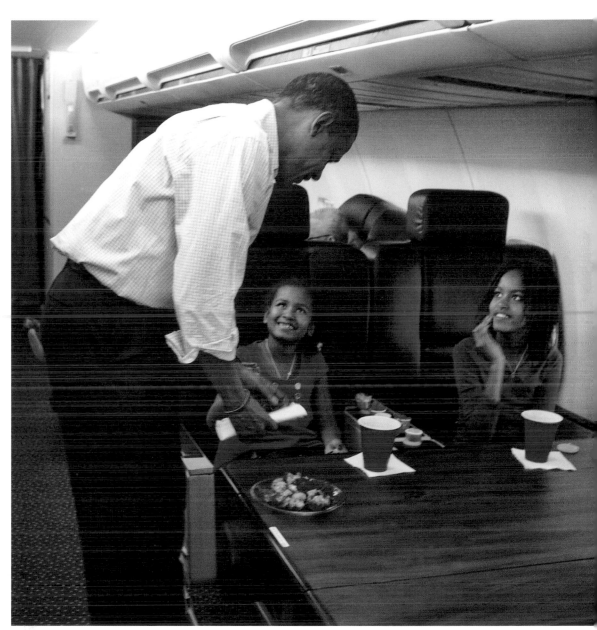

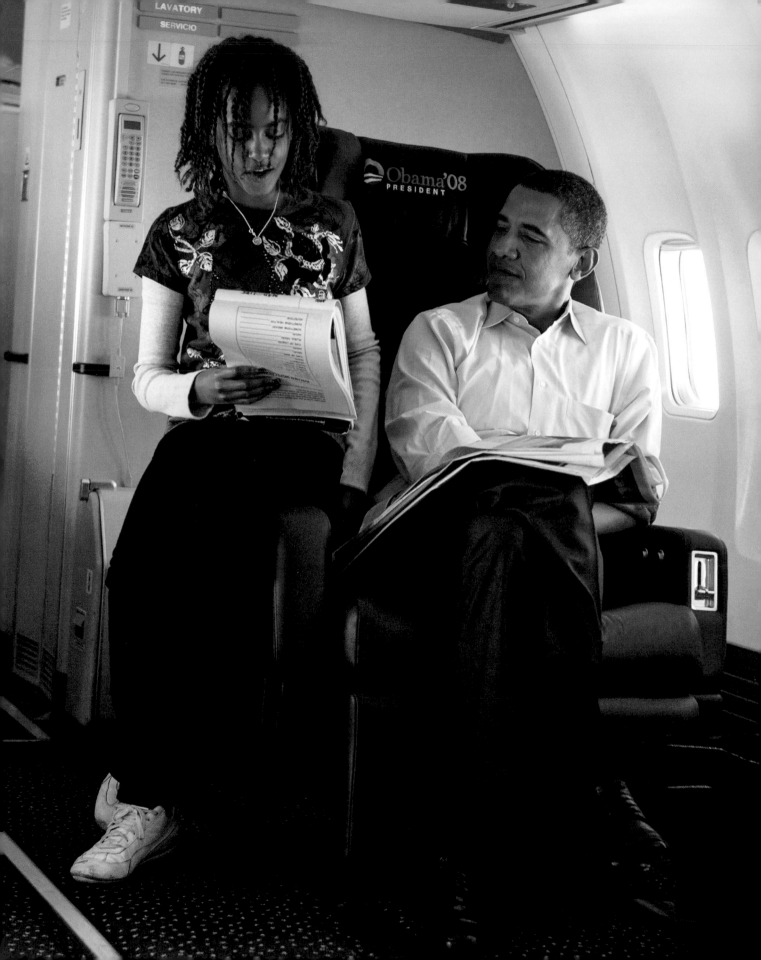

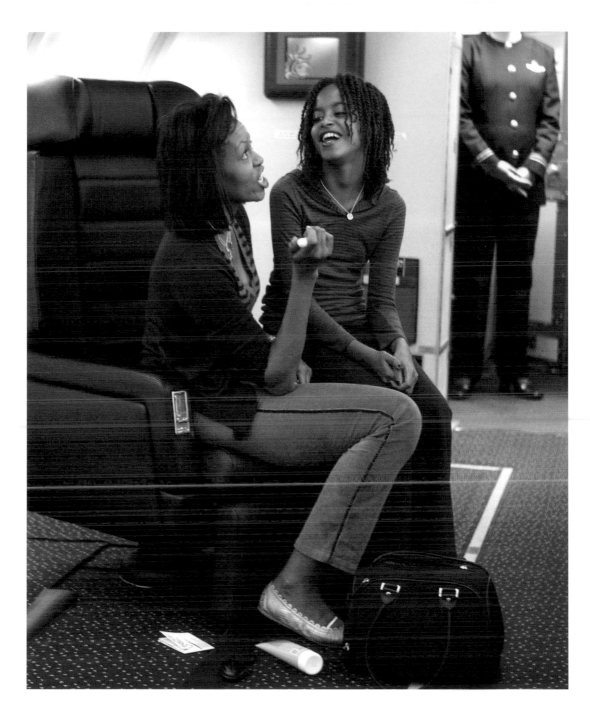

Michelle has always been a grounding influence on her children. After I stopped working as the Obamas' campaign photographer, Malia asked Michelle, "Why isn't David photographing us anymore?" To which Michelle replied, "Do you think he's going to follow you around taking pictures of you his entire life?"

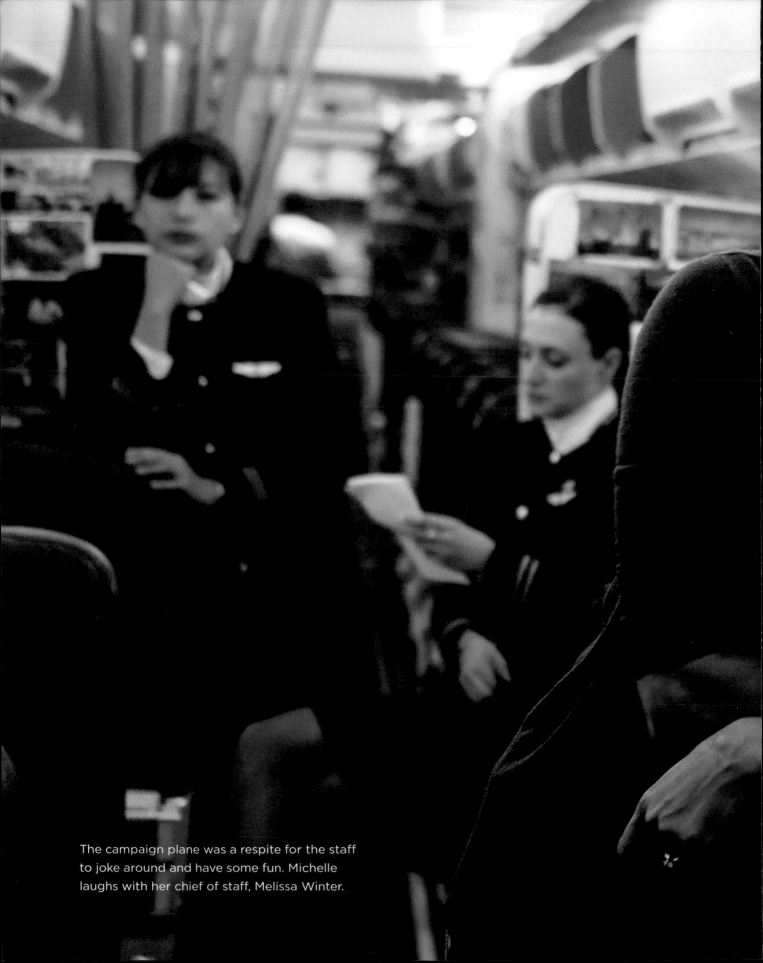

The campaign plane was a respite for the staff to joke around and have some fun. Michelle laughs with her chief of staff, Melissa Winter.

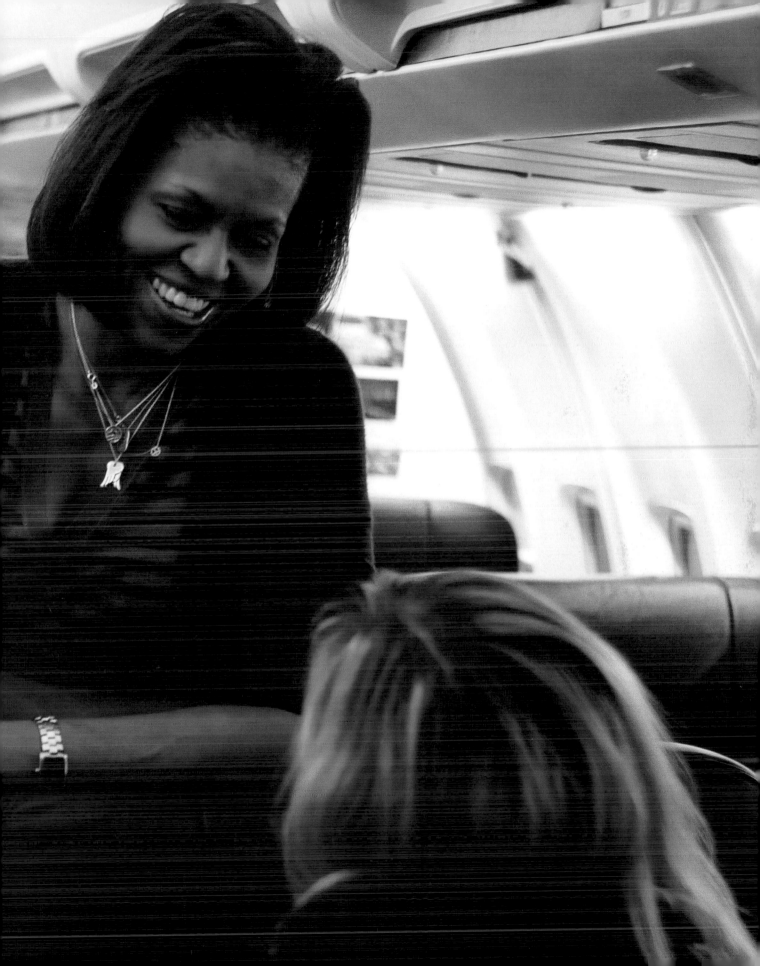

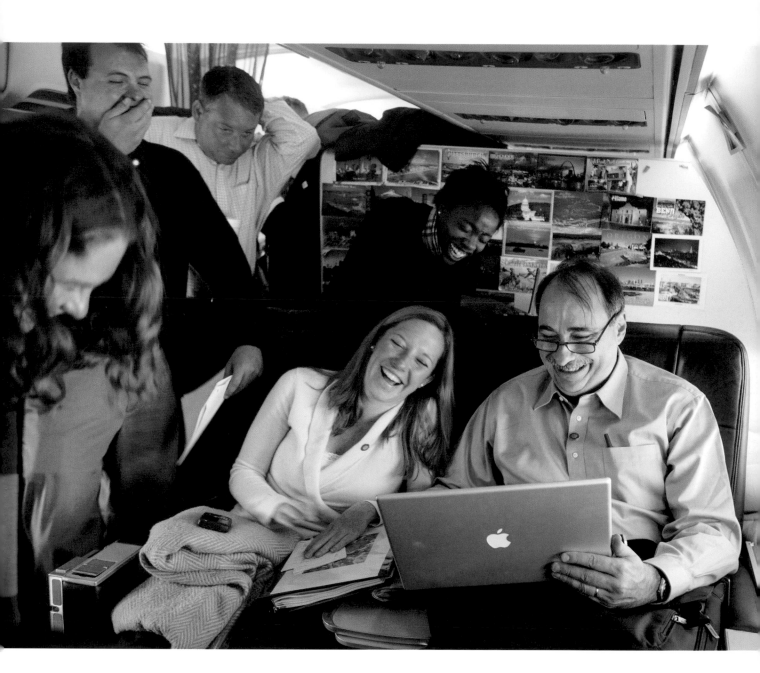

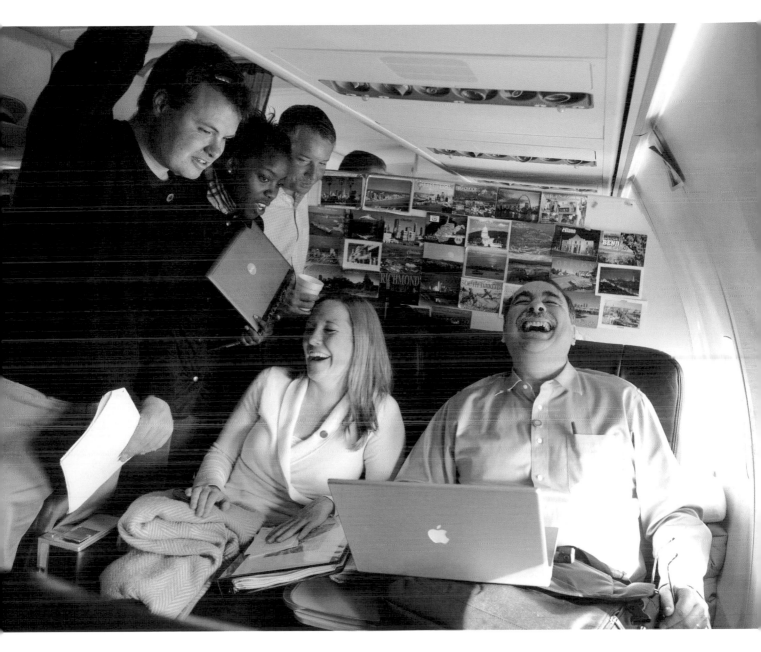

David Axelrod, campaign staff, and a Secret Service agent laugh at a *Saturday Night Live* sketch impersonating Richard Wolffe, a member of thc traveling media during the campaign.

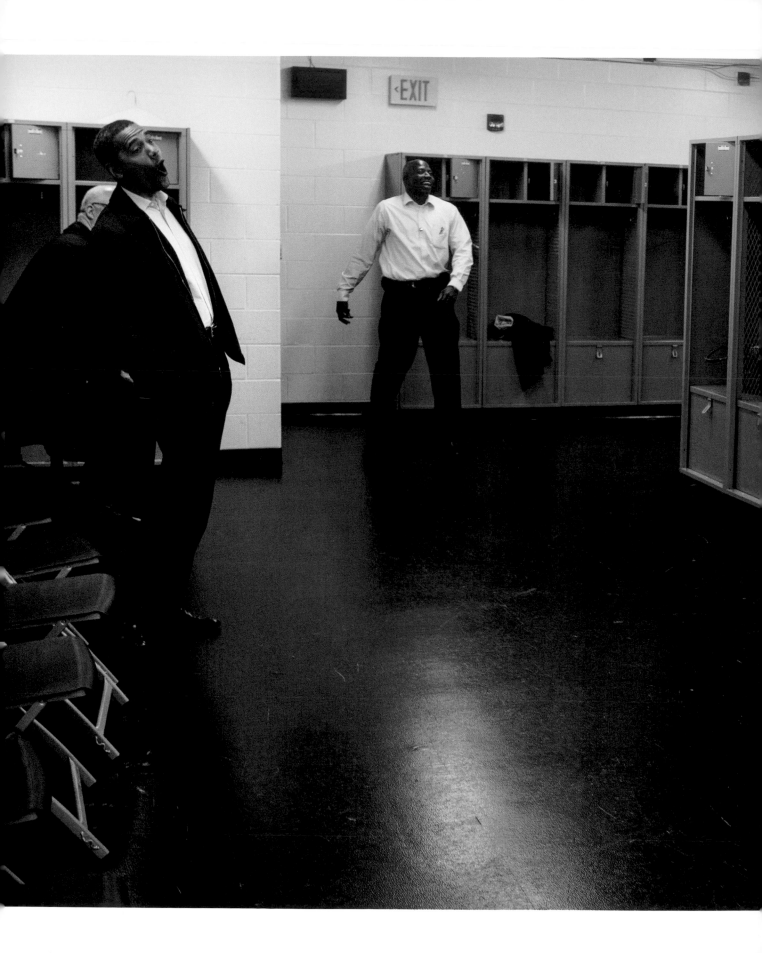

HEADS UP

Reggie Love, then Obama's personal aide, and his travel director, Marvin Nicholson, invented a game to kill time before rallies. Each person took a turn tossing a tennis ball at someone with the goal of hitting them on the head. Of course, Obama was never on the receiving end but was always a vocal spectator. In this photo, Obama reacts to Reggie Love using his sidearm technique to nail Robert Gibbs, the campaign's communications director.

The Obamas had some laughs and fun as they
waited to attend a rally in Columbus, Ohio,
headlined by Bruce Springsteen, where the family
sang along to "This Land Is Your Land."

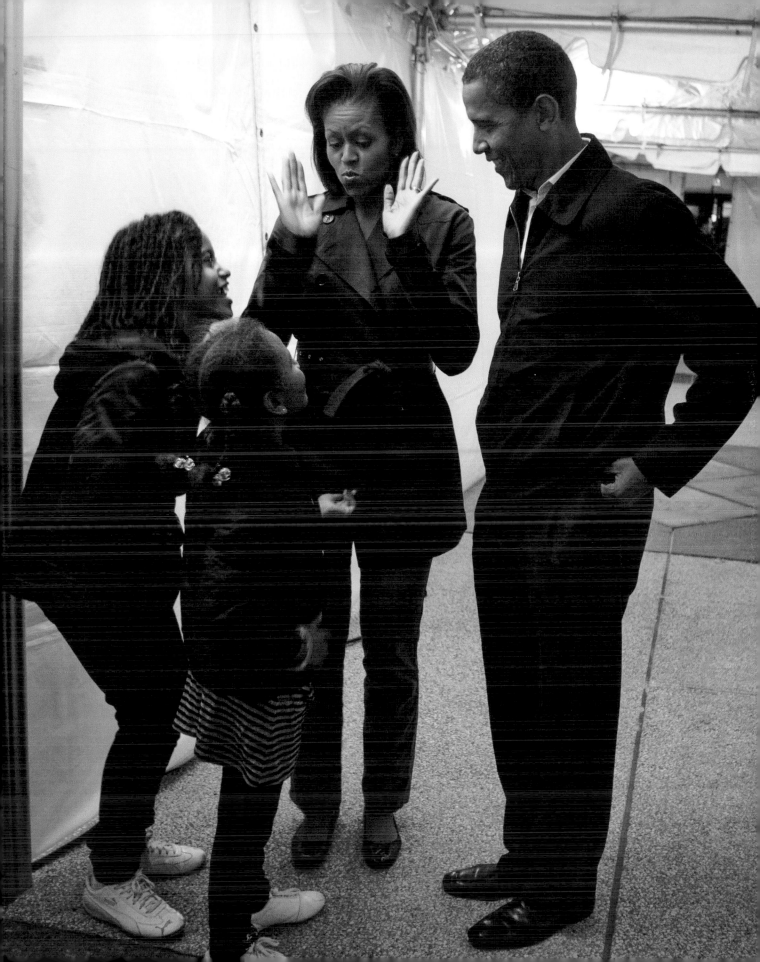

To pass the time at the rally in Columbus,
Sasha practiced her cartwheels to the
enjoyment of her mother, sister, and the staff.

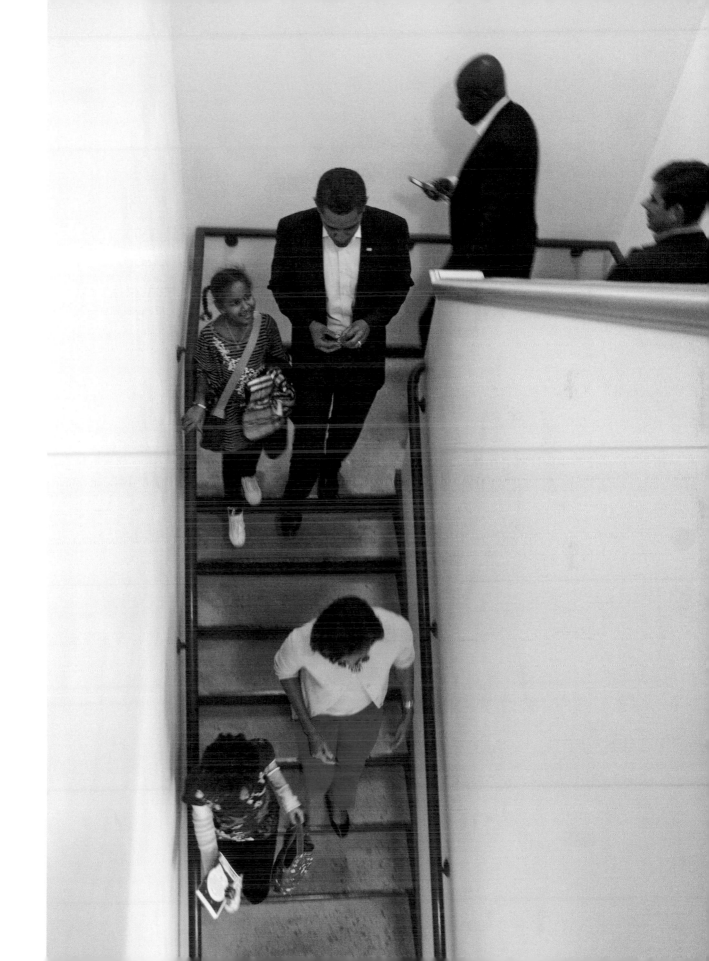

Obama loved to DJ for his campaign staff. He had a wide range of music to choose from, including Outkast, Frank Sinatra, and Indonesian flute. He would tell us his CD collection was frozen in time based on when he had children.

TUTU

Obama had learned hours before this speech in Charlotte, North Carolina, that his grandmother Madelyn Dunham, who had raised him as a child, had died late the previous evening, just two days before he was elected president of the United States.

Obama's sister Maya recalled how they used to go to their Tutu's (Hawaiian for grandmother) house on Beretania Street in Honolulu to play Scrabble. "We always loved wordplay and language, and because I didn't play sports, Scrabble was one of those important sources of connection," said Maya. "In 2008, Barack discovered online Scrabble. We started a game and when that game ended, we would start another game, and we played until the summer of 2019. We often communicated through the Scrabble chat feature when he was in the White House. I didn't want to interrupt important presidential business, so using the chat feature meant he could respond at leisure when he was in a restful place. This is how we normalized an extraordinary situation."

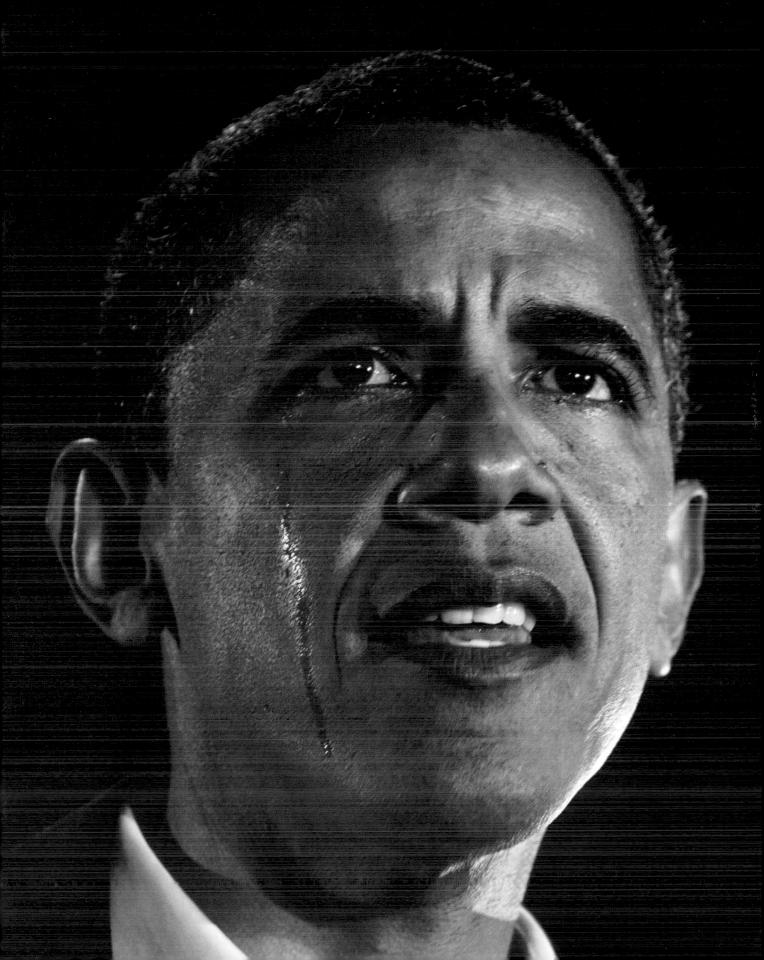

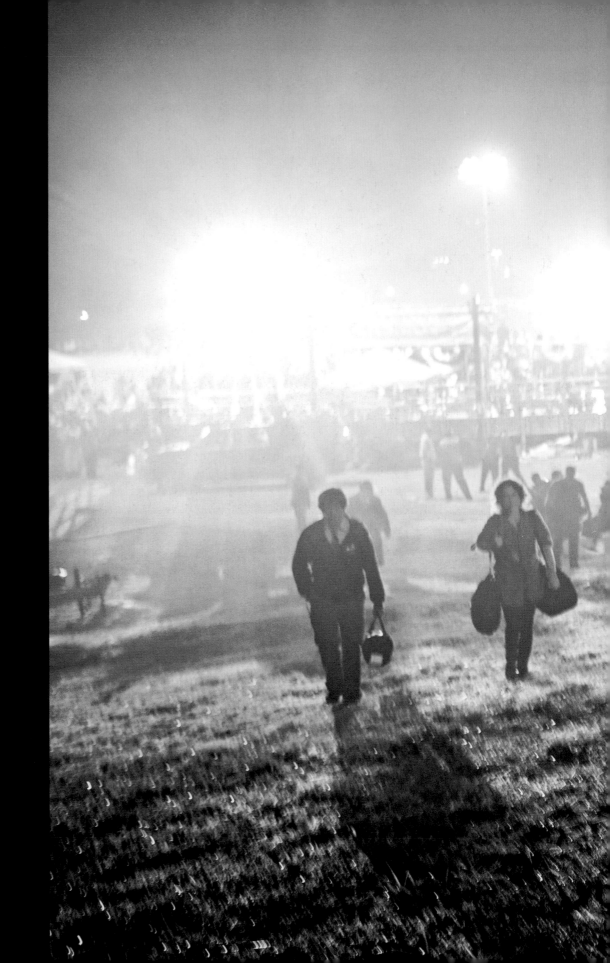

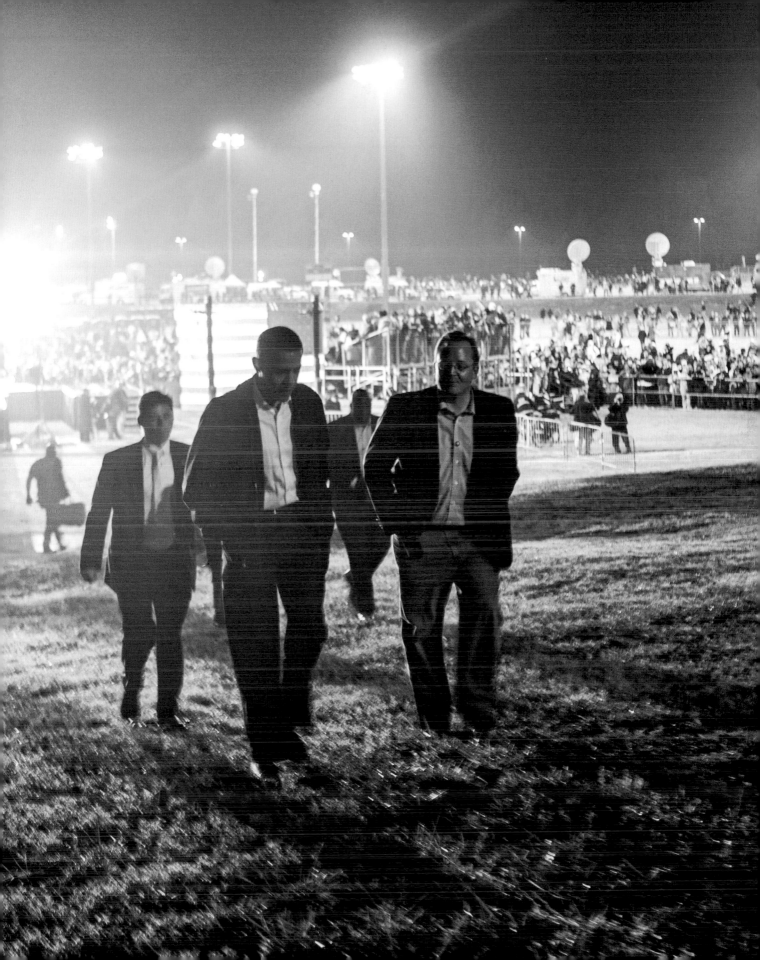

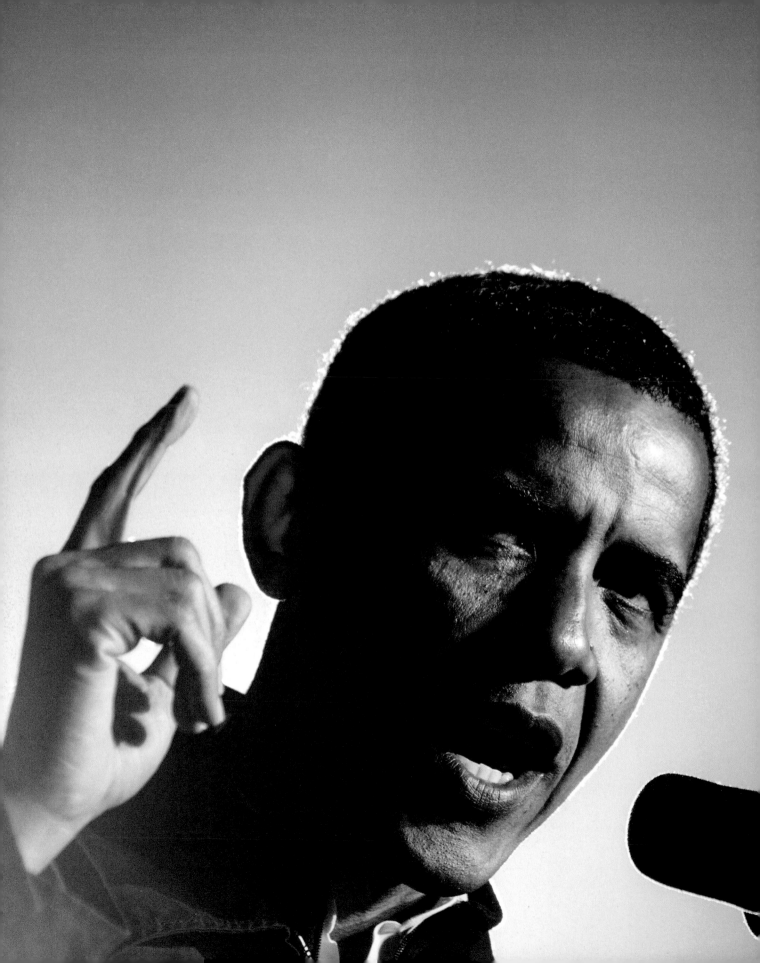

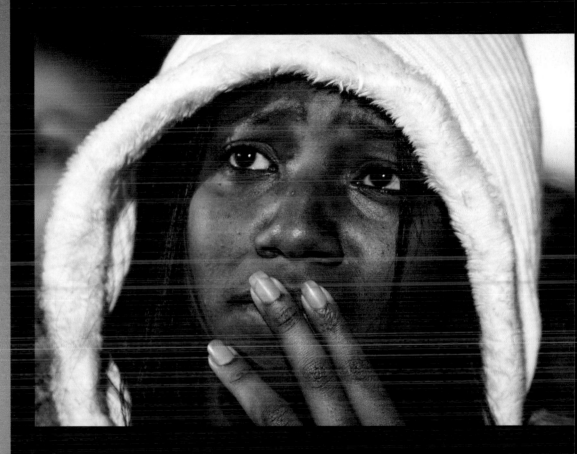

Obama delivered his closing statement
on the eve of the election in Manassas,
Virginia, on November 3, 2008.

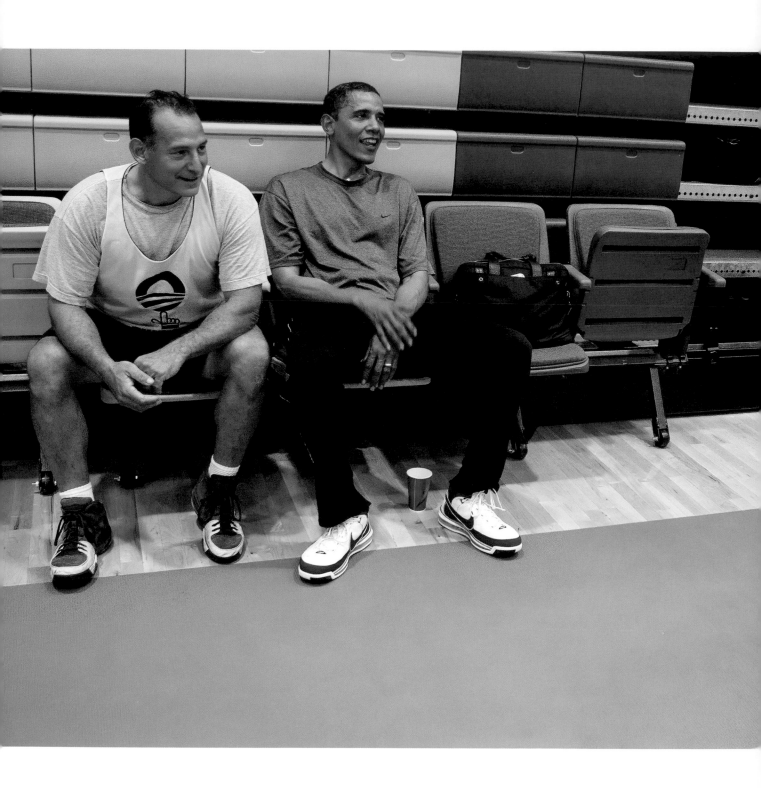

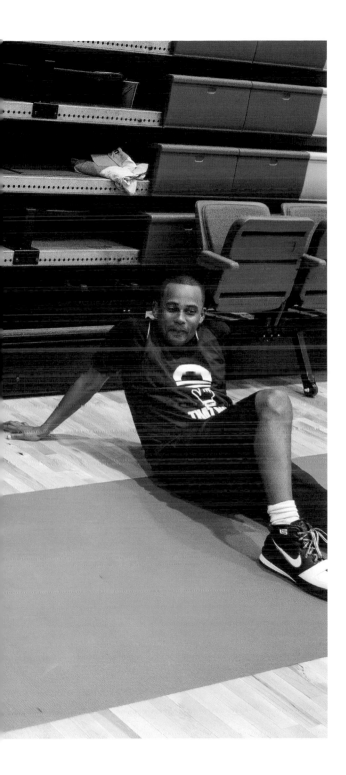

ELECTION DAY BASKETBALL

Obama is not superstitious. He approached the campaign analytically, poring over the numbers in detail and thinking through how and why different outcomes might occur. But he would also take the staff seriously if someone suggested a superstitious reason why something did or did not go as planned. In 2008, Obama won the Iowa caucus but lost in New Hampshire and Nevada. Reggie Love suggested that the losses occurred because he and Obama had not played basketball on election day in those states. Obama agreed, so every election day afterward they organized a pickup game. It was not always easy to find people to play with on the road. They would recruit advance staff; local campaign staff; and, most controversially of all, the Secret Service, who were torn between not wanting to risk the candidate participating in a contact sport at all and their own desire to be in the game. According to Love, the only rule everyone had to follow was "just don't hurt the boss."

Marty Nesbitt, Obama's close friend, said, "Basketball helped him (Obama) take his mind off of election day activities and allowed him to express his competitive nature. Everything is out of your control on election day, so playing basketball, laughing and having some fun, helped break the stress and gravity of the situation."

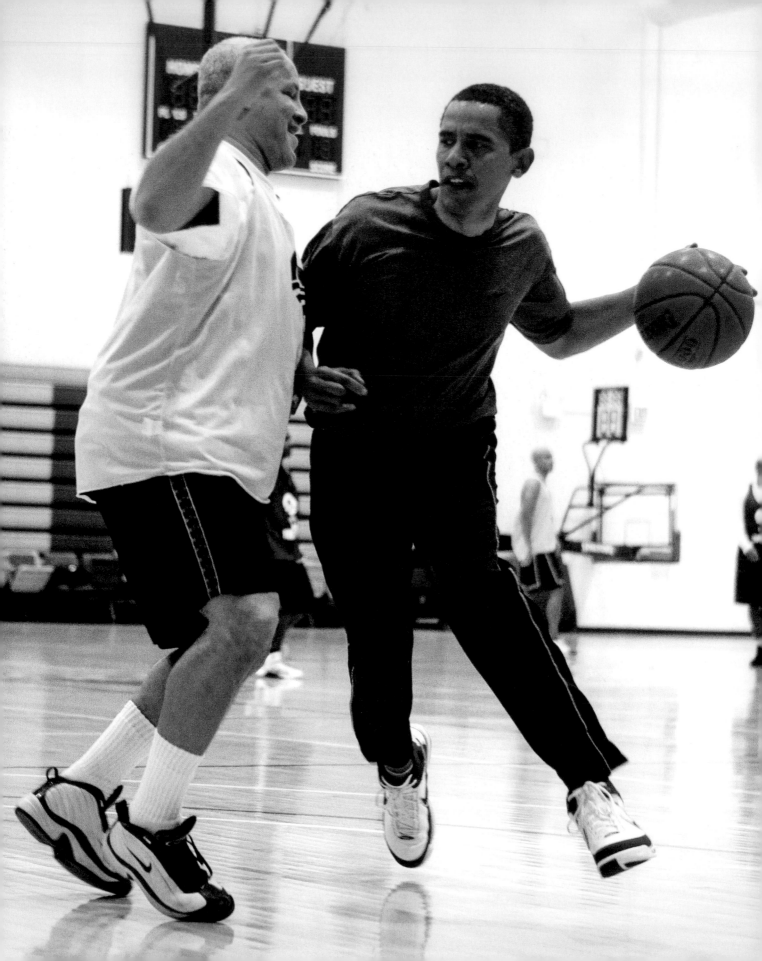

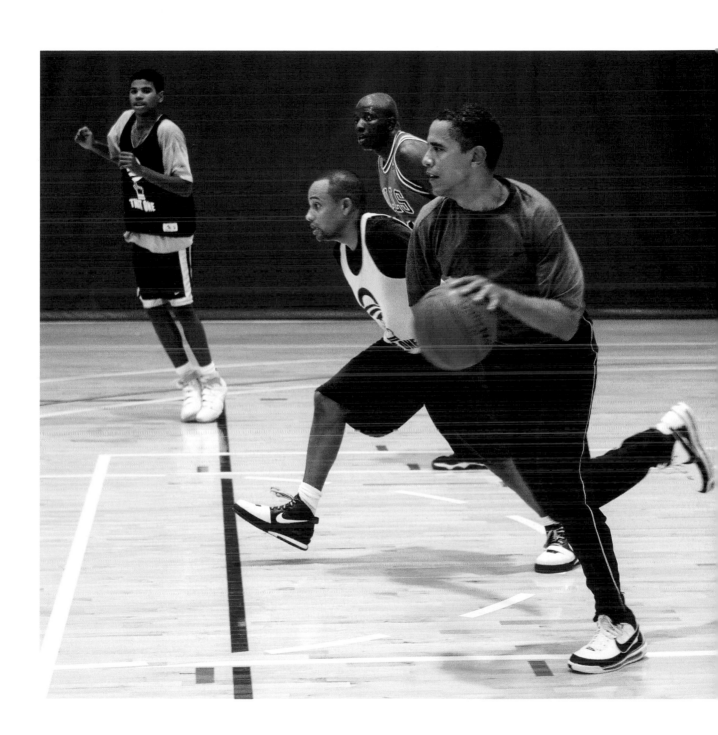

ane Evans was a progressive populist congressman in Illinois's 17th District, an area no Democrat had won since the Civil War until Evans took office in 1983. In 2003, Lane invited all the Democratic Senate candidates to visit his district. Obama was the first to arrive, and he and Lane hit it off immediately. They talked about the Beatles and their common backgrounds as consensus builders and community organizers. They also shared a birthday, August 4, just ten years apart. Erin Saberi, Lane's partner during that time, remembers Lane saying after Obama's visit, "Babe, he reminds me of me." In the summer of 2003, Lane became one of the first Illinois Democrats to endorse Obama for Senate, an endorsement that came in spite of the pressure Lane was getting to support the more establishment candidate. By the 2008 presidential election, Lane had fallen ill with an advanced stage of Parkinson's disease, yet Saberi was able to arrange a meeting with Obama on election night. She recalls Obama saying to Lane, "Brother, I would not be here if it weren't for you." Saberi was shocked by how much time he spent with Lane on the night he was elected president. "Lane had no more influence and couldn't help Obama in any way. Here were two friends connecting, and Obama had never forgotten what Lane had done for him. Lane spent the entire night weeping. He said it was the happiest day of his life."

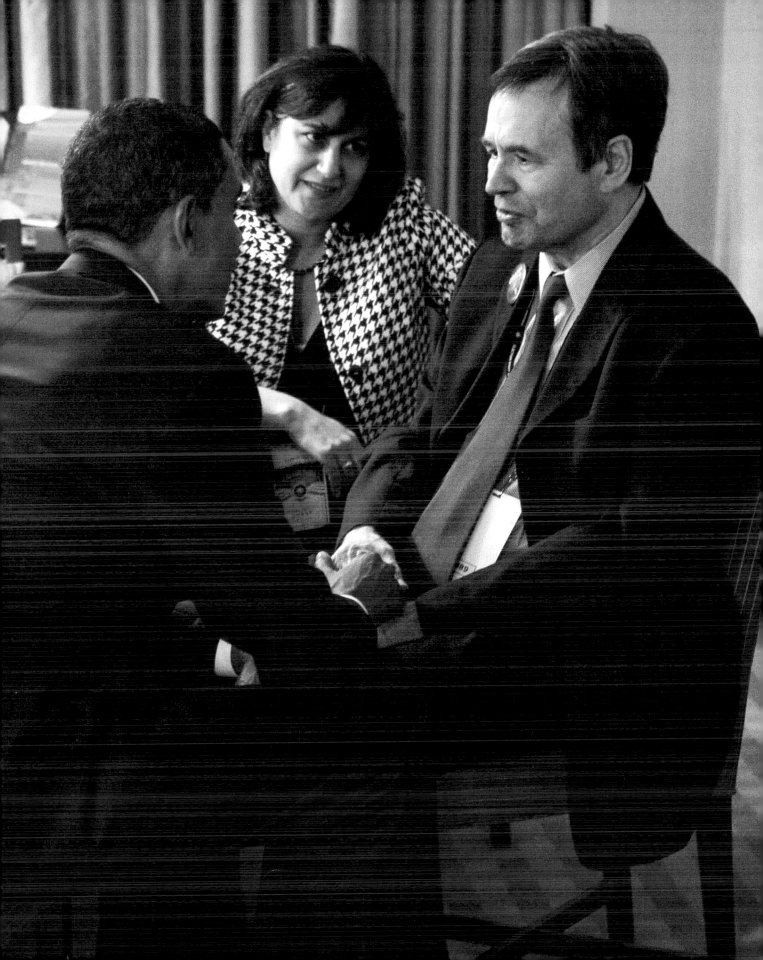

ELECTION NIGHT 2008

One of the most important turning points during the 2008 campaign was the loss in New Hampshire. Valerie Jarrett remembers meeting Barack and Michelle the day after the primary at 9 a.m. in Dartmouth and thinking, "What are we going to do now and how can we turn a victory speech into a concession speech? Hillary Clinton had given an emotional, tearful speech, and it felt like our momentum was slowing. Volunteers were devastated and Obama had to lift their spirits, and that's exactly what he did. He gave an incredibly confident and inspiring speech to the volunteers, and I truly believe this was the wake-up call we needed to get focused on winning." The summer of 2008 is when the campaign felt momentum building.

Obama's sister Maya did not think he would win until the summer of 2008. "I was speaking at events as a surrogate for the campaign, and I could now see he had an appeal with every demographic. He could bridge people who were very different from one another, and he had an appeal—symbolic, emotional, and spiritual—to many people who were hungry for something he was providing. He built a vision in these communities to make people understand their own power and impact in their communities, and got them to engage in broad civic action. He got young people and old people equally excited about participating. I saw lots of artistry and community gatherings that were joyous and creative. I met little old ladies from Southern Illinois—dancing grandmothers—expressing their love, and little tiny children who had written books—creating incredible art. Age four to ninety, they all loved him. He was reaching deeply into the hearts and minds of lots of people who were hungry for a vision of America that was generous, multifaceted, and innovative. I started believing then that he could win."

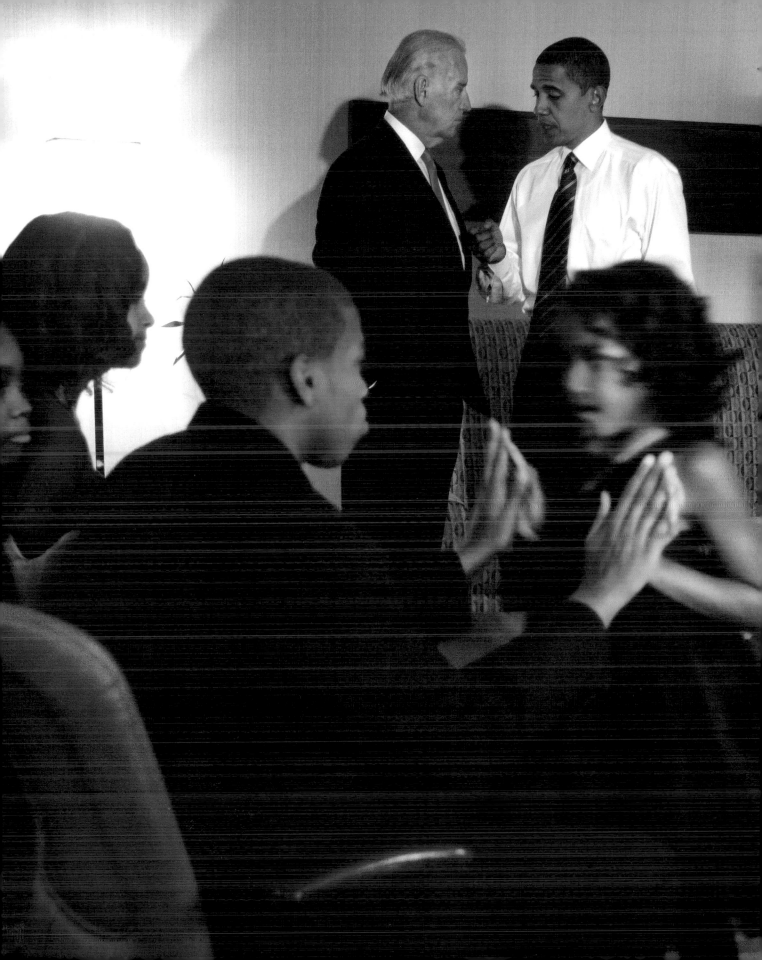

Eleven months later, Obama and his family were in their hotel suite watching election returns come in. He was now minutes away from giving another speech to his supporters in Grant Park in Chicago, this time as president-elect of the United States. I decided to position myself lying sideways on the ground, right under the television. Everyone in the room was comfortable with me, so I was hoping nobody would be distracted. I wanted to be invisible so I could capture the raw emotion in the room. It was like I was watching a movie unfold in front of my eyes. The children were playing with their cousins; Michelle and Barack were watching with anticipation and excitement; Barack and Mrs. Robinson (Michelle's mother) clasped hands on the sofa; the advisers were on the phone gathering information. And, when it was clear he would be the next president of the United States, the Bidens joined the celebration.

The global economic crisis was reaching its peak, with Lehman Brothers collapsing only six weeks before election day. David Plouffe remembers, "It was a sobering moment in the suite. Yes, people were relieved we had won, but there wasn't a lot of champagne flowing. There wasn't a lot of giddy laughter. Obama and the entire team knew what lay ahead and the magnitude of those decisions."

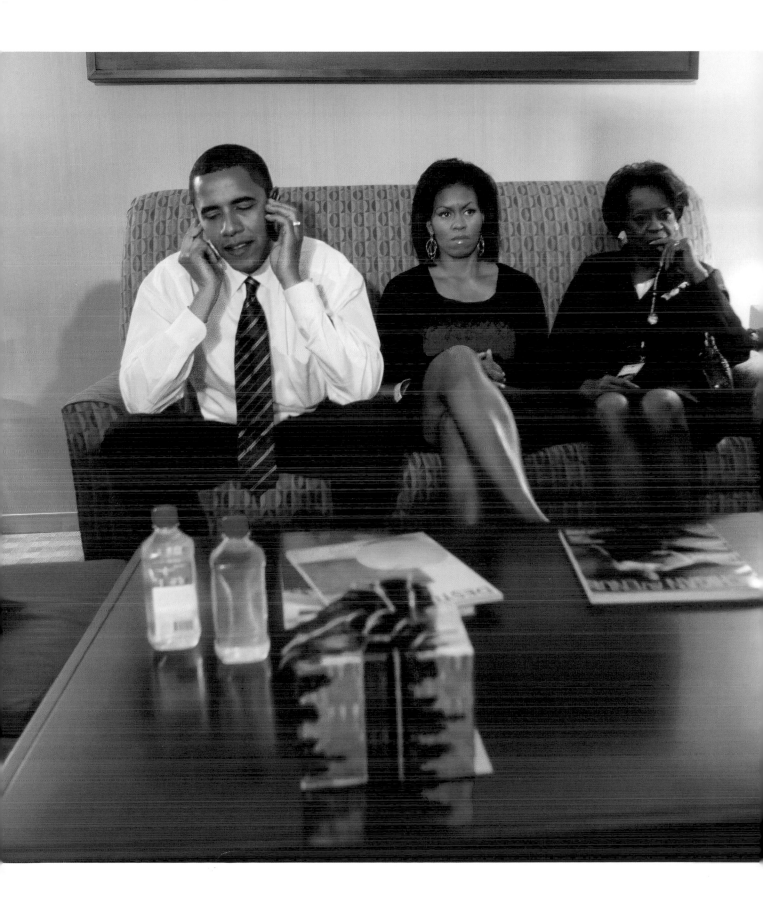

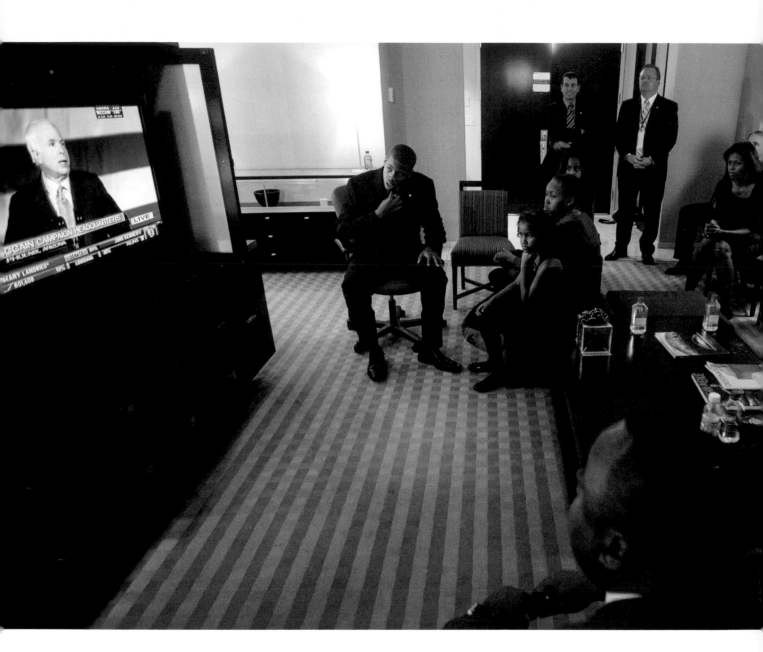

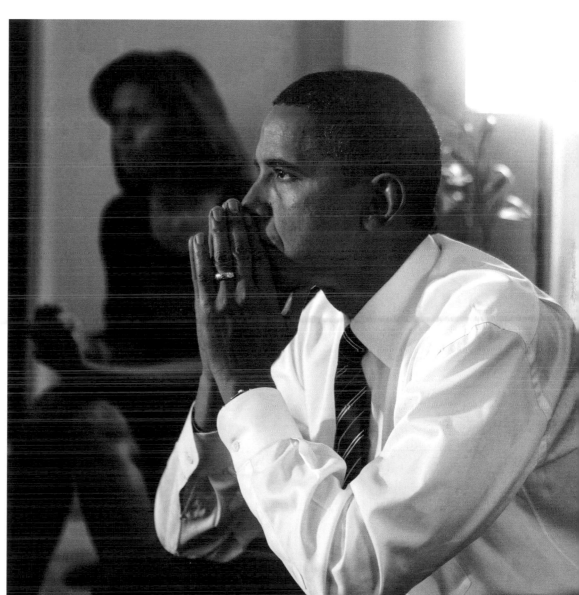

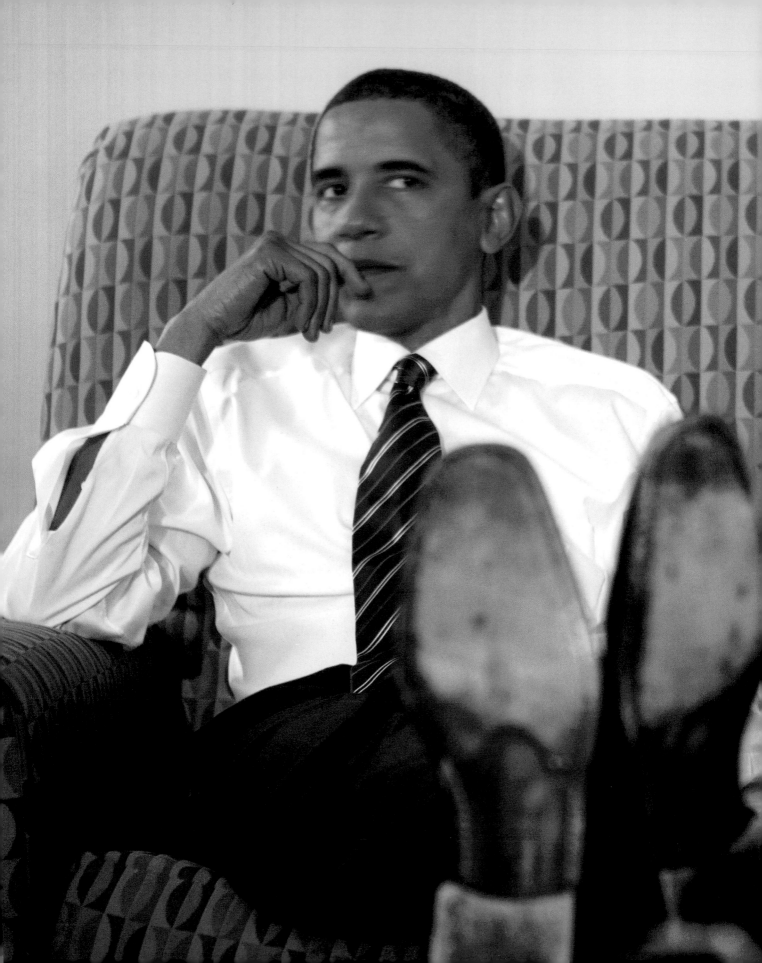

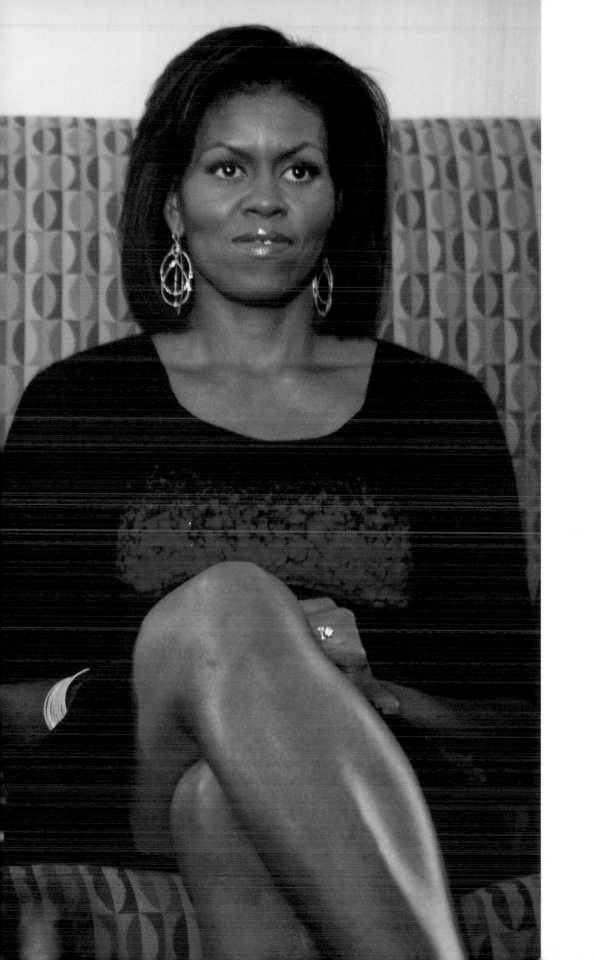

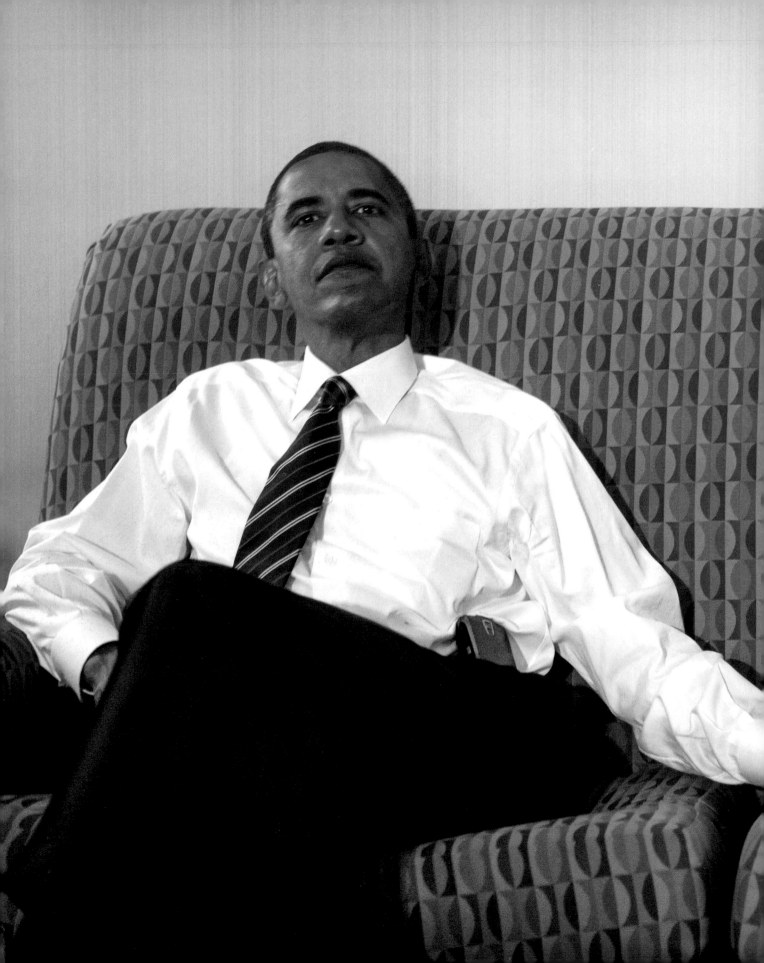

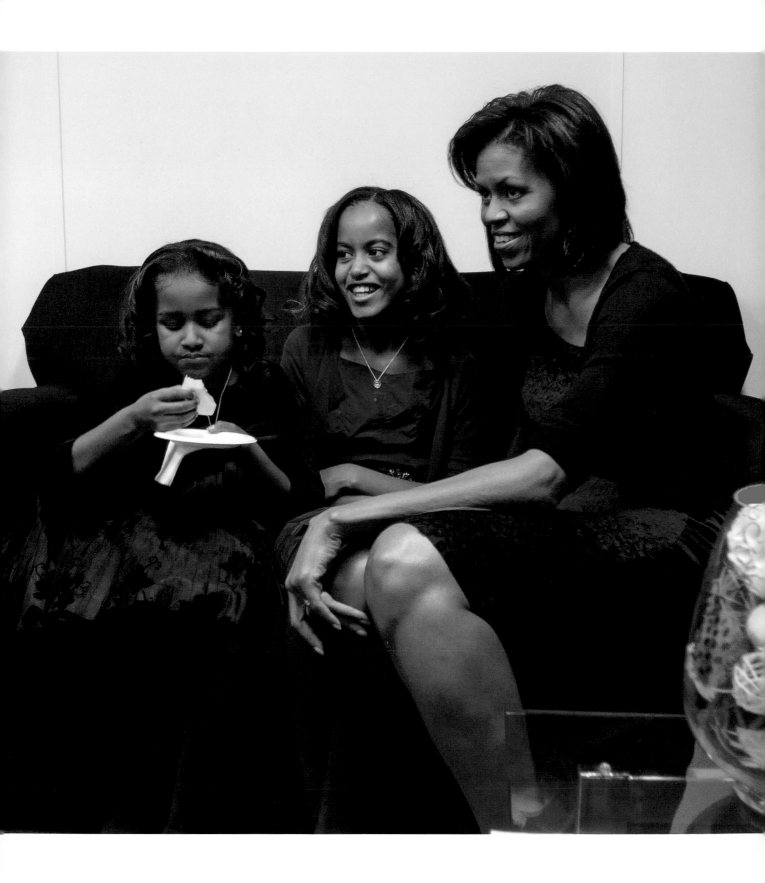

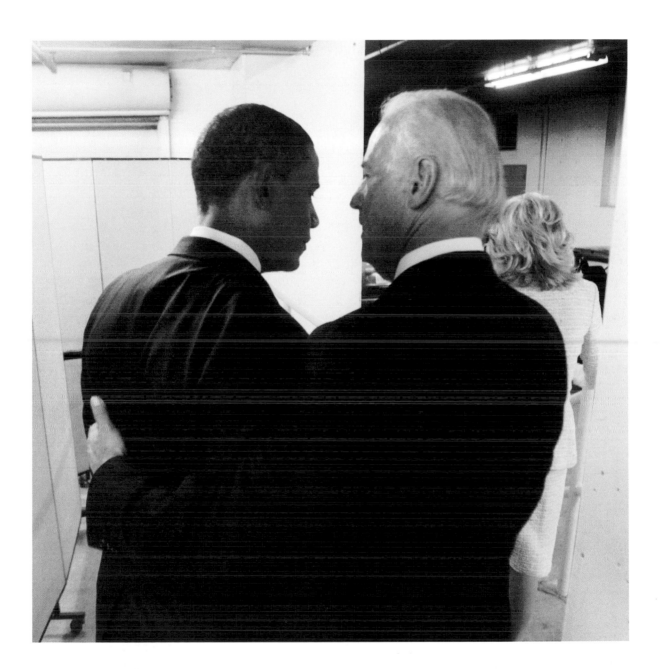

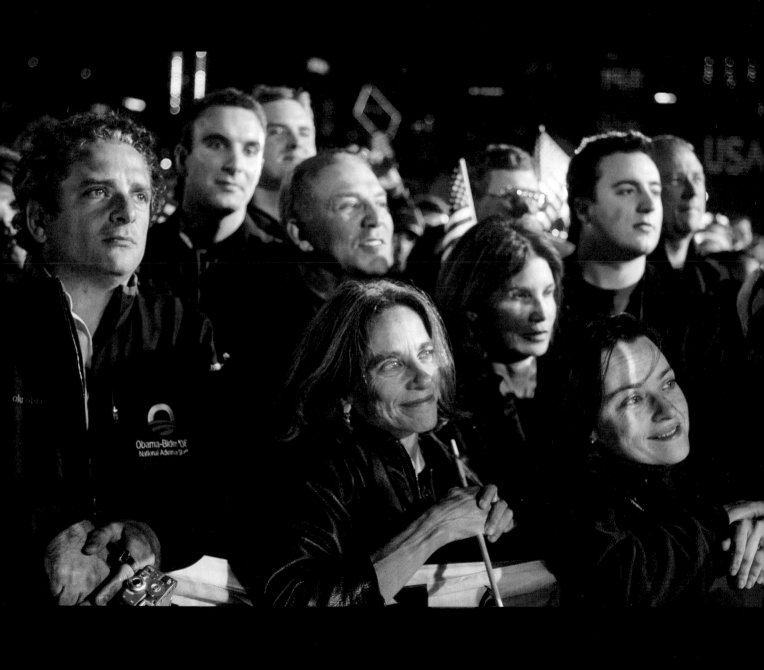

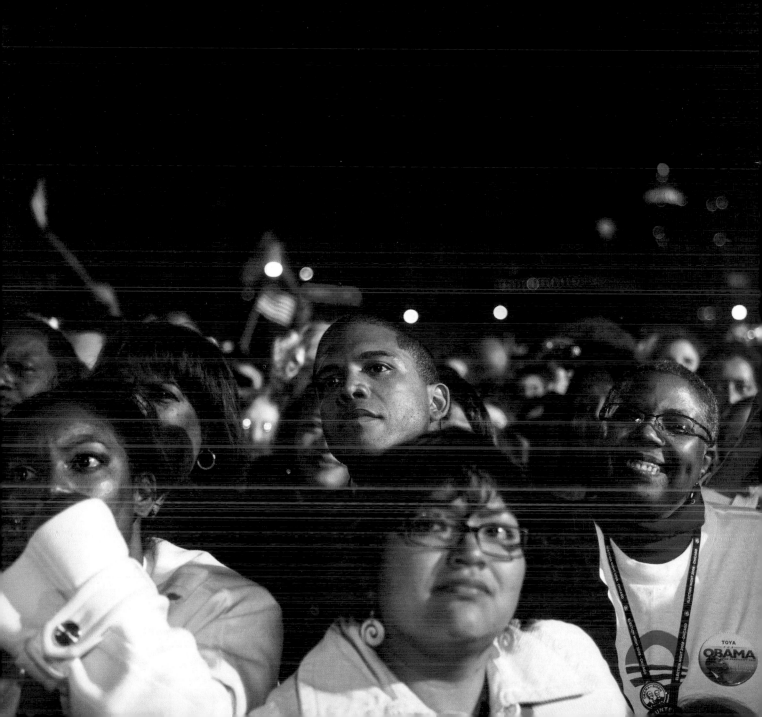

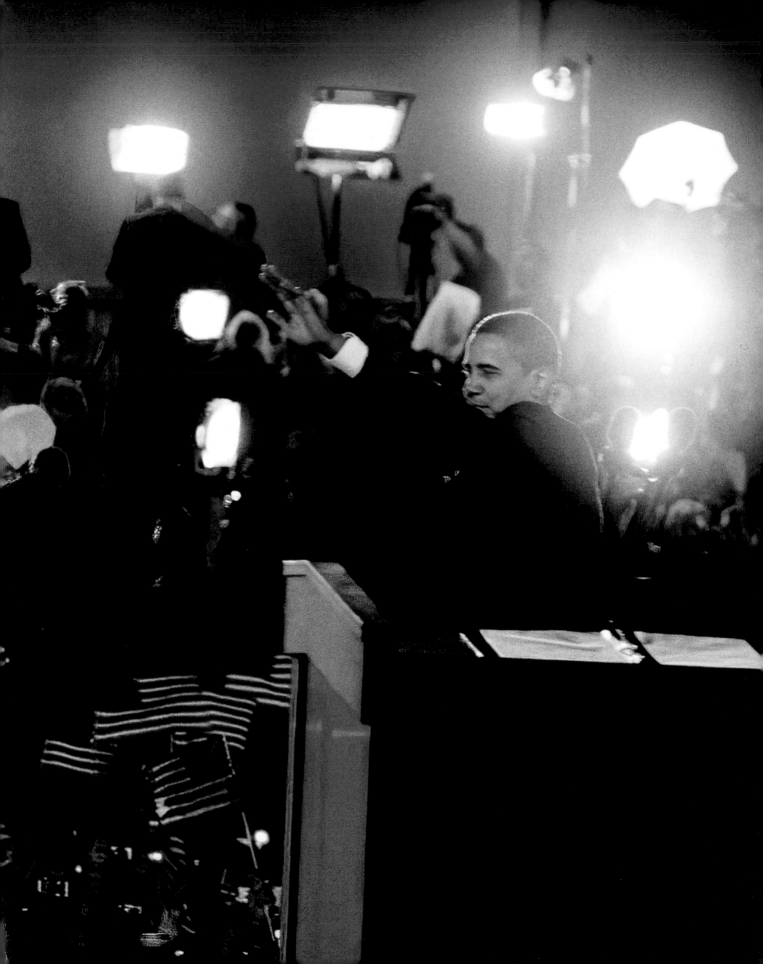

The Obamas rarely drink alcohol, but when they do, their drink of choice is a vodka martini. After Obama addressed thousands of supporters on an unusually warm November evening, they retreated to a trailer, and as CNN flashed Obama's picture as president-elect of the United States, the new commander-in-chief mixed a batch of martinis, and then he and his wife toasted their new lives.

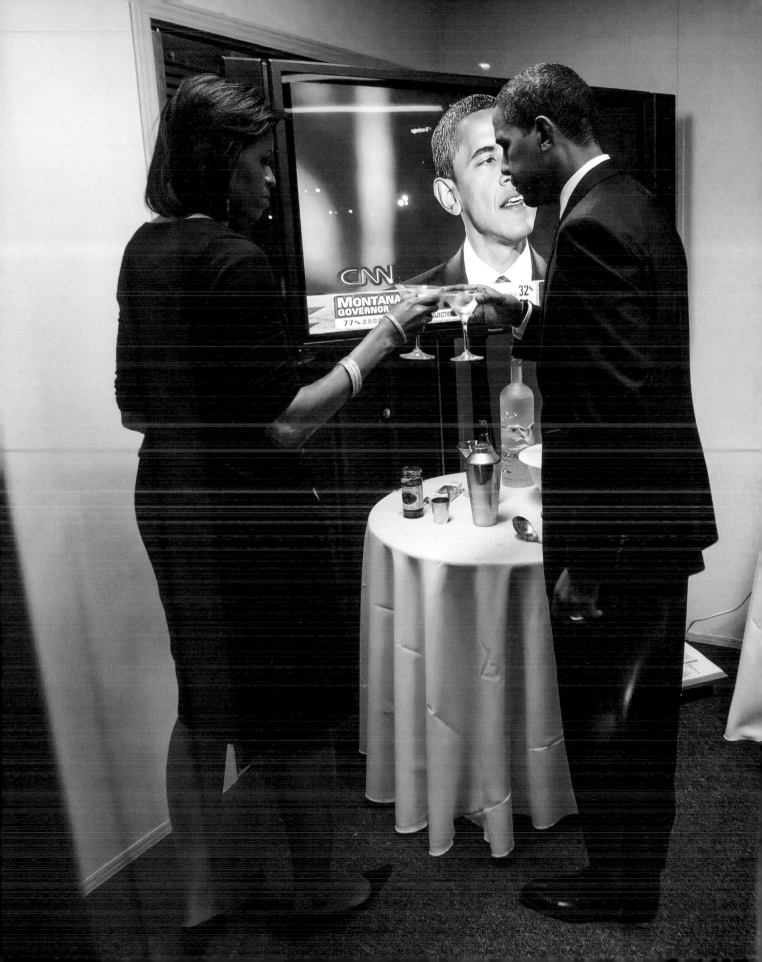

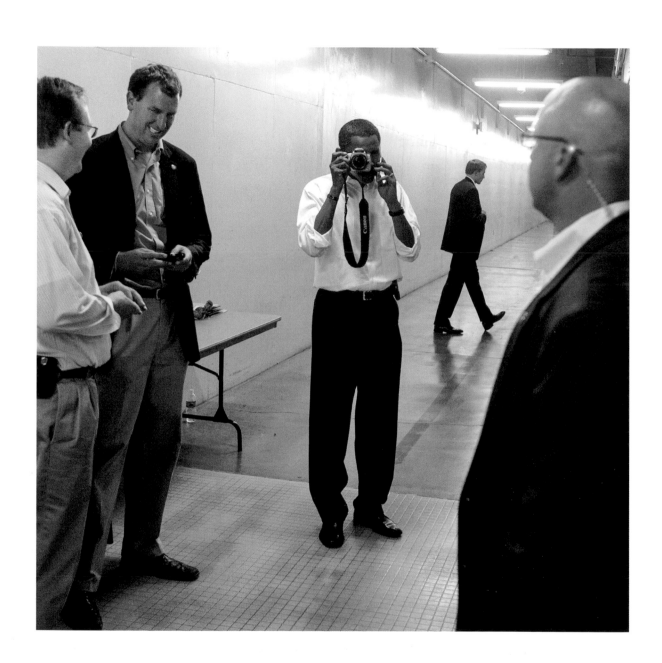

ACKNOWLEDGMENTS

Because *Barack Before Obama* is largely a book of photographs, turning memories into compelling vignettes and captions was a part of this project that brought me some initial anxiety. I am capable of writing clearly, but as my wife reminded me, "Clarity is the bare minimum you should strive for in this project." Luckily, I have family, friends, and a team at Ecco who are extremely talented writers and editors, and they were great sounding boards and thoughtful readers throughout the entire process.

Due to travel restrictions stemming from coronavirus, I actually never met my editor, Denise Oswald, in person. I did learn through her Instagram posts that she is quite the foodie! Thank you, Denise, for being an excellent river guide for a first-time author and for providing the right suggestions at the right time. And Jason Snyder, our talented book designer, without whom I could not have made all the critical layout decisions that go into a book like this. Thanks to my agent, Anthony Mattero, for guiding me to the team at Ecco.

You probably know the few people in your life who are excellent writers. For me, that included my inner circle of informal editors—Deborah and David Epstein, Andrew Shelden, Kim White, and Shira and Lucinda Lee Katz—who helped me immensely throughout this process. Their suggestions and edits are imprinted in this book, and for that I'm grateful. I also want to acknowledge friends and mentors who have influenced my photography, including Danny Moloshok, who advised me on photo selection for this book. And to Anders Johnson, Adam Hamburg, and my photography teachers, Liese Ricketts and Mark Citret, who inspired my initial interest in photography.

And, to my incredible wife, Betsy, who in addition to giving me thoughtful suggestions for the book, put our daughter, Zoe, to bed for three months straight, which allowed me to finish this book on schedule.

HarperCollins books may be purchased for educational, business, or sales promotional use.
For information, please email the Special Markets Department at SPsales@harpercollins.com.

Ecco® and HarperCollins® are trademarks of HarperCollins Publishers.

FIRST EDITION

Designed by Jason Snyder

Library of Congress Cataloging-in-Publication Data has been applied for.

ISBN 978-0-06-302874-6

20 21 22 23 24 TC 10 9 8 7 6 5 4 3 2 1

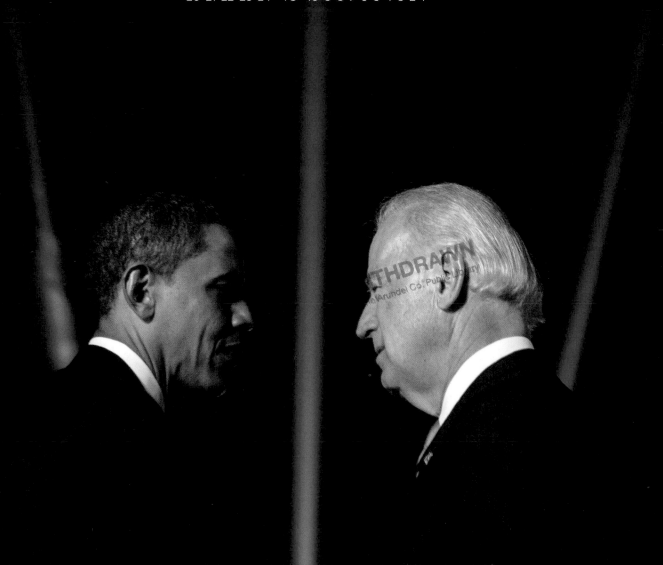